Decorative Painter's Guide to
FRUITS AND FLOWERS

WATSON-GUPTILL CRAFTS

Decorative Painter's Guide to
FRUITS AND FLOWERS

ANDY B. JONES

WATSON-GUPTILL PUBLICATIONS/NEW YORK

This book is dedicated to the loving memory of Anthony DuBose,
who taught me about beauty, kindness, and courage.

And to Dr. Hieu T. Nguyen: Thank you.

A SPECIAL ORGANIZATION

I want to encourage all my readers to join the Society of
Decorative Painters, a special organization dedicated to
promoting and teaching the art of decorative painting.
This membership organization has hundreds of local
chapters throughout the United States and around the
world. To find out more about joining this group of
painters, you can contact the Society at its headquarters:
Society of Decorative Painters
393 N. McLean Boulevard
Wichita, Kansas 67203
(316) 269-9300

Senior Editor: Candace Raney
Edited by Joy Aquilino
Graphic production by Hector Campbell

Copyright © 1998 by Andy B. Jones

First published in 1998 by Watson-Guptill Publications,
a division of BPI Communications, Inc.,
1515 Broadway, New York, N.Y. 10036

Library of Congress Cataloging-in-Publication Data
Jones, Andy.
 Decorative painter's guide to fruits and flowers / Andy B. Jones.
 p. cm. — (Watson-Guptill crafts)
 Includes index.
 ISBN 0-8230-1280-8
 1. Fruit in art. 2. Flowers in art. 3. Painting—Technique.
I. Title. II. Series.
ND1400.J66 1998
751.45'434—dc21 98-8485
 CIP

Manufactured in China

First printing, 1998

1 2 3 4 5 6 7 8 9 / 06 05 04 03 02 01 00 99 98

A NOTE FROM THE AUTHOR

I hope that by picking up the *Decorative Painter's Guide to Fruits and Flowers* you will become interested in a most fascinating art form. Unlike many other types and styles of painting, decorative painting is taught using an orderly, step-by-step method that can give anyone, with practice, the means to become an accomplished artist.

Fruits and flowers offer artists unlimited opportunities to study color and form. Never will you paint two apples in exactly the same way; never will two roses look alike. That's part of the fun of decorative painting: No matter how often you paint something, there's something more to learn, and the result is always different. The lessons in this book, each of which focuses on a specific motif, are demonstrated in both acrylics and oils, which allows readers to work in the medium they are most comfortable with.

I truly hope you will take the time to practice and work toward your goal of becoming an artist, and that the *Decorative Painter's Guide to Fruits and Flowers* will be a benefit to you.

Enjoy painting!

Contents

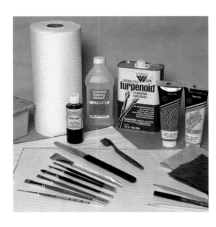

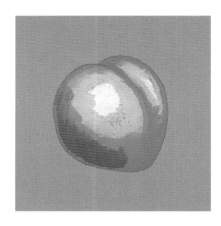

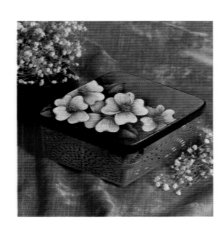

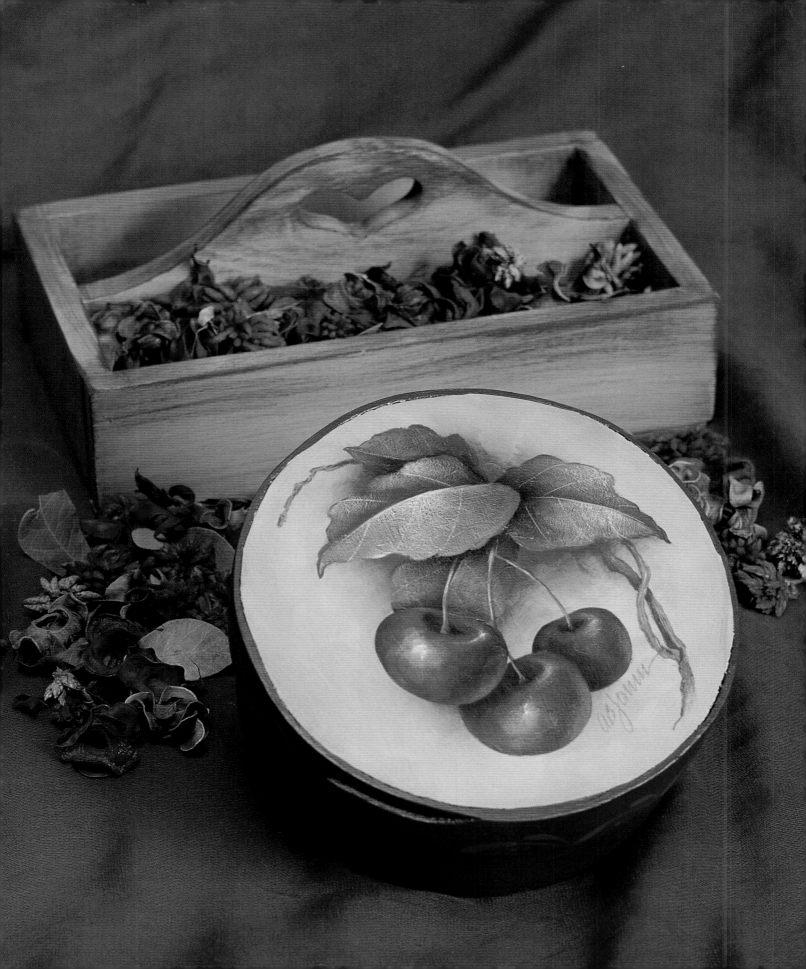

Your Painting Supplies

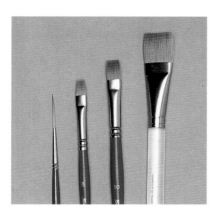

Decorative painting requires a variety of supplies. Note, however, that you won't need all the materials and tools described in this chapter to complete every project in this book; also, some are used only for acrylic painting, while others are strictly for use with oil paints. Read through the entire chapter, make a preliminary list of what you'll need, then check it against the step-by-step instructions for a specific motif or project before making your purchases.

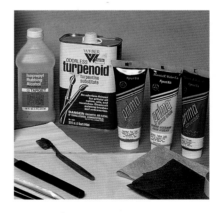

Choosing Your Paints

Most decorative painting projects can be carried out using either one of two mediums, or kinds of paint: acrylic paint or oil paint. Each medium has its advantages and disadvantages, so it's up to you to experiment and decide which is better suited to your personal taste and working style. Before making a final decision about which to try first, read through this section to evaluate the benefits and drawbacks of the working properties of each medium.

ACRYLIC PAINTS

Acrylic paints are available to decorative artists in two basic forms. *Liquid* or *craft acrylics* are commonly packaged in 2-ounce plastic squeeze bottles and labeled with descriptive color names such as "sky blue." These acrylic paint colors are often created by mixing several pigments. Because you won't always know which pigments were used to make a specific color, many times mixing two colors together will produce an unexpected or unpleasant result. Craft acrylics are fine for many styles of decorative painting, but I usually use them only for related applications, such as basecoating a project's surface prior to painting a motif.

For decorative painting, I prefer to work with *tube* or *artists' acrylics*. They contain pure pigments, and each color is identified by the name of the pigment that was actually used to impart color to the paint, such as burnt umber or cadmium yellow light. This information is particularly important when mixing colors. Artists' acrylics will give you consistent results. The brand of artists' acrylics I use is Prima®, which is manufactured by Martin/F. Weber Co.

If you'll be using artists' acrylics, you won't need to buy every single color that's available. You can mix virtually any color you want with just a few tubes of paint. (For information, see "Color Mixing," page 27.) The following is a complete list of acrylic colors that were used to paint the projects in this book:

- *Titanium white.* This white has good covering power.
- *Cadmium yellow light.* Very clean and light—a "true" yellow.
- *Yellow oxide.* An opaque straw color used as a transition between stronger shading colors and lighter values of yellow.
- *Raw sienna.* Use this deep straw color to create a transition between dark shading and mid-values of yellow.
- *Burnt sienna.* A clean rust color, this semitransparent pigment is excellent for darkening reds and yellows and for adding warmth to browns.
- *Burnt umber.* Use this rich brown earth tone to shade objects or add warmth to black and other cool shading colors.
- *Cadmium orange.* A vivid, opaque "true" orange that is more intense than a mixture of red and yellow.
- *Cadmium red light.* This slightly orangey red is semitransparent.
- *Cadmium red medium.* A bright, opaque red that evokes a traditional Christmas red.
- *Alizarin crimson.* This transparent red-violet is an invaluable shading color.
- *Dioxazine purple.* A deep, "true" violet.
- *Ultramarine blue.* A transparent, deep, "true" blue used to create reflected lights and accent colors.
- *Turquoise.* This opaque blue is valuable for accenting motifs.
- *Hooker's green.* A deep, rich, transparent green used to add intensity to green mixtures and to create some shading colors.
- *Mars black.* An opaque black with tremendous tinting strength. A little goes a long way.

OIL PAINTS

Like acrylics, artist-quality oil paints come in tubes and are usually identified by specific pigment names. When working with oils I use the Prima brand, manufactured by Martin/F. Weber Co. The following oil colors were used to paint the projects in this book; as with acrylics, however, it isn't necessary to have all of them on hand.

- *Titanium white.* An opaque and brilliant all-purpose white.
- *Cadmium yellow light.* A very light, semitransparent, clean yellow.

- *Cadmium yellow medium.* A neutral, opaque "true" yellow that is very sunny and bright.
- *Naples yellow hue.* Use this extremely opaque pale yellow to increase the covering power of other yellows.
- *Yellow ochre.* An opaque straw color.
- *Raw sienna.* This opaque deep ochre color is used to create transitions between light yellows and shading colors.
- *Burnt sienna.* An opaque rust color.
- *Burnt umber.* This is a warm, semitransparent earth tone.
- *Cadmium red light.* A red-orange used as a transition between light reds and yellows.
- *Cadmium red medium.* A bright, opaque, "true" red.
- *Alizarin crimson.* This beautiful transparent burgundy can be used alone as a shading color as well as to lend warmth to other shading colors.
- *Cobalt violet hue.* This violet color, which leans a bit toward the red-violet range, is used primarily to modify or impart warmth to other violets.
- *Ultramarine blue.* A "true" blue used extensively for creating accent colors.
- *Turquoise.* A strong, intense blue used mainly as an accent color.
- *Ivory black.* A transparent though neutral black with weak tinting strength.

COMPARING ACRYLICS AND OILS

Deciding whether to use acrylics or oils is a personal choice, one that can only be made after experimenting with both mediums, as each has its benefits and drawbacks. I learned to paint with oil paints, then began using acrylics when they became popular. I enjoy working with both. Before you give either a try, you should have an understanding of some of the principal differences between them. If you can remember the simple guidelines outlined below, you won't have trouble working with either medium.

Acrylic paints consist of pigments suspended in a polymer emulsion (a mixture of an acrylic resin binder and water). They dry quickly, in about 15 to 30 minutes; once dry, the paint film is waterproof. Acrylics allow an artist to execute a step, then let it dry completely (with no chance of smearing) before proceeding to the next. Your painting is finished as soon as it dries.

Oil paints contain pigments mixed with an oil binder (such as linseed oil or safflower oil) and a pine resin– or petroleum-based solvent (either gum spirits of turpentine or mineral spirits). Oil paints have a much slower drying time, which means that you can begin working on something, walk away for a few hours, then return to it later.

The most important reason for knowing about a medium's "working time" is that it determines which methods you can use to blend colors during the painting process. Oils give an artist a great deal of time to "play with" colors to achieve just the right degree of blending while the paint is still wet. With oils, each color can be loaded on the brush and placed on the surface one at a time, then blended together on the surface. Acrylics, on the other hand, dry too rapidly to accommodate this blending method; if you try, you are fighting a losing battle with the intrinsic character of the paint. When working with acrylics, you will use techniques that take advantage of that medium's rapid drying time. For example, you can apply one thin layer of color over another layer as soon as it is completely dry, so that the colors are blended *optically*; that is, two translucent layers of color combine in the viewer's eye to create a third. You can also blend colors on the brush, then apply the already blended color to the surface and leave it alone to dry.

Now that you have a general idea as to how each medium works, you may want to gather the supplies for one to see how you like it, then try the other. None of your efforts will be wasted. I firmly believe that trying both acrylics and oils will make you a better decorative painter, as each new experience will provide you with a different set of skills. For more information on the specific blending techniques that are used for each medium, see pages 29–33.

Selecting Your Brushes

Without a doubt, brushes are your most important decorative painting tools. Whether you paint in acrylics or oils, you should use the best brushes that you can afford. Using brushes of inferior quality will frustrate you because they won't perform properly. I often find that student artists' painting problems are caused by inferior brushes or by brushes that have been ruined by neglect. You must use good brushes in order to achieve satisfactory results. If you start with good-quality brushes and maintain them properly, they will perform well for many years.

HAIRS: SYNTHETIC VS. NATURAL

Although the word "hairs" is commonly used to refer to the part of the brush that holds and applies paint, in fact brushes can be made of animal hairs (sable, camel, squirrel, goat, and badger); animal bristles (hog and boar); synthetic fibers like nylon or polyester; or a combination of natural and synthetic hairs. For most of my own work, I use the latter: The properties of the natural hair allow the brush to hold moisture and release it slowly, while the synthetic hair gives the brush a nice resiliency, or "spring."

SHAPES

The part of the brush in which the hairs are arranged is called a *ferrule*. Ordinarily made of metal, the ferrule also attaches the hairs to the handle. As explained below, the shape of the ferrule determines the shape of the hairs. The basic shapes of brushes used for decorative painting are flat, round, bright, and filbert.

As the name suggests, the hairs of *flat* brushes are held in a flattened ferrule and are all very close to the same length. *Brights* are also flat brushes with same-length hairs, but the hairs are shorter. The hairs of *round* brushes are arranged in a cylindrical ferrule and taper to a soft point. *Liners* are small round brushes whose hairs taper to an extremely fine point. *Filberts* are also rounded at the end, but the hairs are held in a flat ferrule.

For the majority of my decorative painting work I use flat brushes, which can be used with either oils or acrylics. I prefer brights because their relatively short hair length allows for good control. Filberts are useful for highlighting with acrylics, and the smaller round brushes are used primarily for brushstroke work. Liners come in several different hair lengths; for example, spotters have very short hairs, and script liner, or scroll, brushes have very long hairs. Script liners are designed to hold a lot of paint. When you use a liner brush with short hairs you will find yourself constantly having to refill the brush.

Try several brushes of each kind to determine which ones work best for you.

Basic brush shapes.

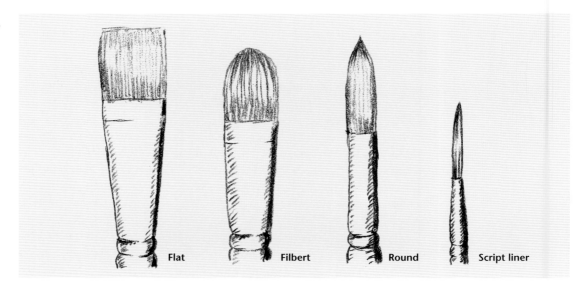

Flat Filbert Round Script liner

SIZES

The sizes of most of the brushes you'll use for decorative painting are listed in catalogs by number—from 10/0 (the smallest) to 24. A size 2, for example, is about 1/8 inch; a size 10 is 3/8 inch. Sizes for larger brushes are often given in inches.

You will want to have a variety of sizes on hand, from a no. 4 through a no. 12. When purchasing brushes, buy every other size at first, then fill in as needed. Of course, if you're going to paint primarily small things, then purchase the smaller brushes first. If you're painting large things, don't forget to get a small brush for detail work.

BASIC DECORATIVE PAINTING BRUSH KIT

Whether I'm working in acrylics or oils, I use brushes manufactured by Silver Brush Limited for decorative painting. Their various lines of brushes are superior in quality and available nationwide. Appropriate for either acrylics or oils, the Golden Natural™ series is manufactured with a blend of synthetic filaments and animal hairs, which gives a nice amount of "spring" or snap to the bristles. The Ruby Satin™ line of brushes, which are made with nylon hairs only, can also be used with both acrylics and oils, though the stiff bristles are a little too coarse for the fine blending that is usually associated with decorative painting in oils.

The assortment of brushes listed below comprise a good basic brush kit for the beginning painter.

- *Flats and brights.* Golden Natural Series 2002S, nos. 8, 10, and 12; and Ruby Satin Series 2502S, nos. 4 and 8.
- *Script liner.* Golden Natural Series 2007S, no. 2. This particular script liner, or scroll, brush can be used for most fine detail work. It has very long hairs and is designed to hold a great deal of paint. If you practice using this versatile brush, you will quickly become comfortable with the long hairs and appreciate its responsiveness.
- *Filberts.* Ruby Satin Series 2503S, nos. 4, 6, 8, and 10. These filberts are used for highlighting

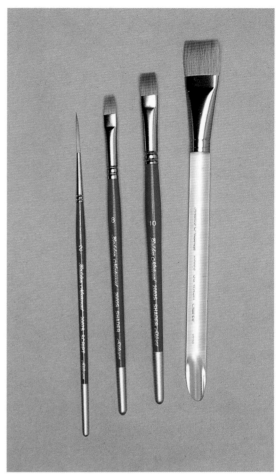

A selection of Golden Natural brushes (from left to right): A no. 2 liner; two flats, nos. 8 and 10; and a 3/4-inch wash. This line of brushes, which features a mixture of natural and synthetic hairs, can be used with either acrylics or oils.

techniques associated with acrylic painting. Because of their rounded corners, they don't leave the visible brush marks sometimes created when flats are used for highlighting with acrylics. You will probably need a range of sizes.

- *Wash brush.* Golden Natural Series 2008S, 3/4 inch. This large flat brush is very useful for creating blended basecoats (see page 38), applying gold leaf size (pages 40–41) and background color (page 44), and for any decorative painting application where large areas must be covered with paint.

- *Mop brush.* Series C9090S, ³/4 inch. This very soft brush, made from top-quality goat hair, is designed for very lightly blending and softening paints or glazes, and for softening background antiquing. It should NEVER be used for paint application.
- *Basecoat bristle brush.* PCM Series 9095S, 1, 2, or 3 inch. This large brush, which was specifically designed for background preparation and other rigorous uses, is a responsive natural-bristle brush. It is a superior tool for applying primers, basecoats, and varnishes to your pieces. If you try to use your delicate decorative brushes for this type of work, they will soon be destroyed. Choose the size most appropriate for the surface on which you will be working: The 3-inch is best for large pieces, the 2-inch for medium-size surfaces, and the 1-inch for small areas.
- *Glaze/varnish brush.* Series 9094S, 1 or 2 inch. Virtually identical to a basecoat bristle brush (above), this sturdy brush is far superior to a foam brush for the application of varnish because it is much less likely to form air bubbles on the project surface. It can also be used to prime and basecoat small and medium-size projects.

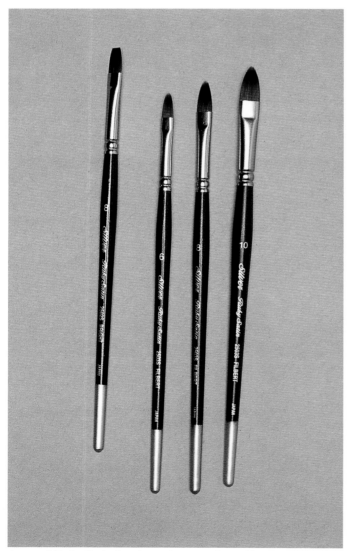

Assorted Ruby Satin brushes, whose synthetic filaments are best suited to acrylics: A no. 8 bright and three filberts, nos. 6, 8, and 10.

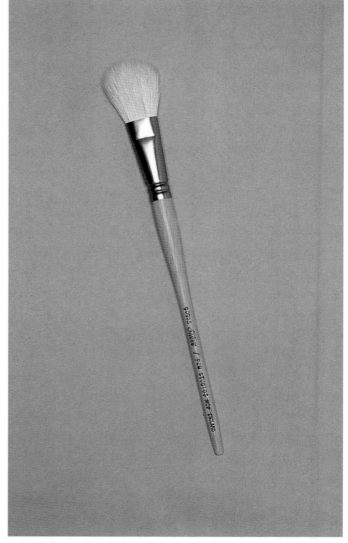

A ³/4-inch mop brush for refining and softening.

BRUSH CARE AND MAINTENANCE

The correct procedure for cleaning a brush must be mastered from the beginning, and your brushes must be cleaned after every painting session. Brushes are quickly ruined if you allow paint to dry or harden in the bristles. No matter how skillful a painter you are, your work will suffer if your brushes are mistreated. With proper care and cleaning your brushes will perform as they were designed to perform, and should last for years.

Cleaning Brushes Used with Acrylic Paints

Use water and a mild soap to clean brushes that have been used with acrylics. Rinse the brushes in cool, running water, working the bristles gently against the palm of your hand. Add a small amount of liquid soap, such as Murphy Oil Soap, as you rinse the brushes. Continue working the brush in your palm until no more color is released from the brush. Store the brushes bristle up in a glass or jar with nothing pressing on or bending the bristles.

Acrylic paint that has been allowed to dry in a brush can sometimes be removed by cleaning the brush in rubbing alcohol, which acts as a solvent, "melting" the paint so that you can loosen it from the hairs of the brush. Once you have loosened the paint, clean the brush with water

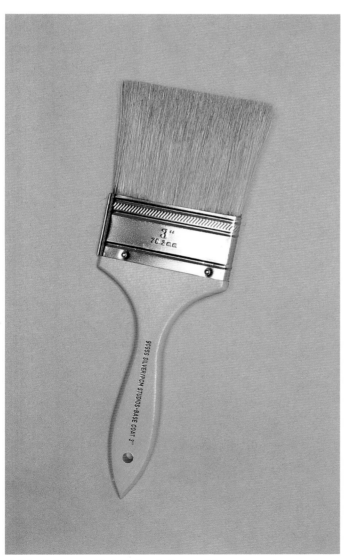

A 3-inch basecoat bristle brush for applying primer, basecoat paint, and varnish.

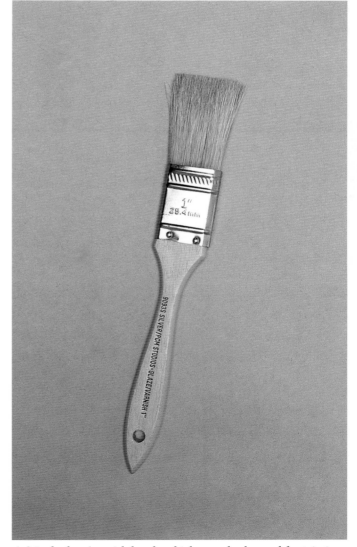

A 1-inch glaze/varnish brush, which can also be used for priming and basecoating small surfaces.

and soap, as described above. Alcohol is hard on brushes, so use this cleaning method only when absolutely necessary. The best strategy is to never allow paint to dry in your brush!

Cleaning Brushes Used with Oil Paints

For cleaning brushes used for painting with oils, you will need mineral spirits (see page 18 for a description of this), a bar of soap (Ivory is recommended), and paper towels.

Begin by wiping all of the excess paint out of the brush onto a paper towel. Next, gently swish the brush in a container of mineral spirits. Do not jam the brush down into the container, or push or hit the bristles against the bottom. It is best to gently tap the brush against the side of the container. As you do this you'll see a tremendous amount of color coming from the brush. Continue to do this until you can't see any more color being released from the brush. Wipe the brush on a paper towel. Now, dip the brush into the mineral spirits and then stroke the brush gently back and forth on the bar of soap. Almost certainly more color will be released. Continue this cycle—wiping the brush, dipping it into mineral spirits, and then gently stroking it on the bar of soap—until you can't see any more color coming from the brush.

Even after you are unable to *see* any color being released, it is highly likely that some paint still remains. To be sure that your brush is completely clean, dip it into a small amount of an oil-based soap (such as Murphy Oil Soap), then gently work the brush in the palm of your hand. Repeat this process until no more color is released from the brush.

When you are sure there is no more paint in the brush, stroke it gently on the bar of soap. Reshape the bristles into position, lie the brush on its side, and allow it to dry. When the brush is dry, store it, bristles up, in a glass or jar. Be sure that nothing is leaning against or bending the bristles.

When you want to paint again, simply wipe any soapy residue out of the brush.

Additional Supplies

In addition to paints and brushes, there are a number of supplies that you will need for painting the projects shown in this book.

ESSENTIALS (FOR ACRYLICS AND OILS)

Disposable Paper Palette. This item consists of a pad of specially coated paper. The water- and oil-resistant coating keeps the paper from buckling and the paint from soaking through, and the surface is excellent for color mixing (see page 27), sideloading, and doubleloading (see pages 32–33). Another advantage of this type of palette is its convenience: Once you've finished a painting session, just tear off the used sheet and throw it away. Paper palettes come in coated and uncoated versions; make sure to buy the coated type.

Palette Knife. Invest in a good-quality palette knife. Choose one that has a long, flexible, metal blade. Do not use a plastic palette knife or one that is stiff. You won't be able to "feel" the paint as you mix it. If you choose a good palette knife, you'll only have to make the purchase one time.

Paper Towels. Always use high-quality paper towels that are both soft and absorbent. You will be wiping and blotting your brushes on paper toweling often while you work, and rough, poor-quality paper towels can cause the bristles to curl and separate, ultimately ruining the brush.

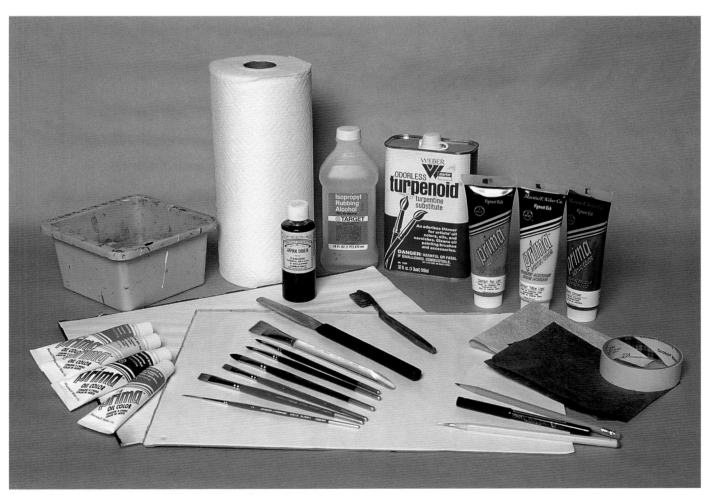

Some of the materials required for painting with acrylics and oils.

JUST FOR ACRYLICS

Water Container. You'll need a container for holding water that you'll use during your painting sessions. You can purchase a container designed for this purpose, or use any sturdy, wide-mouthed jar that will not tip over easily. The container shown opposite has special slots designed to hold a brush in water while you are working with it to keep it from drying. It also has a special ribbed area that is helpful for cleaning brushes.

Rubbing Alcohol. Alcohol can be used to clean any residue of dried acrylic paint from your brushes. You should try and remove all of the paint before it has a chance to dry, but if some paint does dry in the brush you can dip it into some alcohol and then work the hairs gently in the palm of your hand. See "Cleaning Brushes Used with Acrylic Paints," pages 15–16, for details.

Rubbing alcohol can also be used to flyspeck a still-wet acrylic basecoat to achieve a repelled-paint reaction. (See "Antiquing," page 39.)

Sta-Wet Palette. In addition to a disposable paper palette, you'll need a covered palette that will keep your acrylic paints moist. A good choice is the Masterson Sta-Wet brand, which is described on page 22 under "Preparing Your Palette for Acrylics."

JUST FOR OILS

Mineral Spirits. I use Weber Turpenoid®, an odorless turpentine substitute, as a thinner and brush cleaner when I work with oil paints. The strong odor of gum turpentine can be so overpowering that using it may diminish your pleasure in the painting experience.

Japan Drier. As part of my oil painting technique, I use japan drier, a dark brown liquid that reduces the drying time of oil paints by accelerating the oxidation process. Without the addition of a drier, some oil paintings may take anywhere from several weeks to several months to dry before they are ready for varnishing, depending on the thickness of the paint film. Japan drier also affects the consistency of the paint, allowing more control while blending. Note that japan drier is entirely optional; if you do use it, you

must use it very sparingly, as too much will cause your paintings to darken, discolor, or crack. See "Preparing Your Palette for Oils," page 22, for more information on how this product is used.

MISCELLANEOUS PROJECT SUPPLIES

Wood Putty. Use wood putty to fill any holes or cracks in the wood surfaces you will be using for your decorative painting projects. When the putty is dry, sand the surface until it is smooth. See "Applying Wood Putty," page 36, for more information.

Sandpaper. You will need to purchase several grits of sandpaper. Use a #120 or #150 (coarse) grit for sanding very rough places on wood pieces before applying primer, a #220 (medium) grit for sanding primer-coated surfaces, and a #400 (fine) for final sanding to produce a scratch-free surface.

Tack Rag. A tack rag is a very sticky piece of cheesecloth that has been treated with resin and varnish. It is used to remove any sanding residue from your surface. Store your tack rag in a plastic bag or in a tightly closed babyfood jar to keep it from drying out.

Sealer/Primer. You will need a water-based (latex) white sealer/primer to prepare wooden pieces for painting. This product seals wood, raises its grain, and helps prevent tannins from seeping through the basecoat. (Tannins are the substances that cause knot holes and heavy wood grain to bleed through paint.) A water-based sealer/primer is compatible with both oils and acrylics. See "Sealing/Priming," page 37.

Basecoat Paint. For applying basecoat paint to the surface on which you will be painting your fruits and flowers, you can select from the vast array of colors available in the crafts acrylics that come in squeeze bottles, or semigloss or flat latex house paints. If you use one color or a few colors often, you may want to go to the paint store and have a quart or even a gallon mixed. Use a natural-bristle brush to apply the paint. See "Applying a Basecoat," page 37.

Cotton Rags. You'll need a good supply of clean, soft cotton rags for wiping stains,

softening antiquing, and many other surface preparation applications.

Old Toothbrush. You can use an old toothbrush for *flyspecking,* or applying flecks of paint to a surface to add texture and visual interest. (See "Antiquing," page 39.)

Pen and Tracing Paper. You will use a ballpoint or fine-tipped felt pen filled with dark ink to trace decorative painting designs onto tracing paper.

Transfer Paper. Transfer paper is used to apply traced designs to a project's surface. Use white transfer paper when painting on dark backgrounds and use gray when working on light color backgrounds. See page 42 for more information.

Masking Tape. Use masking tape to hold transfer paper and traced designs in place as you transfer them to your surface, and to make flags for your brushes while practicing brush control exercises (see pages 23–26).

Stylus. A stylus is a tool that is used to transfer traced designs. It makes finer lines than a ballpoint pen and helps you make transfers more neatly.

Pencil. Keep a pencil in your painting supplies to help mark off borders or to touch up any designs that don't transfer well.

Varnish. I varnish all of my decorative painting projects with a good-quality water-based polyurethane, which can be applied directly over either oils or acrylics. In the past, a water-based finish couldn't be used over oil paints, but these quick-drying, less toxic formulations are now compatible with oils as well as acrylics. For small projects I like Anita's, which is sold in small cans at many art supply and craft stores. If you plan to varnish many pieces, you can buy gallon-size cans of Varathane at home improvement stores. These two brands are available in a range of sheens, from matte to high-gloss.

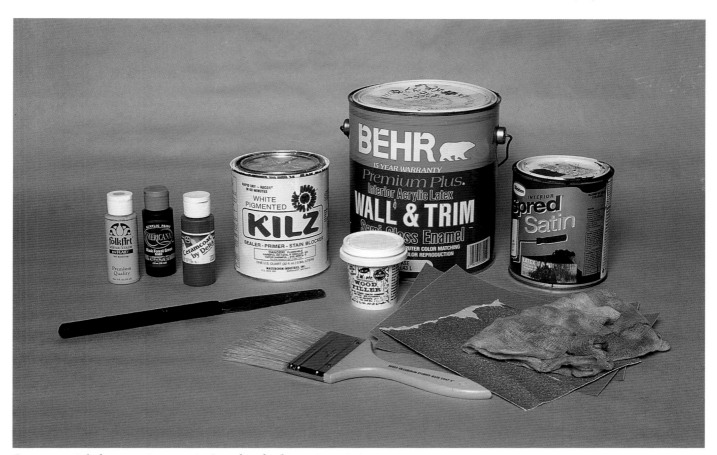

Some essentials for preparing a project's surface for decorative painting.

Decorative Painting Basics

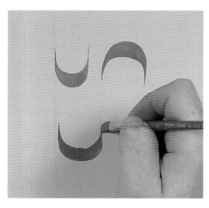

Contemporary decorative painting, broadly defined as a "diverse art form that utilizes a variety of step-by-step, methodical techniques to decorate functional and nonfunctional surfaces," is an art form as varied as the artists and crafters who practice it. While there are formulas for creating decorative paintings, each

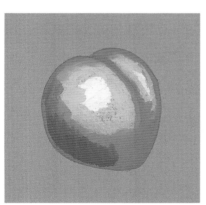

person will make his or her paintings unique, just as each person's handwriting is unique. There are really only two fundamental techniques necessary for decorative

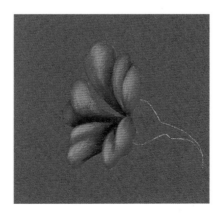

painting: brush control and blending skills. When these two techniques work in harmony, the result is outstanding decorative painting.

Getting Started

Once you've decided to work in a particular medium (either acrylics or oils) and gathered together all of the necessary materials, you'll need to get them organized before you can begin painting. The first step is to set up your paints, palette, and related materials so that everything is arranged for maximum efficiency.

PREPARING YOUR PALETTE FOR ACRYLICS

For painting with acrylics, I use two palettes: a Sta-Wet palette for paint storage and a regular disposable paper palette for mixing paints and loading brushes.

The Sta-Wet, made by Masterson, is a plastic palette tray with an air-tight lid that comes with a sponge and special paper. You soak the sponge with water and place it in the tray, then wet the paper and place it on top of the sponge. Set your paints out on the wet paper. When you want to mix or work with a color, move it to the paper palette with a palette knife. After mixing and using a color, return it to the storage tray, where it will stay wet and workable. Don't load your brush from the wet palette. When you have finished a painting session, seal the tray.

For rinsing brushes and blending techniques, you'll also need a container of water and some paper toweling.

PREPARING YOUR PALETTE FOR OILS

When working with oils, squeeze the colors you will be using along the top of the palette. Use your palette knife to move a portion of these colors to a clean spot on the palette for mixing. I place some japan drier in a small bottle cap and place the cap on the palette. To load the brush, I dip the brush in the drier, blot it very thoroughly on a paper towel, then work the hairs into the paint.

I use japan drier with oil paint for two reasons. First, it changes the viscosity of the paint so that it becomes just slightly sticky, making it less likely that colors will be muddied when they are blended. Second, it reduces drying time so that a finished painting is ready for varnishing in 72 hours instead of several weeks or even months, depending on the thickness of the paint. Note that if the paint is dry to the touch in less than 48 hours you are using too much drier, which can cause the paint film to darken and crack. If the long drying time of oil paints is not an issue for you, you can simply forgo the use of japan drier.

When working with oils, you should also keep a container of mineral spirits handy for thinning paints.

ACHIEVING THE RIGHT CONSISTENCY

Consistency refers to how thick or how thin your paint needs to be for a particular technique. There are several different consistencies that you will need to master in order to be successful with your decorative painting. The thinner you will use to alter the consistency of your paint depends on the type of paint you are using: for oils, use mineral spirits; for acrylics, use water.

For both oils and acrylics, you will use the paint as it comes out of the tube for most of your painting needs. Oil paint from the tube has what I would call a thick or tube consistency. It should have a firm touch when mixed with a palette knife.

For brushstroke work with either oils or acrylics, you'll want to thin the paint so that it will flow freely off of the hairs of the brush as you form your brushstrokes. To do this, add a few drops of the appropriate thinner (mineral spirits for oils and water for acrylics) to the puddle of paint, then mix them together with the palette knife. Be sure to constantly push the paint back into a pile and not let it spread all over the palette. The consistency should be loose. When you pick up paint on the palette knife, it should slide and drip off of the knife with ease.

When using the liner brush for adding detail, the paint needs to be even thinner. For oils, it should have an inklike consistency—very thin, but still containing color. For acrylics, the paint should have the consistency of thin soup and flow freely off the hairs of the liner brush.

Basic Brush Control Exercises

Brush control refers to the skillful handling of a variety of brushes, and brush control techniques are the same whether you are painting with oils or acrylics. In decorative painting, several types of brushes are employed—round, flat, filbert, and mop—and each requires different skills to properly manipulate it. Without adequate brush control you will find decorative painting frustrating, but with brush control you will have many hours of painting enjoyment.

Mastering control of your paintbrushes will take some practice on your part. I can't kid you, some of the practicing will seem boring and not worth the effort. The fact is, every minute you spend on learning and perfecting your brush control is time well spent. If you can make your brush do exactly what you want it to do, your painting will be much easier and more fun for you. Consider the following analogy: Suppose you were driving to the mall, but had no control over the car—you never knew just what the car was going to do, or whether you would even be able to maneuver along your chosen route. Imagine how terrifying the trip would be! Although your brushes have no moving parts, they are tools, just like your car. If you practice

so that you have total control of them, you can go anywhere you want to!

The brush control exercises shown below and on pages 24–26 aren't required to complete the fruit and flower motifs featured in this book, but practicing them will give you an opportunity to learn to how to handle your brushes and paints with confidence. Except for basic line work, all of the exercises require paint with a thinned or creamy consistency, so that it flows freely from the brush with minimum pressure.

LINE WORK

Line work, used primarily for outlining, strokework, or details, is done with a script liner brush, using paint that has been thinned until its consistency is similar to that of drawing ink. To load the brush, completely fill the hairs with paint, then gently twirl them to a fine point as you remove them from the puddle of paint.

You need only the slightest pressure to create fine lines and squiggles, and it takes practice to develop the light touch you need. It also takes practice to create brushstrokes with the liner brush, but it's fun to learn how to use one brush for so many different effects.

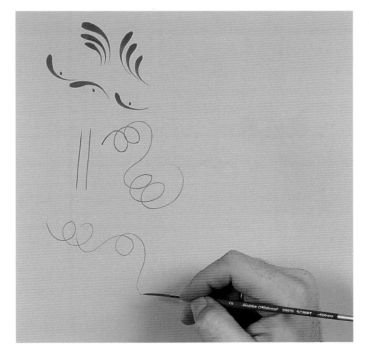

All the brushstrokes and squiggles shown here were created with a script liner brush.

COMMA STROKE

This exercise requires a flat brush; any size will do. To paint a comma stroke, angle your brush toward the corner of your paper. Gently touch the hairs to the paper, then immediately apply pressure to the brush. The ferrule (the piece of metal that attaches the hairs to the brush) should almost touch the paper. (See photo 1.)

Once you have applied pressure, begin to gradually release the pressure and lift the brush back to its edge as you pull. This will form the comma brushstroke. (See photo 2.) Do *not* turn or twist the brush; the stroke will form naturally as you apply and release pressure while dragging the brush.

Note that this stroke is used to finish the center of a pansy (see pages 106–111).

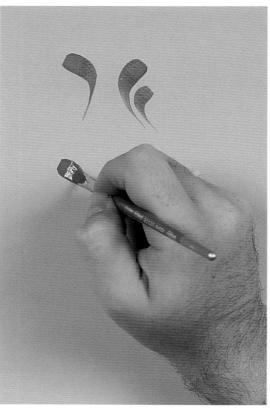

1. Angle your brush toward the corner of your paper, touch its hairs to the surface, then immediately apply pressure.

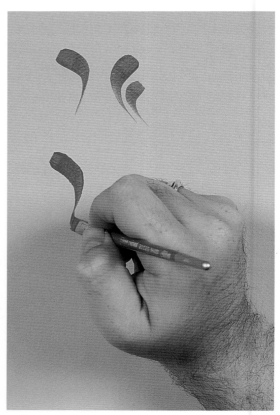

2. Gradually lift the brush back to its edge as you pull.

TROUBLESHOOTING THE COMMA STROKE

If you're having trouble learning this stroke, put a piece of masking tape on the end of your brush handle, like a flag. When you paint the brushstroke, the flag should NOT move. If the flag moves, you are turning or twisting your brush. Although this stroke is illustrated here with two photographs, it is really one fluid motion. It takes time and practice to master this stroke, as it does to master all the basic strokes.

S STROKE

Load a bright or flat brush, then stand the brush on its edge and slide it to create a thin line. (See photo 1.) Note how the brush is angled toward the corner of the page. After creating the line, continue to slide the brush along, gradually increasing the pressure. The pressure should be at a maximum at the middle of the stroke. (See photo 2.)

Now, while still sliding the brush, begin to decrease the pressure, creating another thin line at the end of the stroke. Note that the angles at the beginning and the end of the stroke are exactly the same. (See photo 3.)

If you are having trouble with this stroke, attach a flag of masking tape to the handle. As with the comma stroke, the flag should not twist, turn, or pivot.

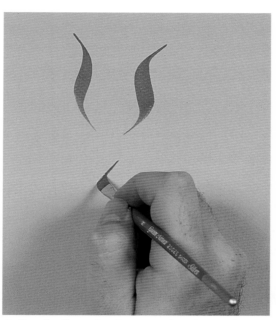

1. *Stand a flat or bright on its edge, then make a thin line.*

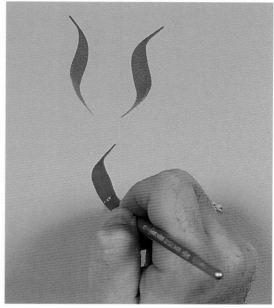

2. *To make the broad part of the stroke, increase pressure while continuing to pull the brush along the surface.*

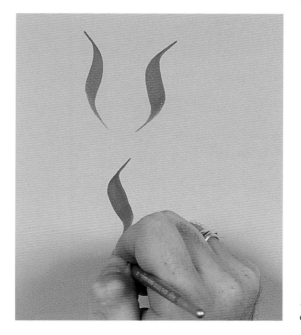

3. *Finish the stroke by lifting the brush on its edge again.*

U STROKE

The U stroke has the same basic steps as the S stroke but its shape is different. Begin by standing a flat brush on its edge; as with the S stroke, create a thin line before applying pressure. Then begin to apply pressure to make the thick part of the U. (See photo 1.) Do not turn the brush.

To see how the stroke works, make a U with your pen and be sure not to turn the pen.

Complete the stroke by smoothly releasing pressure and returning the brush to its edgewise position. (See photo 2.)

See pages 94–99 to see how U strokes are used to finish the centers of black-eyed Susans.

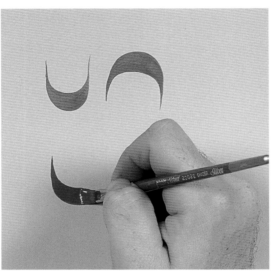

1. Paint a thin line, then apply pressure to make the thick part of the U.

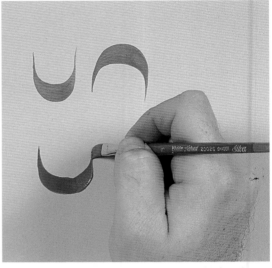

2. Smoothly release pressure to return the brush to its edge.

HALF-CIRCLE STROKE

This is the only time that you will turn, or pivot, your brush to create a stroke. To begin the stroke, hold the handle of a flat brush so that you will be able to rotate it around an imaginary dot. Place the hairs on the surface and begin to pivot the brush between your fingers until you have formed a half-circle. (See photo.)

Practice this stroke until you can form half-circles from either direction. Once you have perfected your half-circles, you can practice making two half-circles together, forming a full circle without any white in the center.

Rotate the loaded brush on the surface until you have formed a half-circle.

Color Mixing

Once you've mastered the brush control exercises described on the preceding pages, you'll be ready to check out the blending techniques demonstrated on pages 29–33, which you'll then use to paint fruit and flower motifs. Regardless of whether you use acrylics or oils, in theory you should only need five colors—red, yellow, and blue, plus black and white for mixing tints and shades—though in reality you'll need a few more. You will use your palette to create the subtle and gradual shift from light to dark that is used to render the three-dimensional form of a fruit or a flower. (For more information, see "Using Value to Create Dimension," page 28.)

Some simple color theory is needed at this point before we move on to the effects of value on your painting. There are three *primary* colors: red, yellow, and blue. They are known as such because they cannot be mixed from any other colors. The three *secondary colors* are produced by combining two primaries: red + yellow = orange, red + blue = violet, and blue + yellow = green. When you mix a primary with a secondary, you create a *tertiary color*, of which there are six; for example, red + orange = red-orange, and yellow + green = yellow-green. (The other tertiaries are yellow-orange, blue-green, blue-violet, and red-violet.)

These twelve colors comprise the basic artist's *color wheel*. If you familiarize yourself with the placement of these colors on the wheel, you will better understand how colors relate to and work with one another. Two colors that lie directly across from each other on the color wheel are called *complements*. Complementary pairs consist of one primary and one secondary color, such as yellow and violet, or of two tertiary colors, such as yellow-orange and blue-violet. Because of their equal strength, complements intensify each other when placed closed together (in a painting or design) and neutralize each other when mixed together. In theory, mixing complements together results in a neutral, grayish hue, but oftentimes the end product is an awful, muddy color.

The following are some color mixing tips for painting the fruit and flower motifs in this book:

- Mix colors according to the sequence cited in the instructions. The first color called for is usually the most dominant color in the mixture. For example, cadmium red light + alizarin crimson indicates that small amounts of alizarin crimson should be added to a relatively large amount of cadmium red light until the desired color is attained.

- Be sure to wipe your palette knife before using it to pick up a new color or to add more color to a mixture; this will keep the piles of paint pure.

- Always add color to a mixture in small amounts. It's easy to add color, but very difficult to reverse the effects of a color once it's been added. At that point, it's usually easier to start over than to try and fix it.

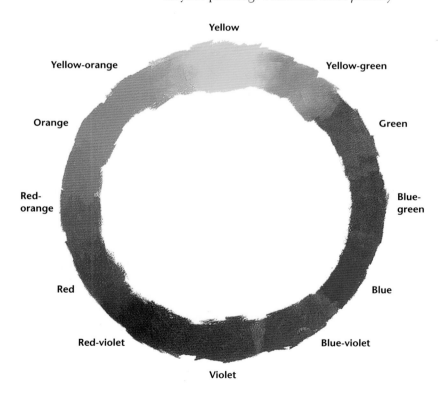

Yellow

Yellow-orange **Yellow-green**

Orange **Green**

Red-orange **Blue-green**

Red **Blue**

Red-violet **Blue-violet**

Violet

A color wheel can provide an artist with a broad range of information about color. The primary colors are the most intense because they are pure; the secondaries and tertiaries are less intense because they are mixtures. Complementary colors, which lie directly opposite each other, contrast with each other most intensely. Cool colors fall on the green-blue side of the wheel, while warm colors are on the orange-red side.

Using Value to Create Dimension

Formally, the *value* of a particular color refers to where it lies on a continuum ranging from pure white to black. For example, a light value of red can be painted using cadmium red light, a medium value using cadmium red medium, and a darker value using alizarin crimson + burnt sienna. Highlights and shadows, both of which add dimensionality to painted objects, are expressions of value.

A straightforward way to lighten the value of a color is to create a *tint* of the color, usually by adding white (or white plus the color you have already used). You can mix a tint on the palette or you can apply a wash over a color you have already applied (see page 30 for a description of this technique). For example, to tint a red apple you can apply a pink wash over a portion of the apple. You can also use tints over part of a design element to create an accent. *Shades*, which are darkened versions of a color, can be created by adding black to a color, and are often used to indicate a shadow on an object. Note that some artists prefer to lower a color's value by mixing it with black plus an adjacent darker value color on the color wheel (for example, red + black + violet), or by mixing it with blue and its complement (red + blue + green).

An *accent* is a small area of color that is usually placed along the edge of an object to help unify colors throughout a design or to help add variety within a grouping. Accents should not be glaring or spotty, but you can be creative in choosing the colors you want to accent your fruit or flower. For example, to accent a red apple you could use a pale green or even a light orange. You may need to add several layers of color, from dark to light, to create the exact accent you want.

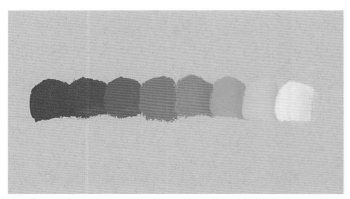

A *value scale showing cadmium red medium that has been incrementally lightened with titanium white.*

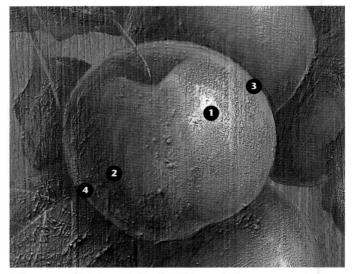

Elements of Light and Shade. *This apple demonstrates how color and value can be used to express dimension and create visual interest.*

1. HIGHLIGHT. *A value scale of red to white has been developed to produce a strong highlight.*
2. SHADING. *A darker value of red helps create dimension.*
3. ACCENT. *Green was applied here to create visual variety.*
4. REFLECTED LIGHT. *Reflected light is the color that is reflected back onto an object from an adjacent surface; usually, it has the same value as the local color of the object. In this example, a tint of violet was used.*

Blending Techniques

Blending skills are necessary to create the beautiful forms characteristic of decorative painting. Without mastery of changes in value, it is impossible to achieve the three-dimensional quality that is the hallmark of fine decorative painting. To successfully create three-dimensional effects, you must be able to paint gradations of color and value without obliterating any of the individual colors. Colors and values should gradually—almost imperceptibly—melt one into the next. The blending skills you use will vary, depending on whether you are painting with oils or acrylics.

BEFORE BLENDING: THE INITIAL STEPS

For many of the projects in this book, your first painting step will be either undercoating an element of the design with a solid color (with either acrylics or oils) or blocking in the main areas of highlight and shading (oils only).

Undercoating. To *undercoat* an element with either acrylics or oils, you use a solid color to fill in the entire area. When you complete your undercoating step, there should not be a tremendous buildup of paint on the surface. With oils your coverage should be thin and even. When working with acrylics, you may need to apply two undercoats, allowing the first to dry completely before applying a second. When you undercoat with acrylics, you should stipple the first color slightly to achieve a subtle bit of texture.

Blocking In (Oils Only). If oil paint is your chosen medium, your first step in painting many of the projects in this book will be *blocking in* several values of the color you are using for each element of the design, initiating the development of the object's form. The visible lines of demarcation among the values are then softened with a dry brush, usually a flat. (See "Drybrushing with Oils," page 31.)

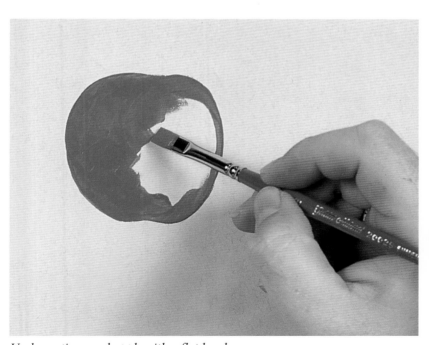

Undercoating a red apple with a flat brush.

Blocked-in light, medium, and dark values for a peach. The titanium white (painted in the area that will have the lightest value in the finished peach) is surrounded by Naples yellow hue, over which has been applied some cadmium yellow light + cadmium yellow medium. The rest of the peach was then filled in with yellow ochre. The darkest values were created by painting a mixture of raw sienna + burnt sienna over the yellow ochre.

APPLYING A WASH (ACRYLICS ONLY)

A *wash* is a layer of translucent color painted over an element that has already dried. To apply a wash, dilute the desired color with water until it is very thin and translucent.

The paint should look just like tinted water. Then gently apply small amounts of the thinned paint to the desired area, feathering out the edges of the application so they are soft and diffused.

The pear at right, top, was first undercoated, then shaded; each application of paint was allowed to dry before the next was added. A wash of cadmium red light was then applied to most of its surface (below). Although the wash changes the overall color of the pear, the thinned paint is so translucent that it does so without obscuring the colors beneath it.

DRYBRUSH TECHNIQUES

A variety of specific painting techniques carried out with a brush loaded with very little paint are part of a general category known as *drybrushing*. For the projects in this book, you need to know how to do *optical blending*, a drybrush highlighting technique used with acrylics in which layers of successively lighter values of a color are painted over a dry undercoat; you should also know how to do drybrush blending with oils.

Optical Blending (Acrylics Only). Let the undercoat or coats of the element you want to highlight dry completely. With a dry brush, pick up a *small amount* of a color that is slightly lower on the value scale than your undercoat color, then wipe the brush on a paper towel to remove any excess paint. Skim your brush over the surface, applying a light pressure; the paint should adhere only to the raised areas and ridges in the undercoated area. You should be able to see the undercoat color underneath. Repeat this process, using a still lighter value

and covering a smaller area. Each time you apply another highlight, you use a lighter value and cover a smaller area. You can use a single-color value scale or a combination.

Drybrushing with Oils. This step follows the initial blocking in that is often used with oils. After colors are in place on a design element, wipe the brush on a paper towel to remove any excess color, then apply a light pressure with the dry brush to create another color or value by blending the existing colors. Make sure your brush is free of thinner.

When blending, work just on the line between two colors. Blend only enough to soften the line. Remember that you worked to apply each color, so when you finish blending you should still see all the colors you applied, and there should be no hard lines between them. If you want to create a gradual transition between two colors that are extremes in value, place an intermediate value between the two, then proceed with blending.

The basic drybrush optical blending technique for acrylics. Here the progression is from a dark red to white.

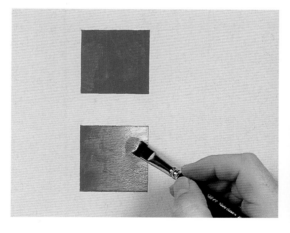

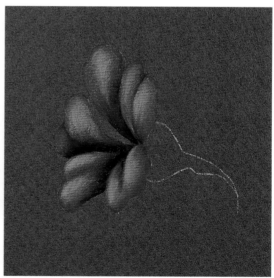

Drybrush blending with oils. Here an intermediate value (pink) has been placed between red and white, so that blending will achieve the desired gradual value change.

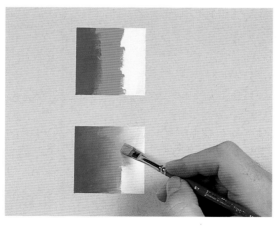

Nasturtium petals painted with acrylics using the drybrush optical blending technique. The undercoat was cadmium red medium. Next, in succession, came cadmium red medium + cadmium red light; cadmium red light; cadmium red light + cadmium yellow light; and cadmium red light + cadmium yellow light + white.

SIDELOADING

There are two blending techniques in decorative painting that employ a special brush-loading method. Each requires a bit of practice, so don't get discouraged if you aren't successful on your first couple of tries.

The first technique is *sideloading*, which produces a stroke that gradually fades from full color on one side to little or no color on the other, an effect known as *floated*, or gradated, color. Although a flat brush is used for the demonstration, any brush can be sideloaded.

1. *If you're working with acrylics, moisten the brush in water, then blot it on a paper towel to remove excess moisture. If you're working with oils, do* NOT *moisten the brush; just thoroughly wipe one you've already been using on a paper towel. Slowly stroke one side of the brush along the edge of the pool of paint, "sneaking" it into the paint to avoid loading too much color on the brush. Repeat several times to carefully work the paint into the hairs.*

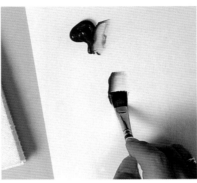

2. *To distribute the paint halfway across the hairs, move to a clean spot on the palette and stroke the brush over and over in the same spot. The color in the stroke should gradually fade from full-strength on one side to transparent on the other. Take care to make your strokes only about 1 inch long; if you make them longer, you'll be painting the palette instead of working the color across the brush.*

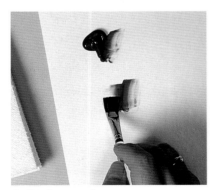

3. *Working in the same spot as in step 2, flip the brush over and begin stroking the more heavily loaded side of the brush against the full-strength edge of the stroke.*

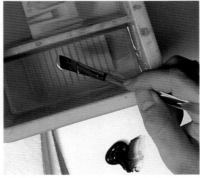

4. *The brush should be properly sideloaded at this point; however, you may need to repeat the process to ensure that it holds enough paint to perform the task at hand. If you're working in acrylics and the brush just doesn't seem to have enough color in it, see "Common Sideloading Problems," point 3, for advice on how to remoisten it.*

COMMON SIDELOADING PROBLEMS

- A common mistake among beginners is to make very long strokes while working the paint across the hairs, which actually *removes* paint from the brush (A). Check to make sure that your strokes aren't more than about an inch long.

- Making too many sets of strokes is another common problem. Keep working on one set of strokes as long as the paint used to make them is moist or workable. If you constantly move the brush to different areas of the palette, you'll end up painting the palette instead of redistributing the paint in the brush.

- If you're working with acrylics and the paint drags or the color in the brush isn't distributing itself evenly (B), dip the corner of the more heavily loaded side into the water. This area of the brush will absorb less moisture, giving you more control over how much is in the brush. Be sure to blot the brush on a paper towel any time you add moisture to it. Also, if there doesn't seem to be enough paint in your brush, chances are it wasn't loaded properly to begin with.

- If the color beads up on the palette, or if the color works itself all the way across the hairs, there is either too much paint or too much moisture in the brush (C). Gently blot the brush on a paper towel, then continue stroking.

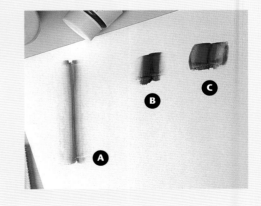

DOUBLELOADING

A variation on sideloading, *doubleloading* charges each side of a brush with two different colors or values of paint. In the stroke produced by this technique, the two colors or values gradually blend in the center.

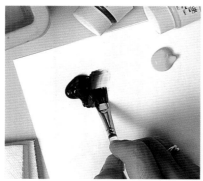

1. If you're working with acrylics, moisten and blot the brush; for oils, wipe the brush on a paper towel until no more paint is discharged. Load one side of the brush with the first color, "sneaking" it into the paint as you stroke along the edge of the paint puddle.

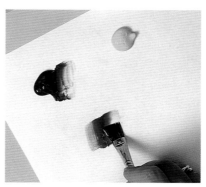

2. Working in one spot on the palette, stroke the brush to distribute the paint halfway across the hairs. Don't make your strokes more than about an inch long or the paint will begin to discharge from the brush. Flip the brush over; working on the same set of strokes, stroke the more heavily loaded side of the brush against the full-strength edge of the stroke.

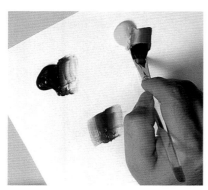

3. Repeat step 1 to load the empty side of the brush with the second color.

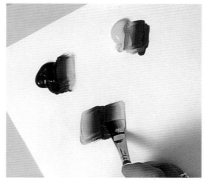

4. On a clean area of the palette, repeat step 2 to gradually blend the two colors together in the center of the brush. Flip the brush over, then stroke the side of the brush loaded with the first color against the corresponding area of the stroke. If necessary, load the brush with a little more of each color and continue blending until the brush is full of paint.

COMMON DOUBLELOADING PROBLEMS

- It is possible to overblend the strokes on the palette; this muddies the colors of the stroke as well as those in the brush (A). If this happens, wipe the brush on a paper towel and try again. Don't clean the brush before reloading or you will undo all the good work you have done to fill the brush.

- If the two colors did not blend enough, leaving a harsh line of demarcation between them (B), or if there is a gap in the center of your tracks, pick up more paint and continue to stroke the same spot on the palette until the two colors gradually blend in the brush.

- Make sure you don't accidentally put the wrong side of the brush into the wrong color (C). Until you become comfortable with this technique, you'll have to pay close attention to what you're doing.

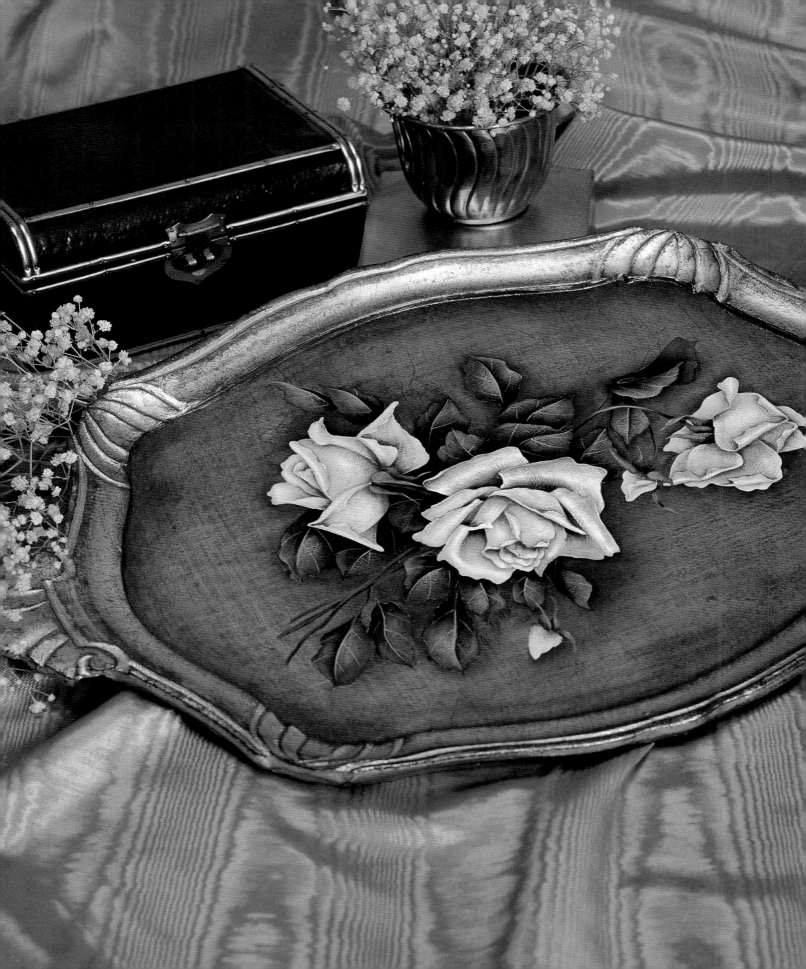

Preparing a Project's Surface

If you're thinking about skipping this chapter, don't! Surface preparation may seem tedious, but imagine how you would feel if your masterpiece started to flake and peel because you left out this critical part of the process. If you take the time to prepare surfaces correctly, the efforts you make to paint them will be preserved for a lifetime.

Because most of the fruits and flowers are painted on a variety of wooden items, detailed instructions are provided for the surface

preparation of wood. Instructions for preparing other kinds of surfaces are included with the painting instructions for the specific motifs that decorate them.

Before You Start Painting

APPLYING WOOD PUTTY

The first step in preparing a wooden surface for painting is to fill in any nail holes, dents, or imperfections (such as knot holes) with wood putty. Pick up a small amount of the putty with a palette knife and smooth it over each affected area, applying enough to overfill it slightly (see photo at right). Follow the manufacturer's instructions with regard to drying times. Once the putty has dried completely, lightly sand the areas with #120 or #150 (coarse) grit sandpaper until they are flush with the wood. If you're planning to stain the piece (see below), you should sand its entire surface at this point; if the item will be sealed/primed in preparation for basecoating (see opposite), sand only the areas to which the putty was applied.

STAINING

The term "stain" means to apply a translucent glaze to raw, unsealed wood, first brushing it on, then wiping it off. Contrary to popular belief, a wood stain doesn't have to be an earth tone or a conventional wood color. A stain can be any color—red, blue, green, or yellow. Staining wood white or off-white is called *pickling*.

You may use either oils or acrylics to stain wood. Using the appropriate thinner (water for acrylics, mineral spirits for oils), dilute the paint to a thin, soupy consistency, then evaluate its translucency by brushing a small amount on an inconspicuous area of the project (see photo 1). Immediately wipe away any excess with a clean, soft cotton rag (see photo 2). If you're pleased with the result, apply the glaze with a basecoat bristle or glaze/varnish brush to the entire surface; if you're not, continue adding thinner to the paint and testing its translucency until you are. Apply the glaze to the surface a section at a time, then immediately wipe off the excess with a cotton rag. Let dry completely. You can then trace a fruit or flower pattern and transfer it to the surface (see page 42) in preparation for painting.

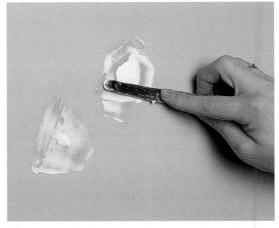

Use a palette knife to smooth putty over imperfections in the wood; let dry, then sand.

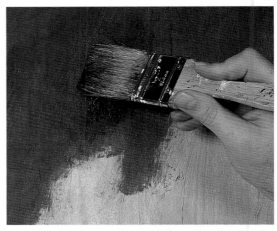

1. Apply the glaze to the sanded wood with a brush.

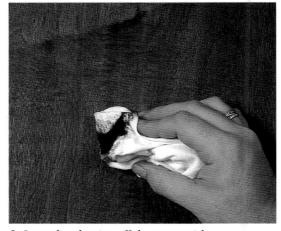

2. Immediately wipe off the excess with a cotton rag.

SEALING/PRIMING

Because a sealer/primer will "raise" the grain of the wood, causing it to swell, it's important that you *not* sand an entire piece beforehand. If you've concealed flaws with wood putty, sand only those areas prior to applying sealer/primer. Use a basecoat bristle or glaze/varnish brush to apply an even coat in the direction of the wood grain (see photo below, left), then let dry according to the manufacturer's instructions.

Once the sealer/primer has dried, sand the piece with a fine grade of sandpaper until the surface feels smooth. Use #220 (medium grit) if the surface feels slightly rough, and #400 (fine grit) if it feels smooth. (Use the finest grade you can, as long as it gets the job done.) Always sand in the direction of the wood grain, and try to keep your strokes straight and even.

Once you've finished sanding, use a tack rag to remove the residue from the surface. Wipe the entire piece to ensure that all stray particles have been cleaned off. Don't skip this step; if you don't remove the sanding residue, it can make your basecoat appear grainy or flawed.

The next step is to apply a basecoat in the color of your choice.

APPLYING A BASECOAT

You can basecoat your project's surface with acrylic paint or semigloss or flat latex paint. For a single project, craft acrylic paints are your most convenient option. In this book, the colors used to basecoat the projects are referred to simply by value and hue (for example, dark green, medium blue, light purple), so if you want to use the same basecoat color that was used for a project you'll have to choose a paint by evaluating its color rather than by matching a color name.

Apply the paint with a natural-bristle (basecoat or glaze/varnish) brush, which is preferable to a foam brush for applying basecoat paint because it is more responsive and provides better coverage.

Make sure your project surface, wood or otherwise, is sealed and smooth before you begin basecoating. Apply the paint in smooth strokes in the direction of the wood grain (see photo below, right). (If you're working on a nonwood surface, apply the paint following the direction of its largest dimension.) Let dry. The coverage should be smooth and opaque. If not, apply a second coat, then let dry completely before continuing with any other surface treatment.

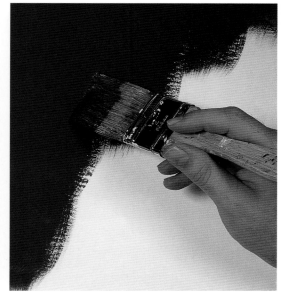

Brush a coat of sealer/primer on the raw wood; let dry, then sand the surface and wipe it with a tack rag.

When basecoating a wood surface, brush on the paint following the direction of the grain.

CREATING A BLENDED BASECOAT

This special effect can heighten the appeal of your decorative painting motifs. You can achieve it by using three colors that are similar in value (for example, light yellow, light orange, and light red) or three values (light, medium, and dark) of any one color. As when painting a single-color basecoat, you'll be working with acrylic or latex paints.

Using a wash brush, apply a coat of the lightest color or value to the entire surface and let dry completely. Dampen the surface with water, then quickly apply the other two colors or values opposite one another but without a harsh line of demarcation between them. (See photo 1.) While the paint is wet, begin to blend the two colors together by working the brush in a crisscross motion (see photo 2). If you pick up too much of one color or value, gently wipe the brush on a paper towel. There should be a gradual transition between the two colors.

To complete the effect, soften the blending by gently "dusting" the still-wet surface with a mop brush (see photo 3). Exert as little pressure on the brush as possible while quickly moving it over the entire surface. Remember, the mop brush is designed for refining already blended color, *not* for blending. Blend with the wash brush and only refine with the mop.

If you aren't satisfied with your first attempt, which is likely, allow it to dry and repeat the procedure right on top of it. It sometimes takes me two or three tries before I'm happy with a blended basecoat. Keep in mind that a good portion of the basecoat will be covered with painted motifs. Your main objective is a soft, mottled background.

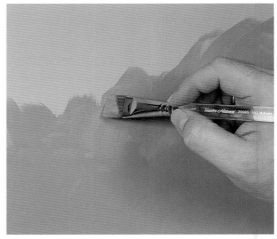

1. Apply the lightest color or value of paint; let dry, then dampen the surface with water and quickly apply the other two colors or values.

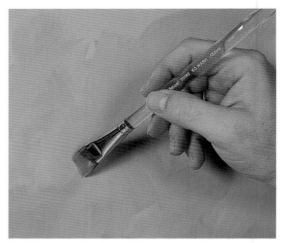

2. Eliminate the line of demarcation between them by softening the area.

3. Gently refine the blended area with a mop brush.

ANTIQUING

Antiquing can add a wonderful richness to a painted fruit or flower motif. You can antique over a completed basecoat prior to painting your motif, or over a finished painting. For the projects in this book, antiquing has only been applied over basecoats, never over any painted designs.

Antiquing can be done in acrylics or oils. The steps are the same for both; the main difference between them is the speed at which you must work. Acrylics dry rapidly, so you must work very quickly in order to achieve an appealing soft shading. With oils, you have all the time you need. In my opinion, oils produce the most beautiful antiquing effects, so I use them almost exclusively for this technique.

To begin, dilute your chosen medium with the appropriate thinner (water for acrylics, mineral spirits for oils) until it reaches a thin, soupy consistency. (When using oils I mix in a drop or two of japan drier as well.) Randomly apply this glaze to the surface with a wash brush. (See photo 1.) Be sure to cover the area completely. While the glaze is still wet, wipe away the excess with a soft cotton rag. To create a highlighted area, start at the center of the surface and work outward in a circular configuration (see photo 2).

Use a mop brush to soften and refine the glaze that remains on the surface. Eliminate any obvious brush or wipe marks left by either the initial application of glaze or its removal with a cotton rag (see photo 3). You should see a subtle transition from light (in the center of the surface) to dark (its perimeter).

Flyspecking. Flyspecking is frequently used in combination with antiquing. Load an old toothbrush with thinned paint, then spritz the surface by pointing the bristles downward and running your thumb over them *toward* yourself. (If you push your thumb away from yourself, you'll flyspeck yourself instead of the surface.) Make sure the paint isn't too thin, or large blobs of it will drip off of the toothbrush onto the surface.

There is an alternate method of flyspecking in which a newly applied coat of paint is spattered with thinner or solvent (rubbing alcohol for acrylics, mineral spirits for oils), which repels the paint and allows the underlying surface to become visible in some spots.

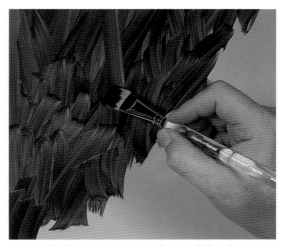

1. Randomly apply glaze with a wash brush.

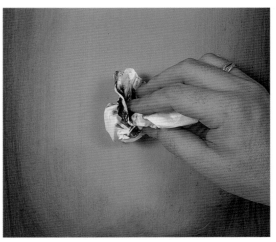

2. Starting at the center and working outward in a circular configuration to create a highlighted area, wipe away excess glaze with a cotton rag.

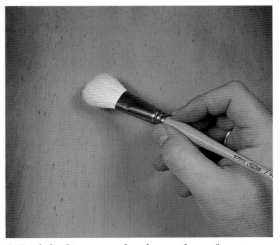

3. Lightly skim a mop brush over the surface to eliminate any obvious brush or wipe marks.

APPLYING METAL LEAF

Metal leaf adds an elegant touch to decorative painting projects that simply can't be duplicated by metallic paint. The stunning results are unquestionably worth the time and effort that are needed to learn to apply it. If you take your time when handling the leaf and carefully follow the time requirements for each step, you'll be delighted with the outcome.

The type of metal leaf that is most commonly used today is imitation gold leaf, also known as Dutch metal leaf. Although real gold leaf is available, it is very expensive. Real silver is also available, but most silver leaf is actually aluminum. Copper leaf is always real. Both real and imitation metal leaf can be found in art supply and craft stores packaged in 4-inch-square books containing twenty-five sheets. The sheets are so thin and fragile that your breath can break one and scatter the pieces, so try to work with leaf in a draft-free area, and don't remove any sheets until you're ready to use them.

The leafing process begins with the application of the basecoat, whose color should complement the tone of the leaf (see photo 1). A dark brownish red is traditionally used with gold, copper, and warm-toned variegated leaf, while dark green or black is used with silver leaf. Follow the instructions outlined on page 37, then make sure the surface is completely dry before proceeding.

At this point, a coat of special adhesive known as *size* is brushed on the surface and allowed to dry until it reaches the proper *tack*, or just the right degree of stickiness. Always use professional gilder's size, which is available in both water- and oil-based formulations; the superior quality of these products will increase the odds for success. I prefer working with oil-based sizes, which flow on more evenly and show fewer brushmarks, which in turn enhances the appearance of the leafed surface. Oil-based sizes are available in "quick" and "slow" versions; both give you plenty of time to work with the leaf, but they also take much longer than water-based sized to reach the proper tack. Set-up and drying times vary, but quick oil sizes are generally ready in about 1 hour and remain tacky for about 3 hours, while slow oil sizes are ready in about 4 hours and remain tacky for up to 12 hours. In contrast, professional water-based sizes are ready in about 20 to 30 minutes and dry shortly thereafter. Do not use "craft" sizes, as most are too thick and dry too quickly for the leaf to be applied successfully.

Use a wash brush to apply a thin, *even* coat of size, making sure you don't miss any areas or apply it too thickly in others (see photo 2). When the size has reached the proper tack, you can begin to apply the leaf. Allow the interval noted in the manufacturer's instructions to elapse, then gently touch the surface with your knuckle. If the surface is sticky and no mark was made where you touched it, then it is ready to be leafed.

If the sheets in the book of metal leaf are larger than you need, use scissors to cut them to just slightly larger than the area you want cover. Cut them all at the same time, since they are too fragile to cut one at a time, and do *not* remove them from the protective tissue, either before or after cutting.

To transport the leaf to the surface more easily, cut a piece of waxed freezer paper a little larger than the piece of leaf. Place the freezer paper waxy side down on the leaf, then rub your hand over the back of the freezer paper. The warmth of your hand will cause the leaf to lift away from the protective tissue and adhere to the freezer paper (see photo 3). To release the leaf from the freezer paper, press the leaf to the surface, lightly brush the freezer paper with your hand, and gently pull the paper from the surface.

Continue applying leaf to the remainder of the sized area, making sure you press each sheet onto the surface so that it adheres to the size. Always cover the leaf with freezer paper before touching it; do *not* touch it directly with your hands. Let the size dry overnight.

Gently brush away large loose pieces of leaf from the surface by burnishing it with a clean, dry wash brush (see photo 4). To remove any minute fragments, gently "polish" the leaf with a clean, soft cotton rag. Do *not* use a tack rag for this step, as it is too coarse and will scratch the leaf.

The shiny metal surface may be softened and colored with a decorative antique finish (see photo 5). Any color can be used; I generally choose one that relates to the overall palette of a piece. You can also follow this rule of thumb: warm colors over gold, copper, and variegated leaf; cool colors over silver leaf.

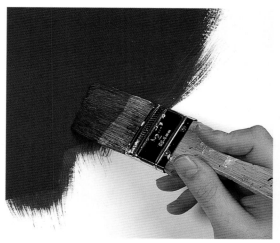

1. *Basecoat the surface with a color that complements the tone of the leaf, then let dry.*

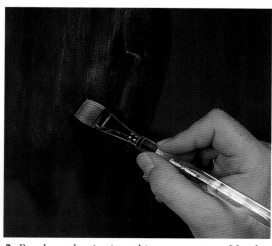

2. *Brush on the size in a thin, even coat and let dry to the proper tack.*

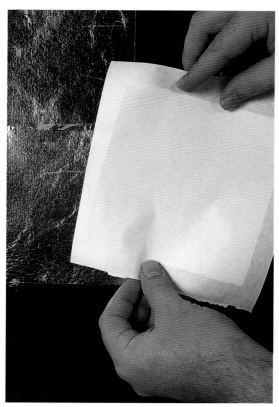

3. *Use a piece of waxed freezer paper to transport the leaf. Press each sheet of leaf onto the surface so that it adheres to the size. Let the size dry completely.*

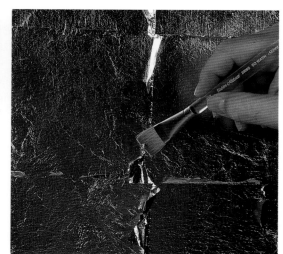

4. *Gently burnish the surface to brush away large loose pieces of leaf.*

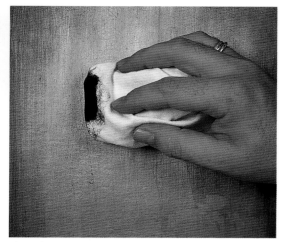

5. *Soften the shiny leaf with an antique glaze.*

TRACING, SIZING, AND TRANSFERRING A PATTERN

The sixteen patterns at the back of this book (see pages 132–142) are provided for your use and enjoyment. You can use them as they appear or alter them to suit your needs. Simplify patterns by eliminating elements, or create more elaborate ones by combining elements from several different patterns. If you don't find something that appeals to you, look for reference material in magazines and books and on fabrics and wallpapers. Of course, you should look for inspiration in real fruits and flowers as well.

Begin by tracing the pattern. Place a sheet of tracing paper over the pattern and carefully outline its contours with a ballpoint or fine-tipped felt pen filled with dark ink (see photo 1). You don't need to trace all the lines that indicate shading, but be sure to include any important details, such as vein lines in leaves.

If the traced pattern fits the painting surface, you can simply transfer it (see below). If you need to adjust its size, you can enlarge or reduce it on a photocopier. To determine the correct percentage of enlargement or reduction, use a *proportion wheel*. Consisting of two concentric circular disks that are printed with measurements around their circumferences, a proportion wheel can give you exactly the percentage of enlargement or reduction you need without having to make numerous copies. In one of the disks is a window that, when the disk is turned, reveals a series of percentages. Simply measure the original pattern's height or width, then figure out what that dimension should be in order for it to fit on the project's surface. When you line up these two numbers on the disks, the correct percentage of enlargement or reduction will appear in the window.

Next, position the correctly sized pattern on your surface. Use masking tape to keep it from moving as you work with it. Slip a piece of transfer paper, graphite side down, beneath it, then trace it with a stylus. (See photo 2.) Start by tracing a small element to make sure it's transferring correctly. Periodically check to see that you haven't missed any lines.

When you've finished transferring the pattern, remove the tracing and the transfer paper (see photo 3).

1. Carefully trace the pattern in pen.

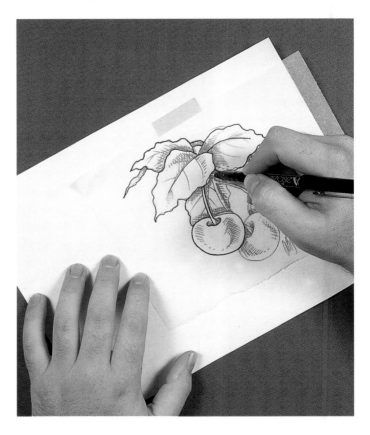

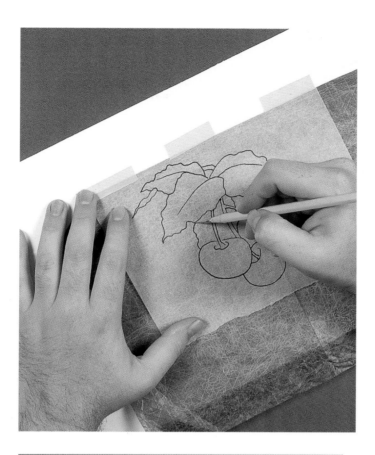

2. *Tape the traced pattern to the surface. Slip a piece of transfer paper beneath it, then trace the pattern with a stylus.*

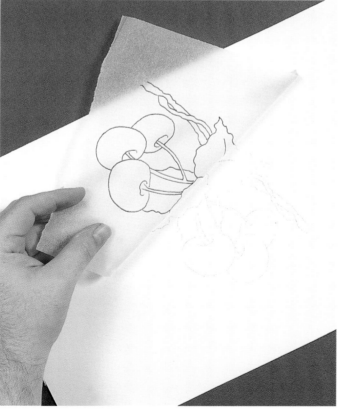

3. *Remove the tracing and the transfer paper to begin painting.*

ADDING A BACKGROUND COLOR

A background color—a subtle glow of color surrounding a motif or design—is one of the most effective ways to increase a project's visual interest. The color can be either faint or strong, but it must complement both the design and the project, not draw attention to itself.

Begin by transferring your pattern to the surface as described on pages 42–43. Sideload a wash brush with a light- or medium-value color, then gently pat and pull the paint along the contours of the design. It isn't necessary to surround the entire design; in fact, it's better to concentrate the color in the recessed areas (the nooks and crannies between elements) and leave some areas blank. (See photo 1.) If you're working with acrylics, allow this first application of color to dry before proceeding to the next step.

To increase the intensity of the background color, sideload the wash brush with a medium- or dark-value color, then use it to enhance only the most recessed areas (see photo 2). If you're working with oils, you can use a mop brush to soften areas where the two colors blend.

Allow the background color to dry, then reapply any pattern lines that are obscured by the paint.

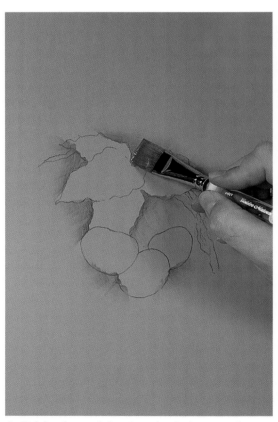

1. Sideload a wash brush with a light- or medium-value color, then gently stroke it around the transferred pattern's silhouette.

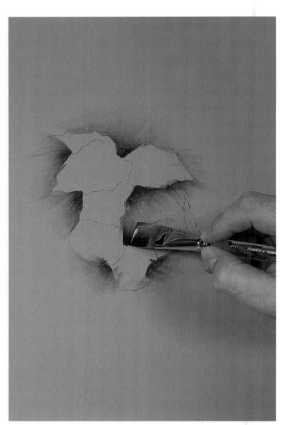

2. Enhance only the most recessed areas with a darker value; let dry. Reapply any pattern lines that were lost before you begin painting.

Varnishing Your Painting

Although the procedure for varnishing is fairly simple, you must take your time and use the proper tools to achieve satisfactory results. Before you begin, you must be sure your painting is sufficiently dry. If you painted your motif in acrylics, wait at least 24 hours before varnishing. The waiting time for varnishing oil paints varies. If you used japan drier as you worked, you should wait at least 72 hours; if you didn't, you may need to wait a few weeks, depending on the thickness of the paint.

You should use a top-quality natural-bristle brush for when applying brush-on varnish, either a basecoat bristle brush or a glaze/varnish brush. These brushes hold plenty of varnish and release it in a controlled and even manner. Never apply varnish with a foam brush, which will leave bubbles on the surface—something you definitely want to avoid.

Using the right kind of brush is essential, but its care is important too. I recommend that you purchase a new brush and set it aside for varnishing only. In fact, I labeled the handle of one of my brushes so there would never be any question as to which one should be used for varnishing. Why earmark a brush exclusively for varnishing? The answer is simple: If you use a brush to apply paint, traces of it may still remain in the bristles even after it has been cleaned. Good-quality water-based polyurethanes contain chemicals that can loosen and soften this residue, which then may be transferred to the painted surface or leave unsightly streaks of color in the varnish. Wash your varnish brush immediately after applying each coat to prevent a buildup of varnish in the hairs.

Before you begin applying it, stir the varnish thoroughly until none of the cloudy "stuff" (dulling agents) is left in the bottom of the container. (Never shake a can of varnish, as shaking produces bubbles.) If you don't distribute the dulling agents throughout the varnish by stirring it, it will become increasingly dull as you use the can, and will eventually cloud your finish.

After stirring the varnish, dip the brush into it, then even out the load on the hairs by scraping its side against the inner rim of the container. The purpose of this is to avoid either "flooding" the surface with varnish or applying so little that you have to scrub it with the brush. The varnish should flow on the surface evenly, and be brushed on in one direction (see photo). Let dry, then repeat the process to apply two more coats. Three coats of varnish should provide adequate protection for your work.

For those nonwood projects that require a very smooth finish with no visible brush marks, such as the ceramic crock on page 58, an acrylic spray varnish should be used.

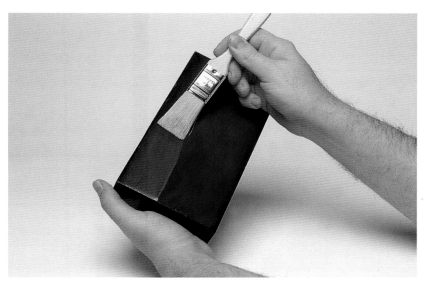

Stir the varnish thoroughly. Load the brush evenly, then flow the varnish on the surface in a uniform layer, working the brush in one direction. Apply a total of three coats.

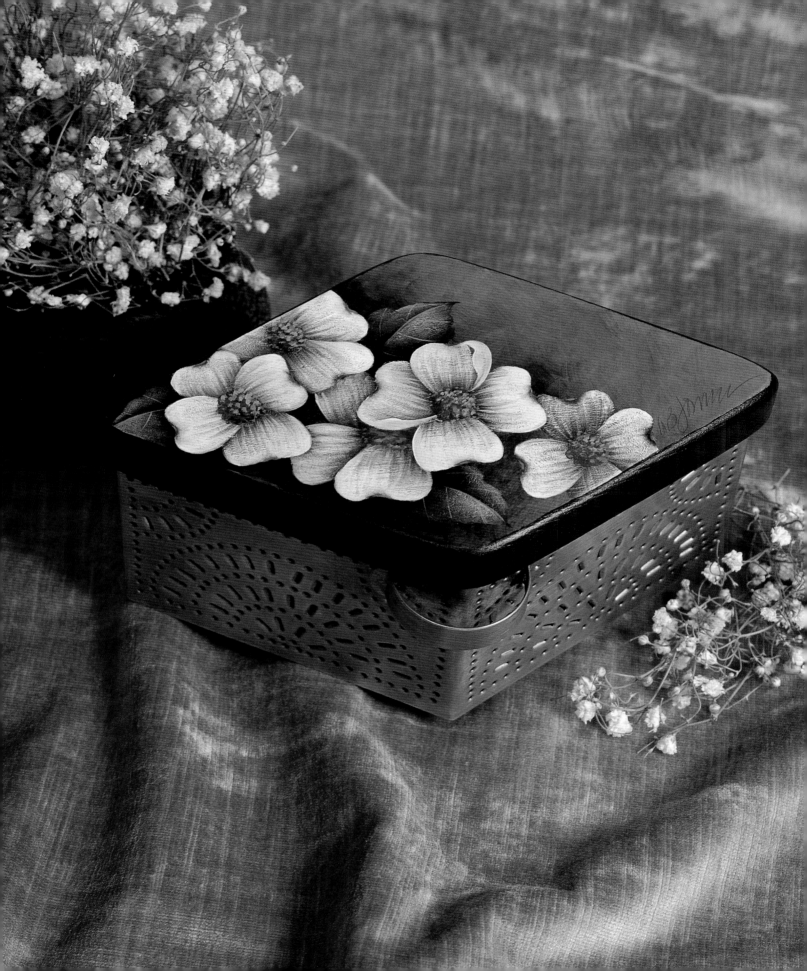

Painting Fruits and Flowers

There are as many ways to paint a subject using decorative painting techniques as there are decorative painters. In this chapter, I share my basic methods—none of which is difficult to master—and offer helpful hints. Before you begin painting a motif, read through the instructions and study the photos of each step as well as the finished piece to give yourself a clear mental picture of what you'll be doing. The process of previewing this information is like studying a road map

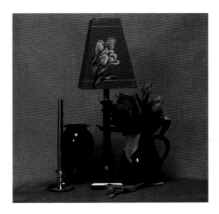

before taking a trip. That way, you'll know the route, but the fun and adventure that lie ahead can only be revealed by the journey itself.

Painting Leaves

Leaves are among the decorative painter's most frequently portrayed subjects, no doubt because they are an element of virtually every fruit and flower design. Compositionally, leaves add interest to what might otherwise be a barren background, provide movement and variety by introducing contrasts of light and dark, and tie diverse elements together by displaying a variety of accent colors. Although leaves generally serve a supporting role and aren't difficult to paint, they should never be dismissed as insignificant or painted with less than the utmost care; to do so would surely undermine the impact of a painting. Beautifully painted leaves set the stage for the primary subject matter.

To see the extent to which the colors and shapes of leaves can vary, study the photographs of the finished projects in this chapter. While some are very pale, nearly receding into the background, others are almost as strong as the fruits or flowers they accompany. As long as their shapes are observed somewhat accurately, leaves allow the decorative painter quite a bit of latitude in color and style.

I usually begin painting a fruit or flower design with the leaves. I do this for two reasons. First, I like to begin at the "back" of the composition and work my way forward so that I can clean up any messy areas as I work on the primary motif. The

only leaves that I would paint last are those that appear in front of a fruit or flower. Second, leaves are generally less exciting than the main subject, and I don't want to be tempted to rush through them after painting the more "glamourous" part just to finish up. The anticipation of painting the subject matter makes painting beautiful leaves worth the effort.

Below and on the following pages are step-by-step demonstrations that summarize the process of painting leaves in acrylics and oils. The instructions for painting the leaves for each motif are included with the preliminary project instructions.

Painting in Acrylics/Leaves

WHAT YOU'LL NEED

ARTISTS' ACRYLICS	BRUSHES	MISCELLANEOUS
Titanium white	Flat: No. 8 (Golden Natural series 2002S)	Disposable paper palette
Cadmium yellow light	Script liner: No. 2 (Golden Natural series 2007S)	Sta-Wet palette
Yellow oxide		Palette knife
Raw sienna	Filbert: No. 8 (Ruby Satin series 2503S)	Paper towels
Mars black		Water container

PAINTING TECHNIQUES

Undercoating (page 29)

Sideloading (page 32)

Optical Blending (page 31)

1

INSTRUCTIONS

1 Create a dark green by mixing cadmium yellow light + Mars black. Using the flat brush, undercoat the leaf with the green, stippling the paint to produce a slight texture. Let dry.

2 Sideload the flat with Mars black, then use it to shade the leaf at its base (A). Pull some of the shading up into the leaf. Let dry.

3 Highlight the leaf with a value scale of greens using the optical blending technique (see page 31). Starting with the green that was mixed for the undercoat (see step 1), load the filbert with a scant amount of paint, wipe it on a paper towel, then lightly graze the hairs over the surface. Slide the edge of the brush along one side of the midrib, then pull it away from the midrib out toward the edge of the leaf (A). Let dry.

Repeat this process to apply a range of greens that have been incrementally lightened by adding small amounts of cadmium yellow light to the undercoat mixture. Let each layer dry before applying the next, and apply each one to a progressively smaller area (B).

After applying several layers of green, begin adding titanium white to the mixture, then continue highlighting (C). The final highlight should be almost pure titanium white (D).

4 Paint the veins with the script liner brush loaded with a pale green (titanium white + a touch of green mixed for the undercoat) thinned with water to an inklike consistency (A). Let dry.

Using the flat brush sideloaded with yellow oxide, place accents along the edges of the leaf. Let dry, then intensify them with a sideload of raw sienna, which should be applied in lesser amounts (B).

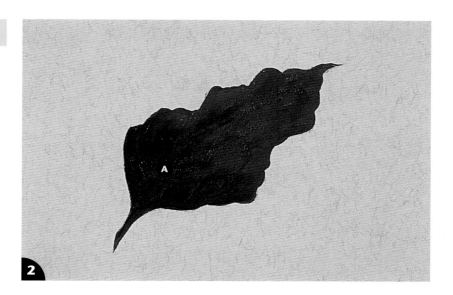

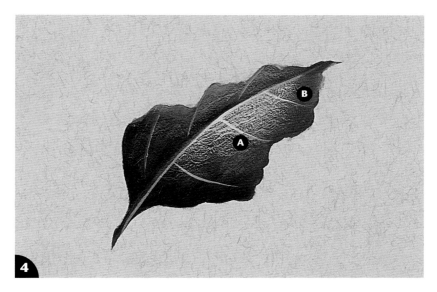

Painting in Oils/Leaves

WHAT YOU'LL NEED

ARTISTS' OILS	BRUSHES	MISCELLANEOUS
Titanium white	Flat: No. 8 (Golden Natural series 2002S)	Disposable paper palette
Cadmium yellow medium		Palette knife
Yellow ochre	Script liner: No. 2 (Golden Natural series 2007S)	Paper towels
Ivory black		Japan drier

PAINTING TECHNIQUES

Blocking In (page 29)

Drybrushing with Oils (page 31)

INSTRUCTIONS

1 Begin by mixing two values of green. For the medium value, combine cadmium yellow medium + ivory black. For the dark value, take a small amount of the medium-value color and add a bit more black to it.

Use the flat brush to apply the dark-value green to the base of the leaf and along the bottom of one side of the midrib (A). Wipe the brush on a paper towel, then apply the medium-value green to the side of the leaf on which the midrib was shaded (B), and to the middle of the leaf on the other side of the midrib (C).

To create a light-value green, pick up some titanium white on the dirty brush and blend it on the palette. Apply this to any unpainted areas that remain, which should be along the midrib opposite the shading (D) and at the edge of the leaf on the same side (E).

2 Wipe the brush on a paper towel and gently blend the areas where two values meet (A). Eliminate harsh lines of demarcation between values everywhere *except* at the midrib, where the distinction between light and dark green should remain (B).

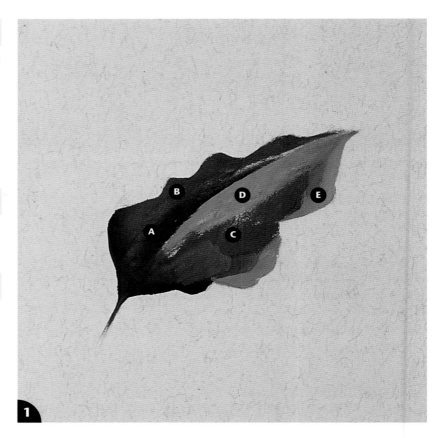

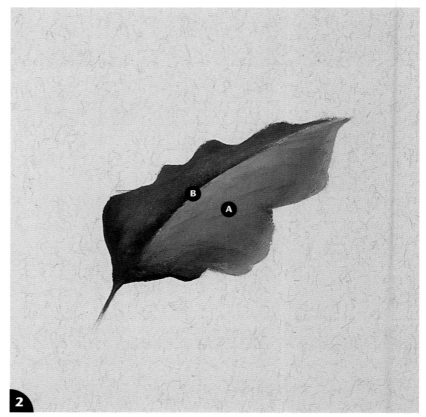

3 Wipe the brush again, load it with a scant amount of titanium white, and reinforce the peak of the highlight (A). Apply it with pressure to "set" it in place.

If desired, repeat to add accents of yellow ochre (B).

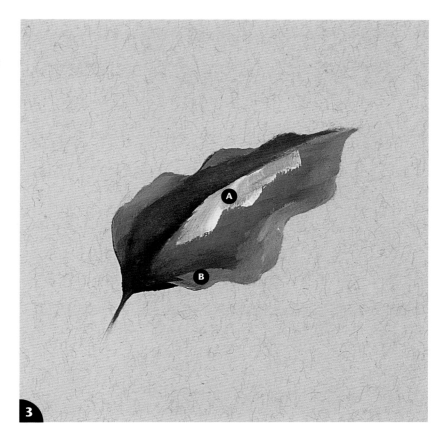

4 Wipe the brush once more, then use it to lightly blend the white highlight (A). If necessary, reapply the highlight and blend a second time. Repeat to gently soften the accents (B).

To paint the veins, use the script liner brush loaded with a very pale green (the light-value green for the leaf + titanium white) thinned to an inklike consistency with mineral spirits (C).

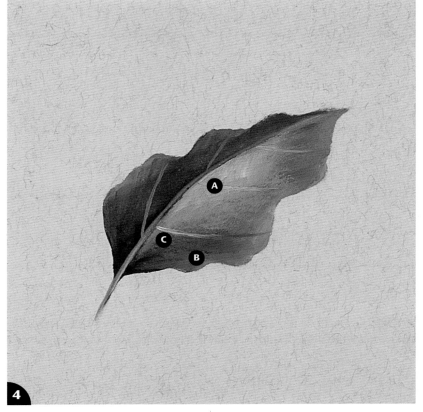

Pears

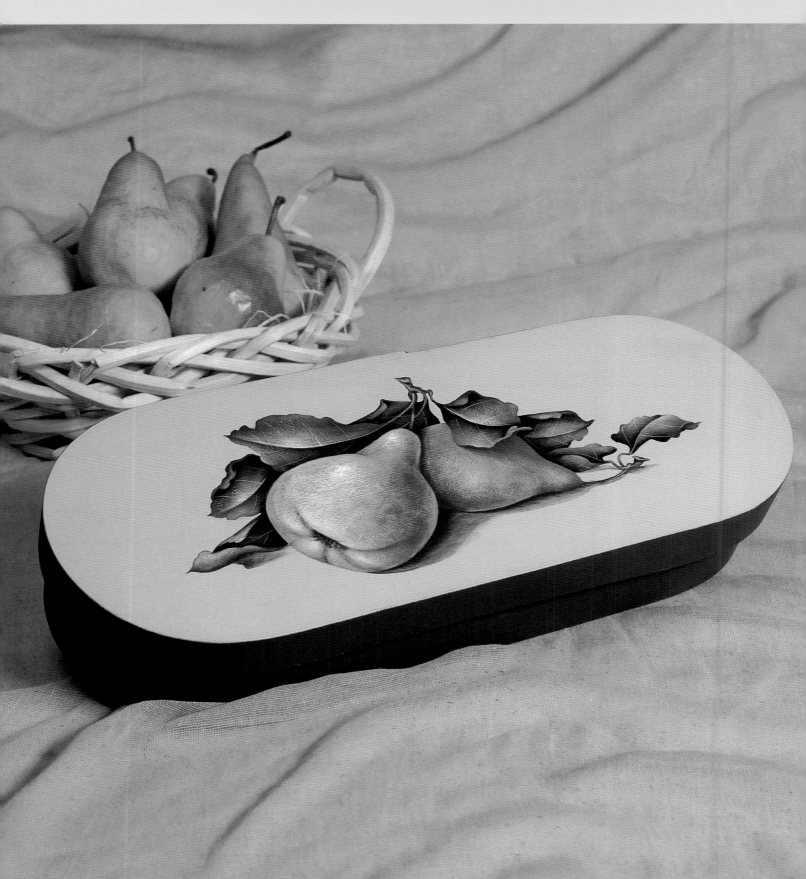

Pears are among the most colorful of all fruits. Depending on the variety, the color of a pear can range from yellow ochre to pale citron green to deep red-purple to ruby red. Its predominant color notwithstanding, a pear can be embellished as creatively as the individual artist's imagination will allow. I love to paint bright, vibrant yellow pears with lots of red and green accents.

SURFACE PREPARATION

If necessary, apply wood putty to any damaged areas or knots, let dry, then sand the puttied areas until they are flush with the surrounding surface. Prime the box and lid with white sealer/primer; let dry. The box shown opposite was painted with a dark, dull green and the lid with a pale neutral green. The pears would also look striking set off against a rich, dark color—rust perhaps, or even black. The possibilities for spectacular color combinations are endless.

Once the basecoat is dry, transfer the pattern to the surface with gray transfer paper.

IF YOU'RE WORKING IN ACRYLICS

See page 54 for a complete list of materials.

Leaves. Use a no. 8 flat brush to paint the leaves. Undercoat with a dark green mixed from cadmium yellow light + ultramarine blue + Mars black. Let dry. Shade with a brush sideloaded with Mars black, then let dry. Using the optical blending technique, highlight with a value scale of greens, ranging from the green of the undercoat to titanium white. Let each layer dry before applying the next. To keep the greens from becoming chalky as you highlight, add small amounts of cadmium yellow light. If you feel the greens are still too chalky, apply a light wash of cadmium yellow light to the entire leaf after the highlights have dried. To paint the veins, load a script liner with a small amount of pale green thinned to an inklike consistency with water (use one of the greens that you mixed for the highlights). Let dry, then accent the leaves with cadmium yellow light and yellow oxide.

Stems. Using a script liner, undercoat the stems with burnt umber. Let dry. Use the optical blending technique and a no. 8 flat to highlight with a mixture of titanium white + burnt umber (only one layer should be required).

Shadows. Paint the shadows cast by the pears with a no. 8 flat brush sideloaded with burnt umber; strengthen the shadows directly beneath the pears with a wash of black.

Varnishing. Wait at least 24 hours before varnishing the completed painting.

IF YOU'RE WORKING IN OILS

See page 56 for a complete list of materials.

Leaves. Begin by mixing three values of green. For the medium value, mix cadmium yellow medium + ivory black. For the light value, lighten the medium-value green with titanium white + cadmium yellow light. For the dark value, darken the medium-value green with ivory black. Block in the values with a no. 8 flat brush, thoroughly wipe it on a paper towel, then use it to soften harsh lines of demarcation. Reinforce the peaks of the highlights with titanium white, then blend the edges of the application. Accent the leaves with yellow ochre and raw sienna.

Stems. Use the script liner brush to block in the stems with burnt umber (the dark value) and titanium white (the light value). Wipe the brush on a paper towel, then soften the edges of the highlights.

Shadows. Sideload a no. 12 flat brush with burnt umber, then stroke the more heavily loaded side along the edge of the pear, letting the color gradually fade toward the right-hand side.

Varnishing. If you used japan drier, you should wait at least 72 hours before varnishing your completed painting; if you didn't, you may need to wait a few weeks to ensure that the paint film is completely dry.

Painting in Acrylics/Pears

WHAT YOU'LL NEED

ARTISTS' ACRYLICS

Titanium white

Cadmium yellow light

Yellow oxide

Raw sienna

Burnt sienna

Burnt umber

Cadmium red light

Cadmium red medium

Ultramarine blue

Hooker's green

Mars black

BRUSHES

Flats: Nos. 8 and 12 *(Golden Natural series 2002S)*

Script liner: No. 2 *(Golden Natural series 2007S)*

Filberts: Nos. 8 and 12 *(Ruby Satin series 2503S)*

MISCELLANEOUS

Disposable paper palette

Sta-Wet palette

Palette knife

Paper towels

Water container

PAINTING TECHNIQUES

Undercoating (page 29)

Sideloading (page 32)

Optical Blending (page 31)

Applying a Wash (page 30)

INSTRUCTIONS

1 Use the no. 12 flat brush to undercoat the pear with a mixture of cadmium yellow light + yellow oxide. Let dry.

2 Apply the shading in layers. Each succeeding layer should be applied to a smaller area.
- *First layer.* Sideload the no. 12 flat with raw sienna. Stroke the loaded side of the brush around the edges of the pear so that the color gradually fades toward the center (A). Let dry.
- *Second layer.* Sideload the no. 12 flat with burnt sienna. Apply this layer to about one-third of the pear, stroking the loaded side of the brush along one of its edges (B). Let dry.
- *Third layer.* Mix burnt sienna + Hooker's green. Sideload the color on the no. 12 flat and apply the paint along the already shaded edge of the pear (C). Let dry.
- *Blossom end.* Use a no. 12 flat to shade the blossom end with a sideload of burnt sienna + raw sienna (D). Let dry.

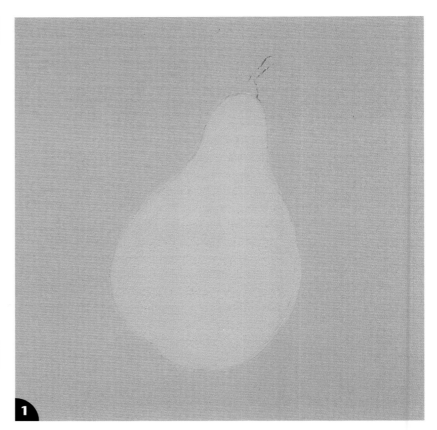

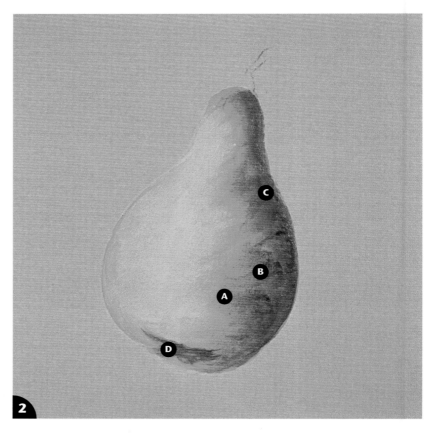

3 Use the optical blending technique to highlight the pear with a value scale of yellows. Make sure you always use a dry brush: Load the no. 12 filbert with just a small amount of paint, then wipe it on a paper towel to remove excess. Lightly skim the hairs over the surface and apply each value to a progressively smaller area. Let each application dry before adding the next.

Begin by applying the undercoat color (cadmium yellow + yellow oxide), which should extend slightly over the shading to soften it (A). Next, apply a mixture of the undercoat color + cadmium yellow light (B), then cadmium yellow light alone (C). To build up to the final highlight, gradually lighten cadmium yellow light with small amounts of titanium white. Paint the lightest portion of the highlight with pure titanium white (D).

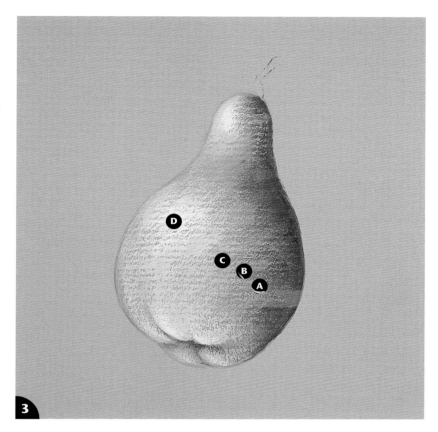

4 Use the no. 8 flat to accent the darker areas of the pear with several washes of cadmium red light and cadmium red medium (A). Extend some of the red washes into medium-value areas as well (B).

Use the optical blending technique and the no. 8 filbert to apply final accents in light green with a mixture of ultramarine blue + cadmium yellow light (C).

Finish the blossom end of the pear by painting its fine lines with a script liner brush loaded with burnt umber. Let dry, then highlight with a mixture of burnt umber + titanium white (D).

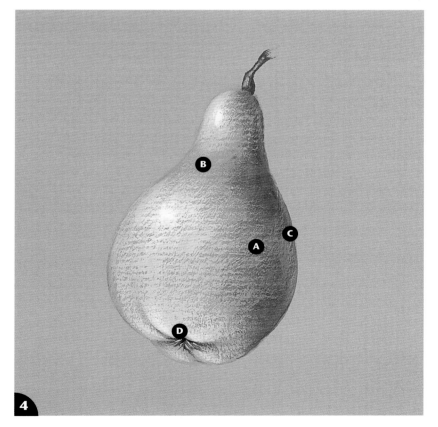

Painting in Oils/Pears

WHAT YOU'LL NEED

ARTISTS' OILS

Titanium white

Cadmium yellow light

Cadmium yellow medium

Naples yellow hue

Yellow ochre

Raw sienna

Burnt sienna

Burnt umber

Cadmium red light

Ivory black

BRUSHES

Flats: Nos. 8 and 12 *(Golden Natural series 2002S)*

Script liner: No. 2 *(Golden Natural series 2007S)*

MISCELLANEOUS

Disposable paper palette

Palette knife

Paper towels

Japan drier

PAINTING TECHNIQUES

Blocking In (page 29)

Drybrushing with Oils (page 31)

INSTRUCTIONS

1 Use a no. 12 flat brush to block in the light, medium, and dark values on the pear. The lightest value is titanium white (A), which is surrounded by cadmium yellow light (B) and cadmium yellow medium (C). (If either of the two cadmium yellows are too transparent, you can make them more opaque by mixing them with Naples yellow hue.) The darkest value is yellow ochre (D). Avoid leaving distinct lines between values.

For the reflected light, paint a thin application of cadmium yellow medium along the outside edge on the shaded side of the pear (E).

2 Wipe the no. 12 flat on a paper towel. Soften the areas where two values converge by lightly blending with the brush, eliminating harsh lines of demarcation between them. Try not to overblend. You should still be able to see all the values you applied in the first step.

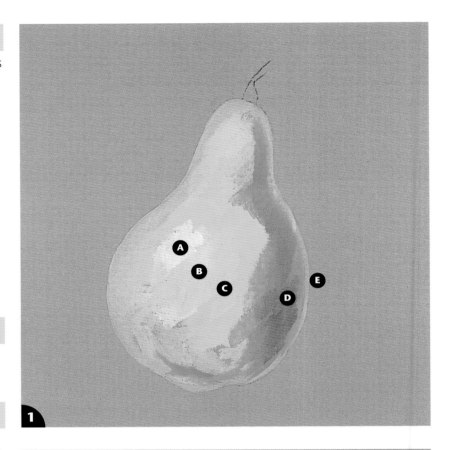

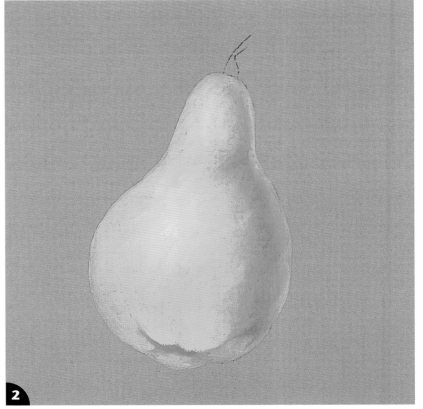

3 Use the no. 8 flat to reinforce the areas of lightest value by applying pure titanium white, exerting firm pressure as you work (A). Accent and heighten the three-dimensional form of the pear by applying raw sienna, burnt sienna, and small amounts of cadmium red light (B). Make sure to add highlights and accents to the blossom end as well (C).

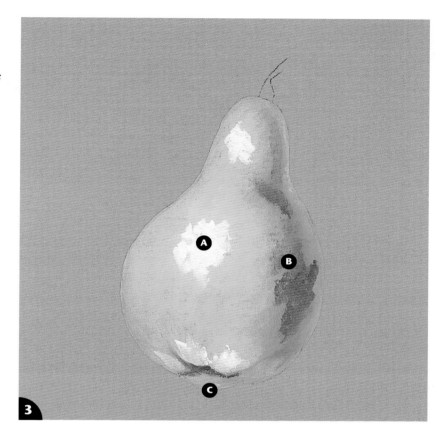

4 Blend and soften the highlights and accents (A, B). Try not to completely obliterate any of the white highlights. Use the no. 8 flat sideloaded with cadmium yellow light + ivory black to add a green accent along the shaded edge of the pear (C).

Paint the fine lines of the blossom end using a script liner loaded with burnt umber diluted to an inklike consistency with mineral spirits. Finally, use the liner brush to highlight a few lines with a "dirty" white (titanium white + burnt umber) over the burnt umber (D).

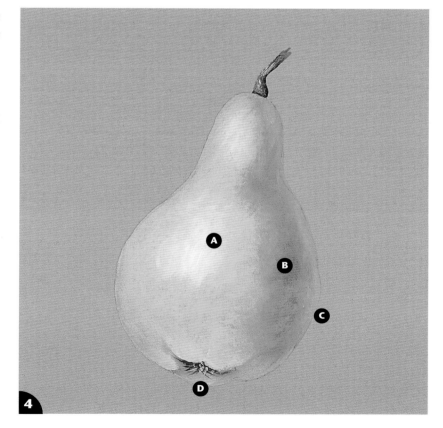

Yellow Apples

The subtle coloration of yellow apples makes them a challenge to paint, mainly because it's difficult to create dimension and visual interest with colors that are very close in value. You'll be able to meet the challenge if you restrain your enthusiasm while blending; otherwise, your overblended apples will look very flat and unappealing.

SURFACE PREPARATION

Try to find something interesting to paint your yellow apples on—you'll love the results. I painted my apples on a ceramic cold drink crock. I had the crock for many years before deciding that its neutral background and blue stripes would complement the yellow of the apples beautifully. The final look is very homespun!

Wash the crock with a grease-cutting dishwashing liquid, wipe it dry with a dishtowel, then let it stand overnight. To remove any remaining residue of grease, wipe the surface of the crock with a paper towel dampened with rubbing alcohol or nail polish remover. This procedure will give you a perfectly clean and dry surface on which to work. No other preparation is necessary.

Transfer the pattern to the surface with gray transfer paper.

IF YOU'RE WORKING IN ACRYLICS

See page 60 for a complete list of materials.

Leaves. Use the no. 8 flat brush to undercoat the leaves with dark green (cadmium yellow light + Mars black). Let dry, then shade them with the no. 8 flat sideloaded with Mars black. Once the shading is dry, use the optical blending technique (see page 31) and the no. 8 filbert to highlight the leaves with several greens, ranging in value from the undercoat color to a pale green, by gradually lightening the undercoat mixture with cadmium yellow light. Make the transition from the lightest green to the lightest highlight (pure titanium white) by adding small amounts of titanium white. Apply this last series of values with a sideloaded no. 8 flat brush. Let dry.

Paint the veins with the script liner brush and one of the pale greens that was mixed for the highlights thinned with water to an inklike consistency. Once dry, accent the leaves with cadmium yellow light and yellow oxide. If used sparingly, burnt sienna accents can also provide interest. Make sure the accents are soft, not distracting.

Stems. Using a script liner, undercoat the stems with burnt umber. Let dry. Use the optical blending technique and a no. 8 flat to highlight with a mixture of titanium white + burnt umber (only one layer should be required).

Varnishing. Wait at least 24 hours before varnishing the completed painting.

IF YOU'RE WORKING IN OILS

See page 62 for a complete list of materials.

Leaves. Use the no. 8 flat brush to block in three values of green: medium (cadmium yellow medium + ivory black), dark (the medium-value mixture + additional ivory black), and light (the medium-value mixture + cadmium yellow medium + titanium white). Wipe the brush on a paper towel, then use it to soften the lines of demarcation between values.

Use the script liner brush to paint the veins with a small amount of the light-value green that has been thinned to an inklike consistency with mineral spirits. Add accents of yellow ochre and cadmium yellow medium, and a few in burnt sienna. Soften.

Stems. Use the script liner brush to block in the stems with burnt umber (the dark value) and titanium white (the light value). Wipe the brush on a paper towel, then soften the edges of the highlights.

Varnishing. If you used japan drier, you should wait at least 72 hours before varnishing your completed painting; if you didn't, you may need to wait a few weeks to ensure that the paint film is completely dry.

Painting in Acrylics/Yellow Apples

WHAT YOU'LL NEED

ARTISTS' ACRYLICS

Titanium white

Cadmium yellow light

Yellow oxide

Raw sienna

Burnt sienna

Burnt umber

Cadmium red light

Cadmium red medium

Hooker's green

Mars black

BRUSHES

Flats: Nos. 8 and 12 *(Golden Natural series 2002S)*

Script liner: No. 2 *(Golden Natural series 2007S)*

Filbert: No. 8 *(Ruby Satin series 2503S)*

MISCELLANEOUS

Disposable paper palette

Sta-Wet palette

Palette knife

Paper towels

Water container

PAINTING TECHNIQUES

Undercoating (page 29)

Sideloading (page 32)

Optical Blending (page 31)

INSTRUCTIONS

1 Undercoat the apple with yellow oxide using the no. 12 flat brush. The undercoat should be completely opaque. If needed, apply several coats, making sure that the preceding one is dry before applying the next.

2 Apply translucent layers of color to the shaded side of the apple using a sideloaded no. 12 flat brush.

- *First layer.* Begin by stroking raw sienna almost halfway across the apple (A). Don't forget to shade the "smile line" (the indentation at the top of apple). Let dry.
- *Second layer.* Stroking the loaded side of the brush along one of the apple's edges, apply a layer of burnt sienna so that it covers only about one-third of the apple, or about half of the shaded area (B). Let dry.
- *Third layer.* Apply a sideloaded mixture of burnt sienna + Hooker's green along the shaded edge of the apple (C). Let dry.

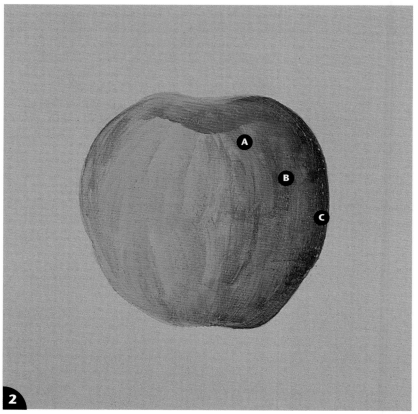

3 Use the filbert brush to highlight the apple with a value scale of yellows using the optical blending technique (see page 31). This technique requires a dry brush, which is loaded with a small amount of paint and wiped on a paper towel. The hairs of the brush are skimmed lightly over the surface and each value is applied to a progressively smaller area. Let each value dry before adding the next.

Begin highlighting with yellow oxide (A). Progress to yellow oxide + cadmium yellow light (B). Lighten this mixture with more cadmium yellow light, then use pure cadmium yellow light (C). Add more highlights with cadmium yellow light + titanium white. Continue adding highlights by lightening cadmium yellow light with titanium white, then finish with a pure titanium white highlight (D).

As you work, use the chisel edge of the brush to draw the highlight colors into curved streaks that follow the apple's contours. (Study the finished example for an illustration of this.)

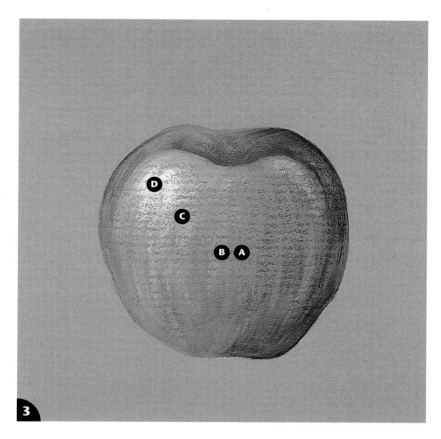

4 Working again with the filbert, apply drybrush accents of green (cadmium yellow light + Mars black) (A). Use a no. 8 flat to apply translucent washes of cadmium red medium (B). If you want to intensify the red accents, increase their opacity by adding more paint, or simply use some thinned cadmium red light.

Use the script liner brush to paint the fine lines and dots of the apple's blossom end with burnt umber thinned to an inklike consistency with water. Let dry, then add some highlights by lightening the burnt umber with a bit of titanium white.

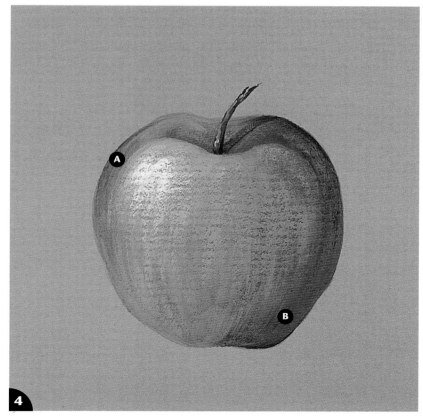

Working in Oils/Yellow Apples

WHAT YOU'LL NEED

ARTISTS' OILS	BRUSHES	MISCELLANEOUS
Titanium white	Flats: Nos. 8, 10, and 12 *(Golden Natural series 2002S)*	Disposable paper palette
Cadmium yellow light		Palette knife
Cadmium yellow medium	Script liner: No. 2 *(Golden Natural series 2007S)*	Paper towels
Naples yellow hue		Japan drier
Yellow ochre		
Raw sienna		
Burnt sienna		
Burnt umber		
Cadmium red light		
Ivory black		

PAINTING TECHNIQUES

Blocking In (page 29)
Drybrushing with Oils (page 31)

INSTRUCTIONS

1 Using the no. 10 flat brush, block in the values on the apple. Start with the lightest highlight (titanium white) (A), then surround it with a wide area of Naples yellow hue (B), which should then be surrounded with (and partially covered by) cadmium yellow light (C). Place some cadmium yellow medium around the cadmium yellow light, extending it all the way to the edge of the apple on the highlighted side (D). Place a small line of cadmium yellow medium along the edge of the shaded side as well. In the space that's left, apply some yellow ochre (E).

2 Wipe the brush on a paper towel, then begin to blend and soften the values. (If you find it helpful to blend the apple with a larger brush, load the no. 12 flat with cadmium yellow medium and wipe it on a paper towel before using it.) Blend only enough to eliminate the distinct lines between values (A, B). You should still be able to discern all the colors that were applied in step 1.

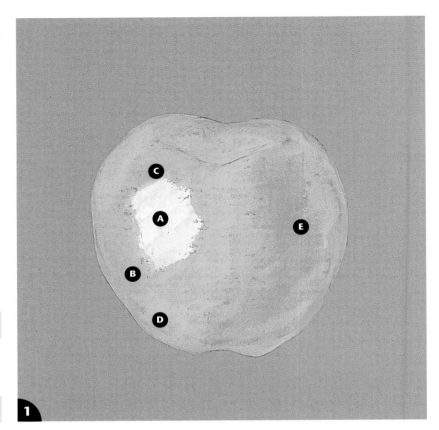

3 Using firm pressure, reinforce the titanium white portion of the highlight with the no. 10 flat (A).

Using the no. 8 flat loaded with a scant amount of paint, accent the shaded areas and the reflected light with raw sienna (B), burnt sienna (C), and burnt umber + a bit of cadmium yellow medium (D). Apply them with short, choppy strokes so that the blending in the next step will be easier. If desired, reddish accents of burnt sienna + cadmium red light can also be added (E).

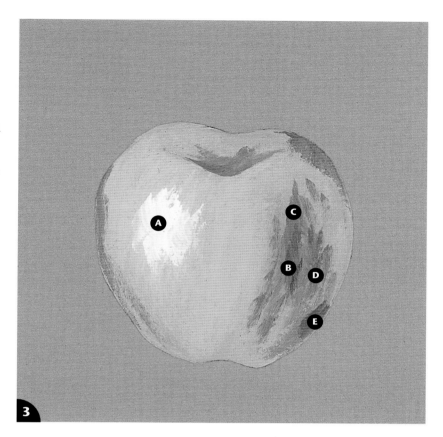

4 Wipe the brush on a paper towel, then use it to soften the highlight just by tickling its edges (A). Soften any accents that were added in step 3. Don't let them remain too strong or distinct.

Use the chisel edge of the brush to extend some streaks over the surface of the apple, which will give it a more natural appearance (B).

Red Apples

Ranging from deep burgundies to very light reds tinged with yellows and greens, the beauty and diversity of color that can be found in red apples never cease to amaze me. This particular fruit provides a valuable exercise in creating dimension, as the reds that are used to paint it blend together easily. Even first-time painters should be able to master the red apple.

SURFACE PREPARATION

I painted my red apples on a wooden cutting board intended for decorative use only. For the surface treatment, I decided to combine staining, basecoating, and antiquing.

Stain the raised portion of the cutting board with a green mixed from cadmium yellow light + ultramarine blue + a bit of black. Let dry. Prime the remainder of the cutting board with white sealer/primer, then basecoat it with a bright Christmas red. Let dry.

Use white transfer paper to transfer the pattern to the surface.

After the painting the apples, antique the red portion of the board with a mixture of burnt umber + black. To add interest, randomly flyspeck the entire board with black.

IF YOU'RE WORKING IN ACRYLICS

See page 66 for a complete list of materials.

Leaves. Undercoat the leaves with the no. 8 flat brush loaded with a green mixed from cadmium yellow light + Mars black. Let dry. Shade with the no. 8 flat sideloaded with pure Mars black. Let dry, then highlight with a no. 8 filbert and a value scale of greens, from the undercoat color to almost pure white, using a dry brush and the optical blending technique (see page 31). Lighten the green by gradually adding small amounts of cadmium yellow light, then titanium white at the lighter end of the scale. (If you don't use yellow to lighten the green, the leaves will end up looking cold and chalky.) Use the no. 8 flat to apply accents in various reds to harmonize the leaves with the apples and to heighten their visual appeal.

Using a script liner brush, paint the veins with a very pale green (use one that was mixed for the highlights).

Stems. Using a script liner, undercoat the stems with burnt umber. Let dry. Use the optical blending technique and a no. 8 flat to highlight with a mixture of titanium white + burnt umber (only one layer should be required).

Varnishing. Wait at least 24 hours before varnishing the completed painting.

IF YOU'RE WORKING IN OILS

See page 68 for a complete list of materials.

Leaves. Start by mixing a green using cadmium yellow medium + ivory black; this will serve as your medium value. For the shading color, darken the medium-value green by adding more black. For the highlights, lighten the green by adding titanium white. If needed, add more yellow to the highlight to keep the leaves from having a chalky appearance. Block in the three values, then blend and soften with a dry brush. Add accents in red, but make sure they aren't spotty or distracting.

Stems. Use the script liner brush to block in the stems with burnt umber (the dark value) and titanium white (the light value). Wipe the brush on a paper towel, then soften the edges of the highlights.

Varnishing. If you used japan drier, you should wait at least 72 hours before varnishing your completed painting; if you didn't, you may need to wait a few weeks to ensure that the paint film is completely dry.

WHAT YOU'LL NEED

ARTISTS' ACRYLICS

Titanium white

Cadmium yellow light

Burnt umber

Cadmium orange

Cadmium red light

Cadmium red medium

Alizarin crimson

Dioxazine purple

Hooker's green

Mars black

BRUSHES

Flats: Nos. 8 and 12 (*Golden Natural series 2002S*)

Script liner: No. 2 (*Golden Natural series 2007S*)

Filbert: No. 8 (*Ruby Satin series 2503S*)

MISCELLANEOUS

Disposable paper palette

Sta-Wet palette

Palette knife

Paper towels

Water container

PAINTING TECHNIQUES

Undercoating (page 29)

Sideloading (page 32)

Optical Blending (page 31)

Applying a Wash (page 30)

INSTRUCTIONS

1 Use the no. 8 flat to undercoat the apple with cadmium red medium. Make sure the undercoat is completely opaque. If necessary, let the first coat dry, then apply a second.

2 Sideload the no. 12 flat with alizarin crimson, then apply it to the shaded side of the apple (to just under half its width) and above its "smile line" (the indentation at the top of the apple) (A). Let dry, then intensify the shaded area closest to the apple's edge by adding a sideloaded layer of alizarin crimson + Hooker's green (B). The first layer of shading should still be visible even after the darker color has been applied. Let the shading dry completely before applying any highlights.

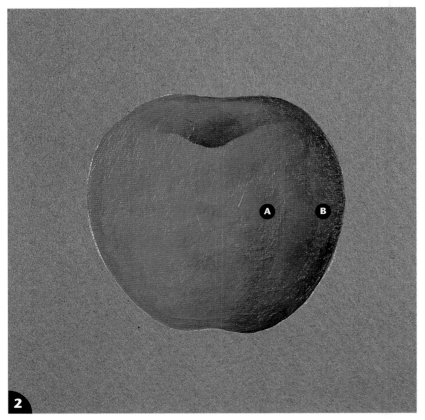

3 Use the filbert to highlight the apple with a value scale of reds, oranges, and yellows, finishing with white. See page 31 for a description of the optical blending technique, in which a dry brush—one that's been loaded with a small amount of paint, then wiped on a paper towel—is skimmed lightly over the painting surface. Each value is applied to a progressively smaller area and allowed to dry before adding the next.

Begin with cadmium red medium. Then use a mixture of cadmium red medium + cadmium red light. Next, use cadmium red light alone, then cadmium red light + cadmium orange. Continue with pure cadmium orange, using the edge of the filbert to drag streaks of color along the surface to establish the apple's contours (A). As you reach the lightest areas of the highlight, begin to add cadmium yellow light to the cadmium orange. Next, add some white to the mix. Finish the highlight with pure titanium white (B).

The highlights should be dry before you proceed to the next step.

4 Again using the optical blending technique described in step 3, accent the apple with green and purple. For the green accents, combine cadmium yellow light + Hooker's green, then apply the mixture with the filbert. If this green is too intense, you can tone it down a bit by adding a touch of Mars black. Apply the green accents to the edge of the highlighted side of the apple with the chisel edge of the brush. Skim the color inward in order to avoid creating a harsh line of green (A).

On edge of the apple's shaded side, add reflected lights in a medium-value purple (dioxazine purple + titanium white). To heighten the drama of the reflected lights, lighten the purple mixture with a touch of white, then layer it over some—not all—of their darker areas (B). The layering of the two values is what adds interest to the apple.

Painting in Oils/Red Apples

WHAT YOU'LL NEED

ARTISTS' OILS

Titanium white

Cadmium yellow light

Cadmium yellow medium

Naples yellow hue

Burnt umber

Cadmium red light

Cadmium red medium

Alizarin crimson

Ultramarine blue

Ivory black

BRUSHES

Flats: Nos. 8 and 10 (*Golden Natural series 2002S*)

Script liner: No. 2 (*Golden Natural series 2007S*)

MISCELLANEOUS

Disposable paper palette

Palette knife

Paper towels

Japan drier

PAINTING TECHNIQUES

Blocking In (page 29)
Drybrushing with Oils (page 31)

INSTRUCTIONS

1 Use a no. 8 or 10 flat to block in the value scale of colors on the apple. Begin by placing Naples yellow hue at the peak of the highlight (A). Surround the Naples yellow hue with cadmium yellow light and cadmium yellow medium (B). Next, apply some cadmium red light (C). Next to the cadmium red light and along the highlighted edge of the apple, add some cadmium red medium (D). Be sure to leave a space for the dark shading, which is alizarin crimson (E).

2 Wipe the flat brush on a paper towel, then use it to blend the blocked-in colors, softening any harsh lines between them (A). Use the edge of the brush to make light, choppy strokes that follow the apple's contours. These "streaks" of color, which will help create the apple's three-dimensional form, should be straighter toward the center of the apple (B).

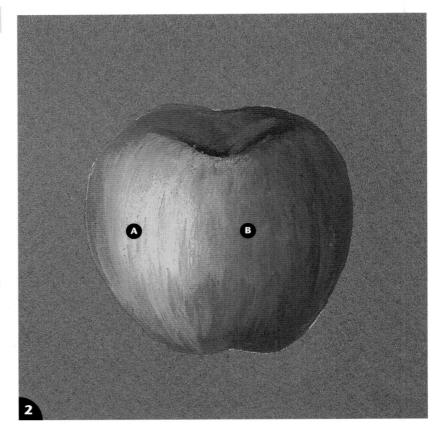

3 Using a no. 8 flat and applying firm pressure as you work, reinforce the center of the highlight with titanium white (A). Soften its edges with some cadmium yellow light (B).

Intensify the darker shaded areas with the no. 8 flat and a mixture of alizarin crimson + burnt umber (C). If desired, a touch of ultramarine blue can be added to the mixture and applied over the darkest areas (D).

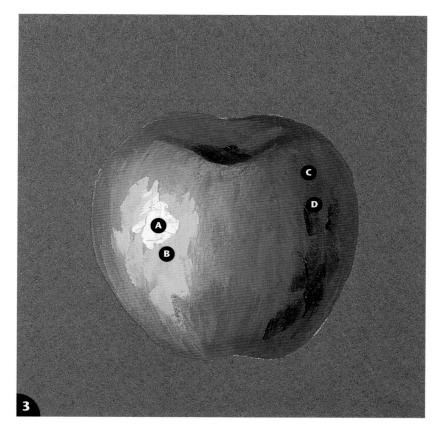

4 To incorporate the strengthened highlight into the rest of the apple, use the no. 10 flat to blend it just enough to soften it, then begin to pull streaks of color through it (A). Blend the touches of shading added in step 3 using this technique as well (B). As you work, be sure to maintain the original positions of the light and dark values. If the placement of the values is disturbed, the apple will appear chaotic and muddied.

Use a sparsely loaded no. 8 flat brush to add green accents on the light side of the apple with a mixture of cadmium yellow light + ultramarine blue (C). If the green seems too intense, tone it down by adding a bit of burnt umber.

Again using the no. 8 flat and a scant amount of paint, add reflected lights of violet or blue on the dark side of the apple if desired (D). To create a soft blue, mix burnt umber + ultramarine blue + titanium white. For the violet, combine titanium white + alizarin crimson + ultramarine blue.

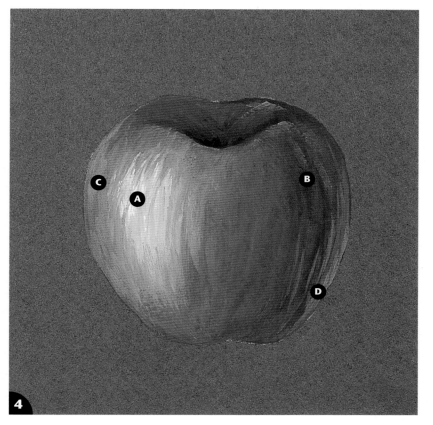

Plums

The plum's gleaming skin and lush colors—from bright burgundy to purple so dark it's almost black—foreshadow the taste of its succulent flesh. The colors of painted plums can be varied using one of two methods: by modifying the colors of the undercoats (for acrylics) or blocked-in values (for oils), or by accenting each plum with different colors. Try incorporating both of these variations when you paint your arrangement of plums.

Once you've become proficient at painting plums, you can try your hand at peaches, which are similar in shape and also have an interesting velvety surface texture.

SURFACE PREPARATION

Stain the basket's woven base with a dark blue glaze of ultramarine blue + Mars black, then let dry. To create highlights on the weave, rub on some light blue acrylic paint with a cotton rag. Let dry. Prime the basket lid with white sealer/primer, then basecoat it with the light blue acrylic paint.

Once the basecoat has dried, draw the rectangular band with a pencil and ruler. Thin a mixture of ultramarine blue + burnt umber to a nice flowing consistency. Load the ruling pen with the thinned paint by raking a loaded no. 8 flat brush across its slotted opening. Test the consistency of the paint by drawing a practice line on a piece of scrap paper. When the paint is flowing smoothly, align the raised edge of the ruler with one of the lines. Hold the pen at a 45-degree angle and gently pull it along the edge of the ruler. Repeat until the band is complete. Let dry, then erase stray pencil marks.

Transfer the pattern to the surface with gray transfer paper.

IF YOU'RE WORKING IN ACRYLICS

See page 72 for a complete list of materials.

Leaves. Use a no. 8 flat brush to paint the leaves. Undercoat with a green mixed from cadmium yellow light + Mars black + ultramarine blue. Let dry, then shade with a sideload of Mars black. Highlight with a value scale of greens ranging from the undercoat through titanium white. Lighten the green with small amounts of white as you proceed. Accent the leaves with very transparent washes of alizarin crimson. Don't let the accents become too large or overpowering.

Varnishing. Wait at least 24 hours before varnishing the completed painting.

IF YOU'RE WORKING IN OILS

See page 74 for a complete list of materials.

Leaves. Use a no. 8 flat brush for all the leaf-painting steps. Mix three values of green: medium (cadmium yellow medium + ivory black + ultramarine blue), dark (the medium value + additional ivory black) and light (the medium value + titanium white). Block in the values, then blend away any harsh lines between them with a dry brush.

Reinforce the shading with ivory black and the highlights with titanium white. Accent with alizarin crimson and a pale blue mixture of ultramarine blue + burnt umber + titanium white. Soften all with a dry brush.

Varnishing. If you used japan drier, you should wait at least 72 hours before varnishing your completed painting; if you didn't, you may need to wait a few weeks to ensure that the paint film is completely dry.

Painting in Acrylics/Plums

WHAT YOU'LL NEED

ARTISTS' ACRYLICS

Titanium white

Cadmium yellow light

Alizarin crimson

Dioxazine purple

Ultramarine blue

Turquoise

Mars black

BRUSHES

Flats: Nos. 8 and 10 (*Golden Natural series 2002S*)

Script liner: No. 2 (*Golden Natural series 2007S*)

Filbert: No. 8 (*Ruby Satin series 2503S*)

MISCELLANEOUS

Disposable paper palette

Sta-Wet palette

Palette knife

Paper towels

Water container

PAINTING TECHNIQUES

Undercoating (page 29)

Sideloading (page 32)

Optical Blending (page 31)

Applying a Wash (page 30)

INSTRUCTIONS

1 Use the no. 10 flat brush to undercoat the plum with a mixture of ultramarine blue + dioxazine purple. Let dry before proceeding to the next step.

2 Shade the plum with a no. 8 flat sideloaded with Mars black. Apply the shading on one side of the plum (A) and in the ridge of the cleft (B). Let dry.

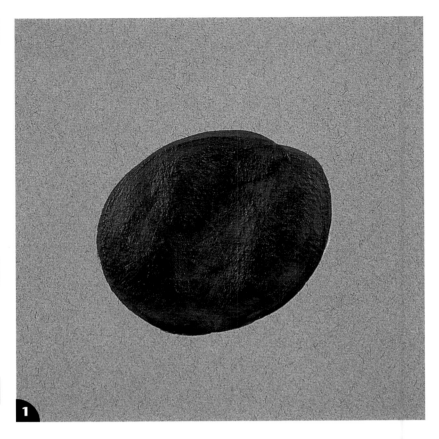

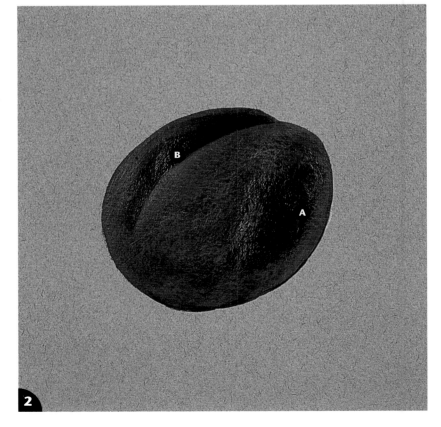

3 For the highlights, use the optical blending technique (see page 30) to apply a value scale of blue-violet tints with the filbert. For each value you apply, load the brush with a small amount of paint, wipe it on a paper towel, then skim it lightly over the surface. Apply each layer to a progressively smaller area, and let each dry before applying the next.

Start with the undercoat color (see step 1) + a touch of titanium white (A). As you develop the highlight, continue lightening the mixture by adding white a little bit of at a time (B) until the final layer is pure titanium white (C).

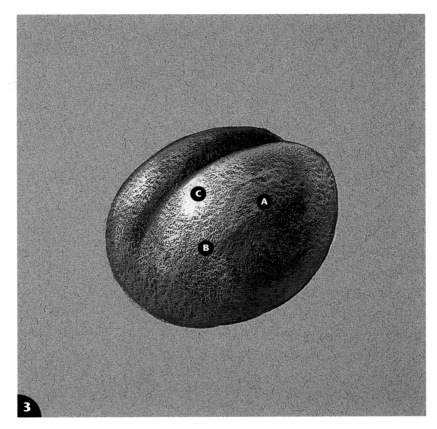

4 Use the optical blending technique and the filbert to add accents and reflected lights of turquoise (turquoise + a little titanium white) or red (alizarin crimson and alizarin crimson + white) (A). Be sure to vary the accents you use on each plum.

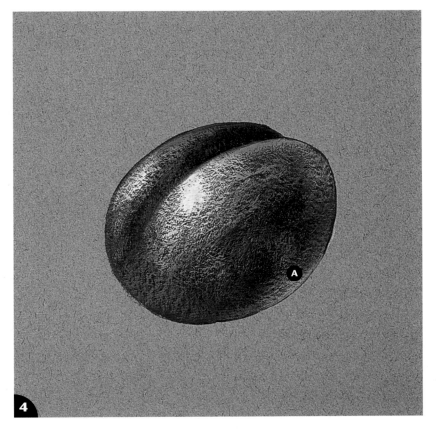

Painting in Oils/Plums

WHAT YOU'LL NEED

ARTISTS' OILS
Titanium white

Cadmium yellow medium

Burnt umber

Alizarin crimson

Ultramarine blue

Ivory black

BRUSHES
Flats: Nos. 8 and 10 *(Golden Natural series 2002S)*

Script liner: No. 2 *(Golden Natural series 2007S)*

MISCELLANEOUS
Disposable paper palette

Palette knife

Paper towels

Japan drier

PAINTING TECHNIQUES

Blocking In (page 29)

Drybrushing with Oils (page 31)

INSTRUCTIONS

1 Use the no. 10 flat brush to block in the plum's three basic values. Begin with the peaks of the highlights, which require large areas of titanium white (A). Surround the highlights with a medium-value violet color made by mixing ultramarine blue + alizarin crimson + titanium white (B). For the shading (the darkest value), use a mixture of ultramarine blue + alizarin crimson (C).

2 Wipe the no. 10 flat on a paper towel, then use it to soften the areas where values converge. The lines between colors should dissolve to create a gentle gradation of values (A). Don't be concerned at this point if the white highlights are no longer clearly visible (B).

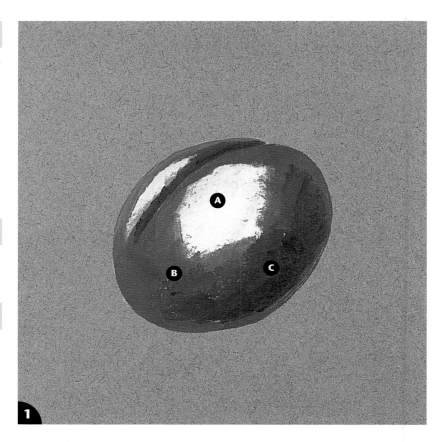

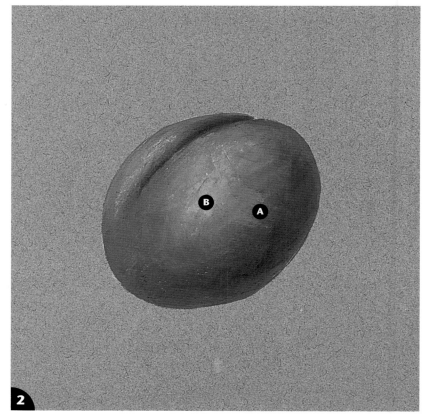

3 Again using the no. 10 flat, reinforce the peaks of the highlights with titanium white (A), applying firm pressure as you work. Intensify the darkest areas of shading with ivory black (B). Add a reflected light with a tint of alizarin crimson (C).

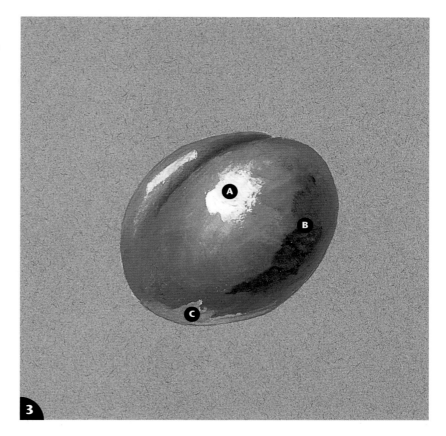

4 Thoroughly wipe the brush on a paper towel, then use it to carefully blend the edges of the white highlights. If the highlights disappear, allow the paint to "rest" for a while, then reapply them with firm pressure. If you gently blend the highlights' edges, they should remain in place (A).

Soften the shading (B) and the reflected light (C). If necessary, intensify the reflected light by reapplying a medium value of alizarin crimson + titanium white, then lightly blending it into the plum.

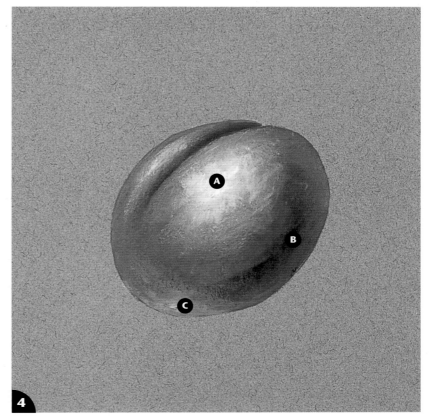

Strawberries

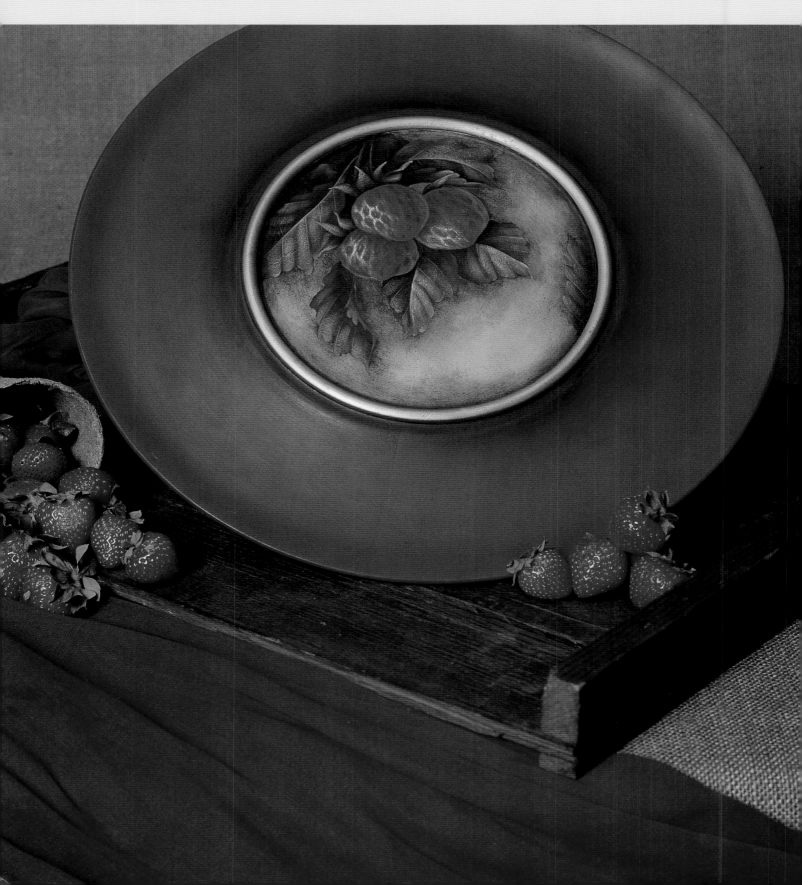

These little berries are not only beautiful, they're also fun to paint. Though the surface of a strawberry is somewhat complex, comprising seeds, seed pockets, and "honeycomb" highlights, it actually isn't all that difficult to paint as long as you concentrate on what you're doing and avoid rushing through it. You'll do a better job and enjoy the task more if you work through each step slowly and carefully.

SURFACE PREPARATION

I painted the strawberries on a large wooden plate because it complemented the design's circular shape. This design could work well on other shapes, like the lid of an oval basket or the cover of a rectangular box. Simply paint the circle in acrylics, let dry, then paint the design in your chosen medium.

Prime the plate with white sealer/primer, then basecoat it with bright red acrylic paint. Paint the central area of the plate and the surrounding bead in metallic gold. Antique the red area with a mixture of burnt umber + ivory black. Once dry, lightly flyspeck the entire plate with ivory black.

Transfer the pattern to the surface with white transfer paper.

IF YOU'RE WORKING IN ACRYLICS

See page 78 for a complete list of materials.

Background Color. To achieve depth of shading, mix two or three values of Mars black + cadmium yellow light. Sideload the wash brush with the lightest value, then apply it around most of the pattern's outline. Let dry. Sideload the wash brush with the medium value and stroke it only in the recessed areas. Once the medium value has dried, you can increase the intensity of the shading by applying the darkest value to the nooks and crannies of the pattern. After the final application of color has dried, retransfer any pattern lines that were obscured by the paint.

Leaves. Undercoat the leaves with a no. 8 flat brush loaded with a mixture of cadmium yellow light + Mars black + Hooker's green; let dry, then shade with Mars black using a sideloaded brush. To paint the highlights, create a value scale of greens by gradually adding small amounts of cadmium yellow light + titanium white to the green mixed for the undercoat. Thin these mixtures, then apply them with a dry brush. To paint the veins, use a script liner brush loaded with a very pale green (use one that you mixed for the highlights) thinned to an inklike consistency. Working with a dry brush, accent the darker areas of the shading with burnt sienna and alizarin crimson. If used sparingly, cadmium red medium can also serve as an accent color.

Varnishing. Wait at least 24 hours before varnishing the completed painting.

IF YOU'RE WORKING IN OILS

See page 80 for a complete list of materials.

Background Color. Mix two or three values of burnt umber and a dark green (cadmium yellow medium + ivory black). Working from light to dark, apply one value at a time with a sideloaded wash brush, blending to eliminate the lines of demarcation between them. Soften the blending with a mop brush. Once the background color has dried to the touch, carefully retransfer any pattern lines that were lost.

Leaves. Using a no. 8 flat brush, block in the leaves with three values of green. Mix a medium-value green by combining cadmium yellow medium + ivory black. To create the highlights, combine the medium-value green with cadmium yellow medium + titanium white; gradually lighten this mixture by adding white, setting aside small amounts of each value step as you work. For the shading, add more ivory black to the medium value. Accent the leaves with alizarin crimson and burnt sienna. You can also add a few accents of cadmium red light as long as they don't appear patchy or distracting.

Varnishing. If you used japan drier, you should wait at least 72 hours before varnishing your completed painting; if you didn't, you may need to wait a few weeks to ensure that the paint film is completely dry.

Painting in Acrylics/Strawberries

WHAT YOU'LL NEED

ARTISTS' ACRYLICS
Titanium white

Cadmium yellow light

Burnt sienna

Cadmium red light

Cadmium red medium

Alizarin crimson

Hooker's green

Mars black

BRUSHES
Flats: Nos. 8 and 10 (*Golden Natural series 2002S*)

Script liner: No. 2 (*Golden Natural series 2007S*)

MISCELLANEOUS
Disposable paper palette

Sta-Wet palette

Palette knife

Paper towels

Water container

Pencil

PAINTING TECHNIQUES

Undercoating (page 29)

Sideloading (page 32)

Optical Blending (page 31)

INSTRUCTIONS

1 Use the no. 8 flat brush to undercoat the strawberries with a full-strength load of cadmium red medium. Make sure this layer of paint is opaque enough to cover the basecoat, antiquing, and flyspecking completely. Let dry.

2 This step, in which two layers of shading are added, will give the strawberries some shape.

For the first layer, sideload a no. 10 flat with alizarin crimson, then use it to cover almost half of each berry (A). Let dry.

For the second layer, mix alizarin crimson + Hooker's green, then apply it by sideloading the same flat brush, but this layer of shading should cover only about one-third of each berry (B). Make sure the second layer does not extend beyond the first, and leave a narrow area at the edge of the berry exposed; this will serve as the reflected light (C). Let dry.

3 The highlighting step requires time and patience. Work on one strawberry at a time.

Using the pattern (see page 134) and the final step as your guides, lightly mark the positions of the seeds with a pencil. It is important that the seeds are properly spaced before you proceed.

Load the script liner with cadmium red medium and begin to apply the "honeycomb" highlighting pattern that runs around the seed pockets. You're not actually painting the seed pockets; you're highlighting the areas *around* the seeds. Apply this first layer to the entire strawberry, although it won't be visible on the unshaded areas (A). Let dry.

Using the liner brush, repeat this step with increasingly lighter values, reducing the size of the area each time, eventually building up to a bright highlight that surrounds just one or two seed pockets in one area of the strawberry. Let each layer of highlighting dry before applying the next.

- For the second layer, use a mixture of cadmium red medium + cadmium red light. Apply this color to most of the berry, but use it minimally in the shaded areas (B).
- For the third layer, use cadmium red light, but don't carry it into the shaded areas (C).
- For the fourth layer, which should be confined to the highlighted half of the berry, use a mixture of cadmium red light + a bit of cadmium yellow light.
- For the last few layers, gradually lighten the mixture created for the fourth layer by adding touches of titanium white.
- Paint the final hightlight with pure titanium white (D).

4 Create a "sparkle" by reinforcing the titanium white highlight (A). Let dry.

Use a script liner brush to paint the seeds with a dark green mixture of cadmium yellow light + Mars black thinned to an inklike consistency. Let dry. Highlight with a tiny, fine line of cadmium yellow light + a touch of the dark green mixture (B).

A greenish accent (cadmium yellow light + Mars black) may be added to the seed pockets in the shaded area (C). This color is applied like a highlight using the script liner brush (see step 3).

Paint the bracts (D) with the same colors that were used for the leaves (see page 77).

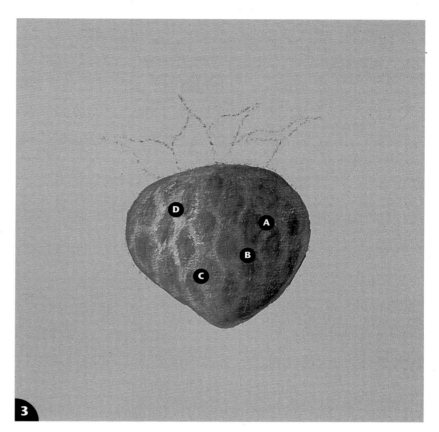

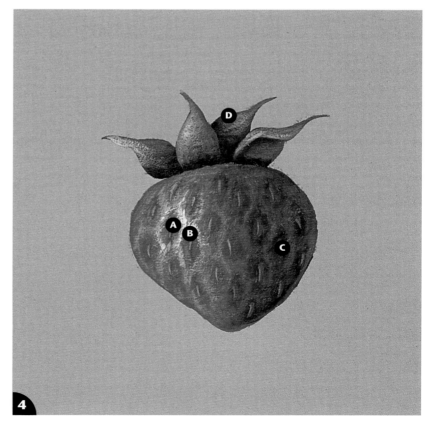

Painting in Oils/Strawberries

WHAT YOU'LL NEED

ARTISTS' OILS

Titanium white

Cadmium yellow medium

Burnt sienna

Burnt umber

Cadmium red light

Cadmium red medium

Alizarin crimson

Ivory black

BRUSHES

Flat: No. 8 *(Golden Natural series 2002S)*

Script liner: No. 2 *(Golden Natural series 2007S)*

MISCELLANEOUS

Disposable paper palette

Palette knife

Paper towels

Japan drier

Pencil

PAINTING TECHNIQUES

Blocking In (page 29)

Drybrushing with Oils (page 31)

INSTRUCTIONS

1 Use the no. 8 flat brush to block in light, medium, and dark values on the strawberry. Use cadmium red light for the light value (A), cadmium red medium for the medium value (B), and alizarin crimson + burnt sienna for the dark value (C).

2 Wipe the brush on a paper towel to remove excess color, then use it to blend the values, forming soft, gentle gradations between them (A, B). Be careful not to overblend; just soften the harsh lines where two colors meet. Let the paint dry to the touch before proceeding to the next step.

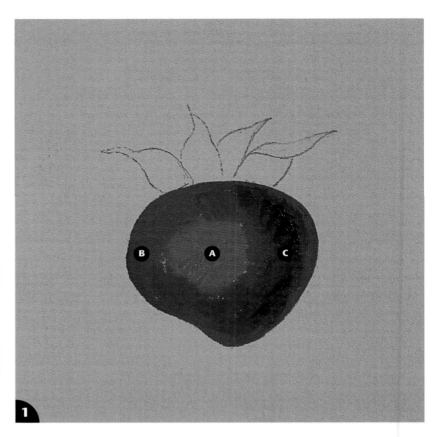

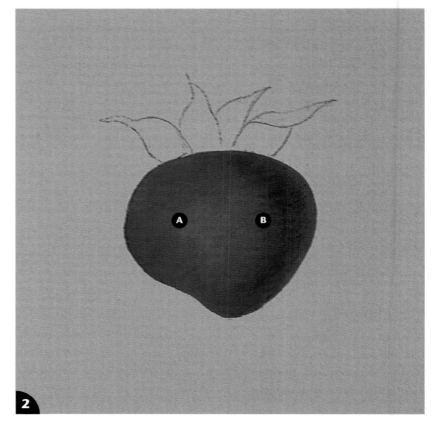

3 Use a pencil to lightly mark the positions of the seeds on the strawberry. Refer to the pattern (see page 134) and the final step as guides to placement. The seeds should be spaced at regular, consistent intervals.

Using the script liner brush, lay in the "honeycomb" pattern of highlights. Before you begin, it's important that you map out a pleasing design that gradually becomes darker in value as it moves away from the white portion of the highlight. Start by placing titanium white in the area of lightest value (A). Next, apply cadmium yellow medium (B), then cadmium red light (C), and finally cadmium red medium (D). At this point, your strawberry will look very garish and strange.

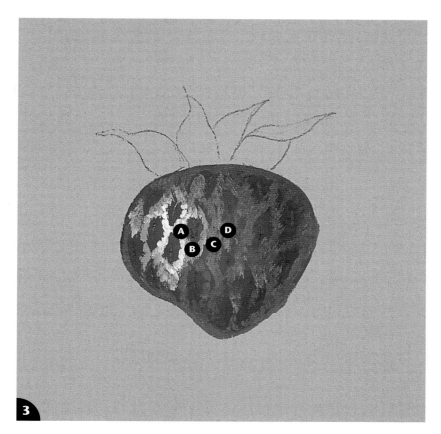

4 Gently blend the light-to-dark highlights into the strawberry by stippling with the tip of the script liner brush. Begin in the white area of the highlight, then gently work outward over the rest of the berry. If you should overblend any part the highlight, simply apply a little more of the color to the area with the script liner, then resume stippling. The white of the highlight should remain crisp while its remaining value steps soften into the berry (A).

Use the script liner to paint the seeds with a green mixed from cadmium yellow medium + ivory black (B). To paint the highlights, use cadmium yellow medium + a bit of the green mixture (C).

Paint the bracts (the small leaves at the top of the strawberry) with the same colors and techniques that were used to paint the leaves (see page 77) (D).

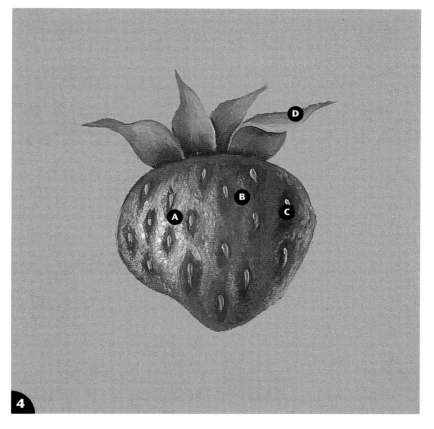

Green Grapes

A cluster of green grapes and its leaves can be dull and uninspiring if they're painted only with green. Add some pizzazz with subtle accents of soft rusts, blues, and violets, vibrant chartreuse greens, or almost any color you desire. You must exercise some restraint, as harsh splotches of color will make your grapes look uneven and strange. Use color wisely and you'll delight in the results. Also, be consistent in your placement of lights and darks throughout the cluster.

SURFACE PREPARATION

I painted my green grapes on a small round serving tray that is a traditional Hindeloopen design. (Hindeloopen is a region of the Netherlands celebrated for its distinctive style of decorative painting and folk arts.)

Prime the tray with white sealer/primer, then basecoat it with rust-colored acrylic paint. Apply red-toned variegated gold leaf to the sides of the tray, inside and out, as well as to the top edge. Antique the entire tray with burnt umber glaze. (I left a heavier application on the base and the lower inside edges of the sides.)

Transfer the pattern to the surface with white transfer paper.

IF YOU'RE WORKING IN ACRYLICS

See page 84 for a complete list of materials.

Leaves. Try to keep the colors of the leaves dull and soft so they won't compete with the grapes. Use a no. 8 flat brush to paint all the steps.

Undercoat the leaves with a very muted green mixed from yellow oxide + cadmium yellow light + Mars black. Let dry, then shade with Mars black. Highlight with a value scale of greens made by gradually adding small amounts of titanium white to the green mixed for the undercoat. To help soften some of the leaves into the background, place accents of burnt sienna along their edges.

Stems and Tendrils. Use a script liner to undercoat the stems with burnt umber. To highlight the stems, create various tints of the green that was used to undercoat the leaves (see above). If desired, accent with a mixture of ultramarine blue + burnt sienna + titanium white, which is also used to paint reflected lights on the grapes (see step 4 on page 85).

Varnishing. Wait at least 24 hours before varnishing the completed painting.

IF YOU'RE WORKING IN OILS

See page 86 for a complete list of materials.

Leaves. Work on the leaves with a no. 8 flat brush. Block in three values of green: medium (yellow ochre + ivory black), dark (the medium value + ivory black), and light (the medium value + titanium white). Soften the lines between values with a dry brush, then reinforce highlights by lightening the lightest value with more titanium white. Apply accents of burnt sienna to help establish a visual link between the surface treatment and the painted grapes.

Stems and Tendrils. Using a script liner brush, paint the stems and tendrils with burnt umber, then highlight them with green (cadmium yellow medium + ivory black + titanium white) and white. Add some dull blue accents of burnt sienna + ultramarine blue + titanium white.

Varnishing. If you used japan drier, you should wait at least 72 hours before varnishing your completed painting; if you didn't, you may need to wait a few weeks to ensure that the paint film is completely dry.

Painting in Acrylics/Green Grapes

WHAT YOU'LL NEED

ARTISTS' ACRYLICS

Titanium white

Cadmium yellow light

Yellow oxide

Burnt sienna

Burnt umber

Cadmium red medium

Ultramarine blue

Hooker's green

Mars black

BRUSHES

Flats: Nos. 8 and 12 *(Golden Natural series 2002S)*

Script liner: No. 2 *(Golden Natural series 2007S)*

Filbert: No. 8 *(Ruby Satin series 2503S)*

MISCELLANEOUS

Disposable paper palette

Sta-Wet palette

Palette knife

Paper towels

Water container

PAINTING TECHNIQUES

Undercoating (page 29)

Sideloading (page 32)

Optical Blending (page 31)

Applying a Wash (page 30)

INSTRUCTIONS

1 Undercoat the entire clump of grapes with a green mixed from cadmium yellow light + Mars black + a touch of Hooker's green. The color should be a fairly dark value. Use the no. 8 flat brush to form the outside of the cluster, then fill in with the no. 12 flat. Allow the undercoat to dry, then retransfer the shapes of the individual grapes with white transfer paper.

2 Sideload the no. 8 flat with Mars black, then shade each grape in the cluster. Beginning with the whole grapes, apply the shading in the shape of a number 3. Work on one half of each grape only (A), leaving a space for the reflected light at the edge (B). Continue with the partially visible grapes, concentrating the shading wherever a grape is hidden behind another, or behind a stem or leaf (C). Continue working until all the grapes are shaded. Let dry.

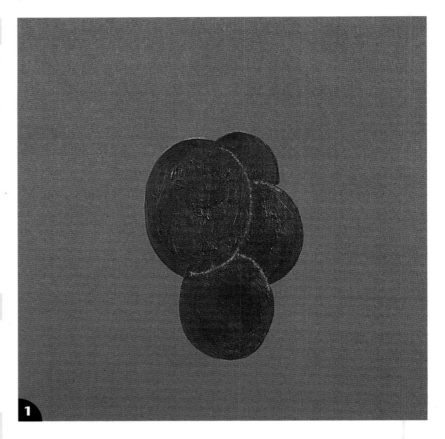

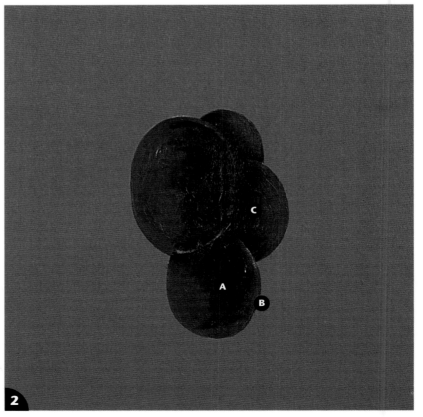

3 Use the optical blending technique (see page 31) to highlight the grapes with several layers of highlights. You can apply highlights to as much of the cluster as you want. For a dramatic effect, I concentrated the brightest highlights on one side of the cluster.

Apply each layer of highlighting to every grape before moving on to the next. For the first layer, load the filbert brush with a small amount of the green mixed for the undercoat (see step 1), wipe it on a paper towel, then lightly skim the hairs over most of the unshaded area of each grape (A). Let dry.

For the second layer of highlights, add a touch of titanium white to the green of the undercoat, then repeat the procedure, but this time apply the color to a smaller area (B).

For the third and fourth layers, you can adjust the coloration of the grapes by adding more cadmium yellow light to the green, which will impart a warmer cast to the highlights (C).

Once you've applied three to four layers of highlights to every grape, you can reinforce the peaks of the highlights on individual grapes—those that are in the direct path of your imaginary light source—with a "sparkle" of pure titanium white (D). Let dry.

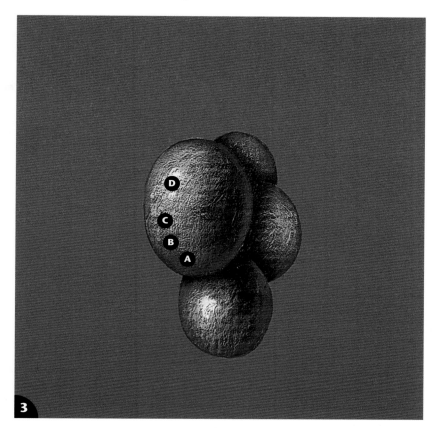

4 At this point, you can accent the grapes as desired. Add some rusty tints to the shaded side of the grapes with a wash of burnt sienna (A). To make the reds more noticeable, let dry, then add a wash of cadmium red medium to a few grapes on the lighter side of the cluster (B).

To further define the areas of the cluster in shadow and heighten the overall drama of the composition, add reflected lights to the shaded areas of some of the grapes using a filbert sideloaded with a soft blue mixed from ultramarine blue + burnt sienna + titanium white (C). You can intensify some of the reflected lights by making them wider, or by lightening the blue mixture with a bit of titanium white. Take care, however, when lightening the blue—its value should be the same as that of the green mixed for the undercoat. Study the finished painting on page 82 to see how the reflected lights define individual grapes and give the cluster dimension.

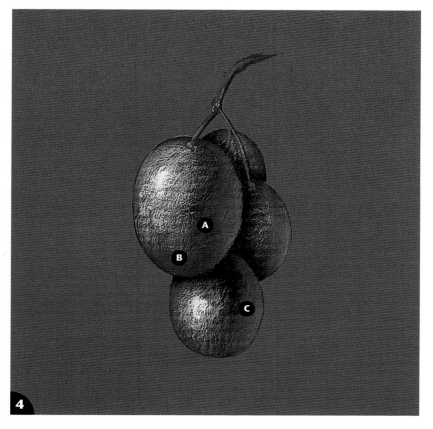

Painting in Oils/Green Grapes

WHAT YOU'LL NEED

ARTISTS' OILS	BRUSHES	MISCELLANEOUS
Titanium white	Flat: No 8 *(Golden Natural series 2002S)*	Disposable paper palette
Cadmium yellow medium	Script liner: No. 2 *(Golden Natural series 2007S)*	Palette knife
Yellow ochre		Paper towels
Burnt sienna		Japan drier
Burnt umber		
Alizarin crimson		
Ultramarine blue		
Ivory black		

PAINTING TECHNIQUES

Blocking In (page 29)

Drybrushing with Oils (page 31)

INSTRUCTIONS

When painting grapes in oils, perform each step on all the grapes in the cluster before moving on to the next step.

1 Begin by mixing three values of green: a dark value (cadmium yellow medium + ivory black) (A), a medium value (the dark value + titanium white + a tad of cadmium yellow medium) (B), and a light value (titanium white + a bit of the medium value) (C). Use a no. 8 flat brush to block in the three values on each grape as shown.

2 Wipe the brush on a paper towel, then use it to blend the values within each individual grape. Blend only enough to soften lines of demarcation between values. You should still be able to identify the three values that were applied in step 1.

3 Use the no. 8 flat to strengthen the center of each highlight with titanium white (A). Apply these sparingly to the grapes on the shaded side of the cluster (B). To warm and lighten the side of the cluster in direct light, surround the titanium white center of each highlight with a bit of cadmium yellow medium (C). Deepen the darkest areas of shading with ivory black applied in a "3" shape (D).

Be sure to apply firm pressure to the brush as you work to ensure that colors will stay in place when they are softened in step 4.

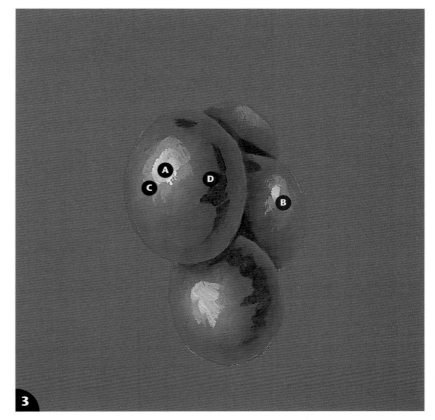

4 Using a light touch, blend the newly added highlights and shading into each grape with the no. 8 flat. To maintain the gleam of the white highlights, you should really only "tickle" the edges of each one (A).

Again using the no. 8 flat, create a transition between areas of medium and dark value by adding some tints of burnt sienna (B), then soften them.

To add the reflected lights, wipe the no. 8 flat on a paper towel until it feels dry, then sideload it with a dull blue mixture of burnt sienna + ultramarine blue + titanium white. Apply the blue along the shaded edge of each grape, then blend it inward to soften it (C). If you want to amplify some of the reflected lights, add a touch of titanium white to the blue mixture, sideload your brush with it, then apply it over the first layer of color. Note that the reflected light should not simply outline the edge of each grape; its inner contour should follow that of the shading.

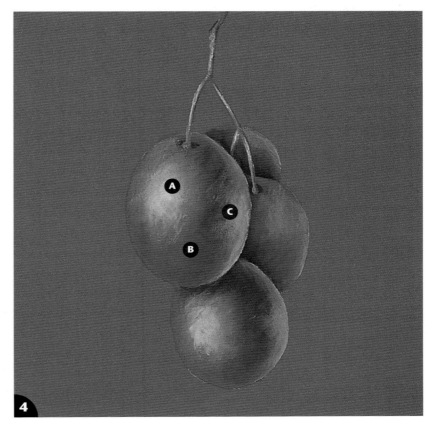

Poppies

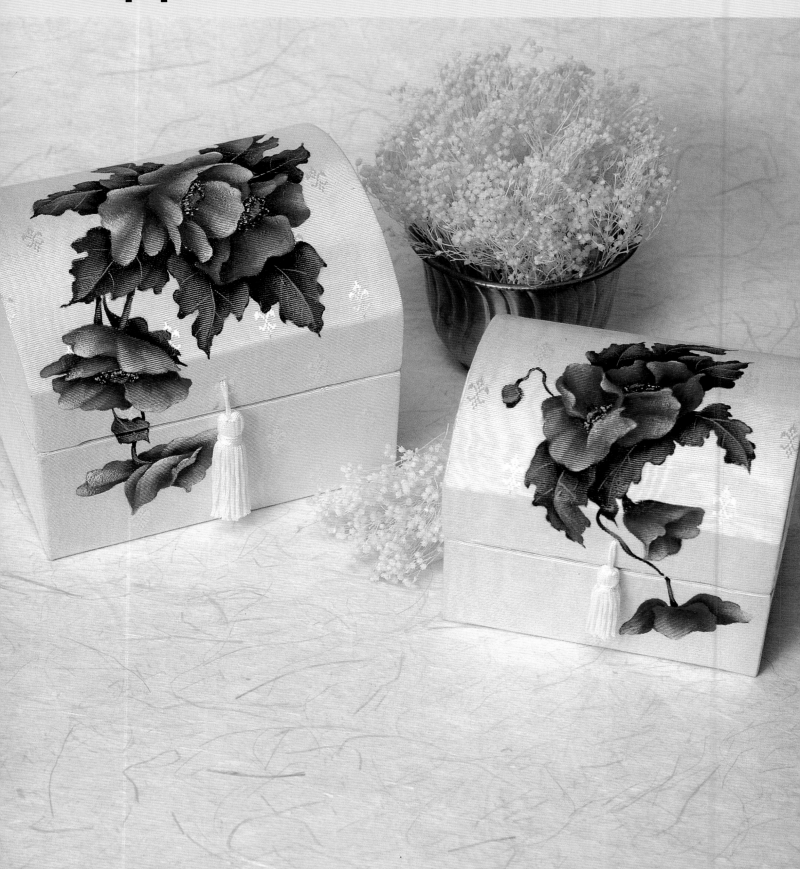

I love wildflower meadows that include vast fields of poppies. The petals of poppies are so delicate that they seem to move with the slightest breeze. I like the classic red poppies, but they can also be found in vibrant pinks, bright and soft yellows, oranges, and creams. The techniques described on the following pages can be used to paint poppies in any color. Experiment with your paints to discover your personal favorite.

SURFACE PREPARATION

I painted the poppy designs on boxes covered with a cream-colored fabric that I found in a discount store. They required no preparation prior to painting. If you look in bargain stores in your area you can probably find something similar.

Should you want to paint your poppies on something else, you can use all sorts of wooden objects as painting surfaces—a mirror frame, a candle sconce, or a small trunk. The poppies would look dramatic against a black background, or on a piece of wood stained with a very dark, dull pink.

Transfer the design to the surface with gray transfer paper.

IF YOU'RE WORKING IN ACRYLICS

See page 90 for a complete list of materials.

Leaves. Paint the leaves with the no. 8 flat brush. Undercoat with a dull green mixture of cadmium yellow light + Mars black + a bit of cadmium red medium. Let dry, then shade with Mars black. Paint the highlights with a value scale of greens made by gradually lightening the green of the undercoat with cadmium yellow light and titanium white.

Accent the leaves close to poppies here and there with tints of pink (titanium white + alizarin crimson + cadmium red medium). If the pink seems too bright, tone it down by adding a tad of burnt umber.

Stems. Paint the stems with the script liner brush using the same colors that were used for the leaves.

IF YOU'RE WORKING IN OILS

See page 92 for a complete list of materials.

Leaves. Use a no. 8 flat brush for all the steps. Block in the leaves with three values of green. For the medium value, mix cadmium yellow medium + ivory black + a touch of cadmium red medium. For the dark value, add more ivory black to the medium value. To create the light value, lighten the medium value with titanium white + a touch of cadmium yellow medium. Soften the blocked-in values with a dry brush, then strengthen the peaks of the highlights with titanium white applied with firm pressure. Add accents of pink with a bit of titanium white + alizarin crimson + a touch of cadmium red medium. Soften them with a dry brush; if they seem a bit too bright, continue blending them into the leaf.

Stems. Use a script liner brush and the palette for the leaves to paint the stems.

Painting in Acrylics/Poppies

WHAT YOU'LL NEED

ARTISTS' ACRYLICS

Titanium white

Cadmium yellow light

Burnt umber

Cadmium red medium

Alizarin crimson

Hooker's green

Mars black

BRUSHES

Flats: Nos. 8 and 10 (*Golden Natural series 2002S*)

Script liner: No. 2 (*Golden Natural series 2007S*)

Filbert: No. 8 (*Ruby Satin series 2503S*)

MISCELLANEOUS

Disposable paper palette

Sta-Wet palette

Palette knife

Paper towels

Water container

PAINTING TECHNIQUES

Undercoating (page 29)

Sideloading (page 32)

Optical Blending (page 31)

INSTRUCTIONS

1 Use the no. 8 flat brush to undercoat the petals of the poppy with cadmium red medium + a touch of burnt umber. Make sure the undercoat is opaque. Reapply any pattern lines that were lost once the undercoat is dry.

2 Shade the petals with two layers of paint. Sideload the no. 10 flat with alizarin crimson and apply it along the base of the petals, feathering out the edges of the application (A). Let dry. For the second layer, sideload the brush with a combination of Hooker's green + alizarin crimson and apply it over the first (B). Let dry.

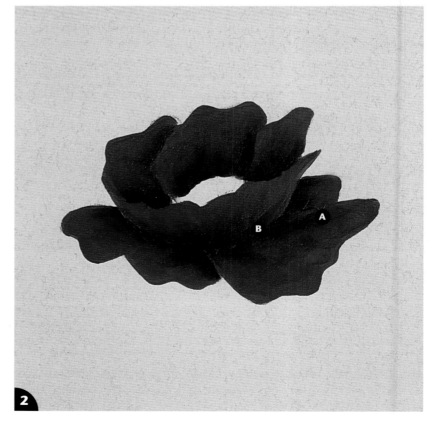

3 Highlight the petals with a value scale of pinks using the optical blending technique (see page 31). Load the filbert brush with a small amount of the undercoat color and wipe the brush on a paper towel. Apply the paint by lightly grazing the hairs of the brush on the unshaded area of each petal (A). Let dry. Repeat for each subsequent layer of highlight, gradually lightening the undercoat by adding a small amount of white, applying the highlight to a progressively smaller area, and letting each layer dry before adding the next. If you want to adjust the color of the poppy, mix in touches of alizarin crimson or cadmium red medium (B).

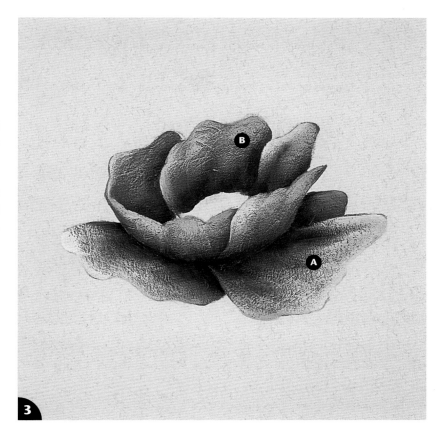

4 Undercoat the center of the poppy with burnt umber. Let dry. Shade it with a no. 10 brush sideloaded with Mars black. Let dry, then highlight with a mixture of burnt umber + titanium white (A). Let dry.

Thin a little each of Mars black, burnt umber, and burnt umber + titanium white to an inklike consistency. Use the script liner brush and each of these colors to paint the stamens and stigma surrounding the center (B). Let dry.

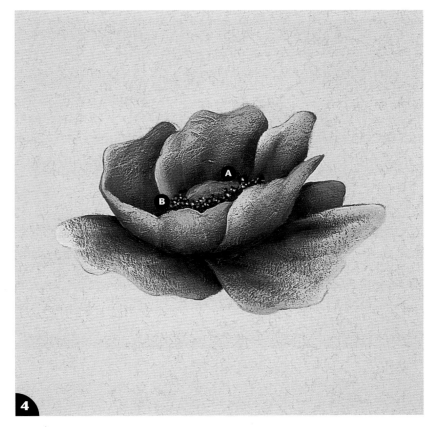

Painting in Oils/Poppies

WHAT YOU'LL NEED

ARTISTS' OILS
Titanium white

Cadmium yellow medium

Burnt sienna

Burnt umber

Cadmium red light

Cadmium red medium

Alizarin crimson

Ivory black

BRUSHES
Flat: No. 8 *(Golden Natural series 2002S)*

Script liner: No. 2 *(Golden Natural series 2007S)*

MISCELLANEOUS
Disposable paper palette

Palette knife

Paper towels

Japan drier

PAINTING TECHNIQUES

Blocking In (page 29)

Drybrushing with Oils (page 31)

INSTRUCTIONS

1 Begin by blocking in the petals with two values, one medium and one dark. For the medium value, mix cadmium red medium + a tad of burnt sienna, then use the no. 8 flat brush to apply it to the outer two-thirds of the petals (A). Wipe the brush on a paper towel, reload it with a mixture of alizarin crimson + burnt umber, and fill in the rest of each petal (B).

2 Wipe the brush on a paper towel, then use it to blend the areas where the two values meet to create a third (A). Don't overwork the paint, or you'll end up with one value instead of three.

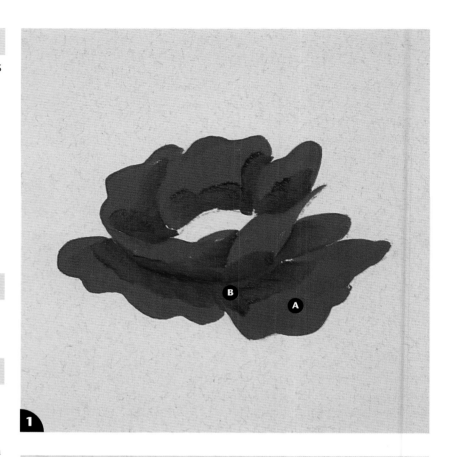

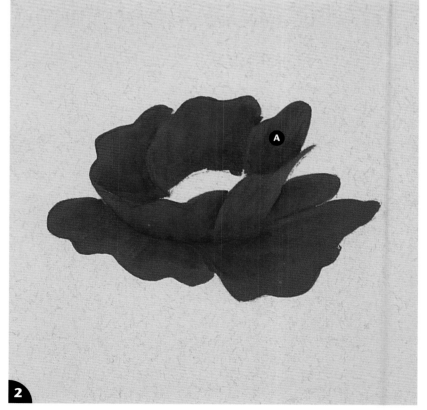

3 Mix a light pink by combining titanium white + a touch of alizarin crimson + a touch of cadmium red light. Apply this mixture with the no. 8 flat to the outside edges of the petals, pressing firmly on the brush (A); this will help the color stay in place when it is softened in the next step.

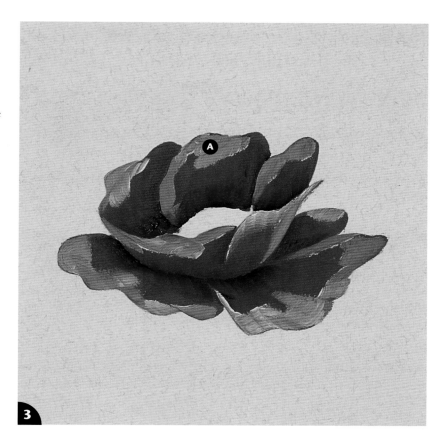

4 Wipe the brush on a paper towel and gently blend the pink into the petal (A). If it disappears, apply it once more, this time exerting more pressure on the brush, and blend it again. If you want to strengthen the highlights, selectively apply pure titanium white to a few of the petals, then soften it with the brush (B).

Paint the center with burnt umber, shade its base with ivory black, then add and blend in a white highlight (C). Thin a little each of ivory black, burnt umber, and titanium white + burnt umber to an inklike consistency. Use the script liner brush and each of these colors to paint the stamens and stigma surrounding the center (D).

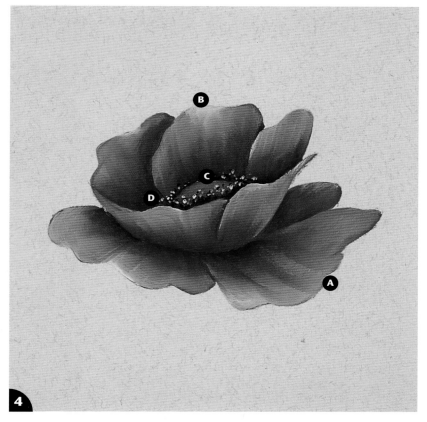

Black-Eyed Susans

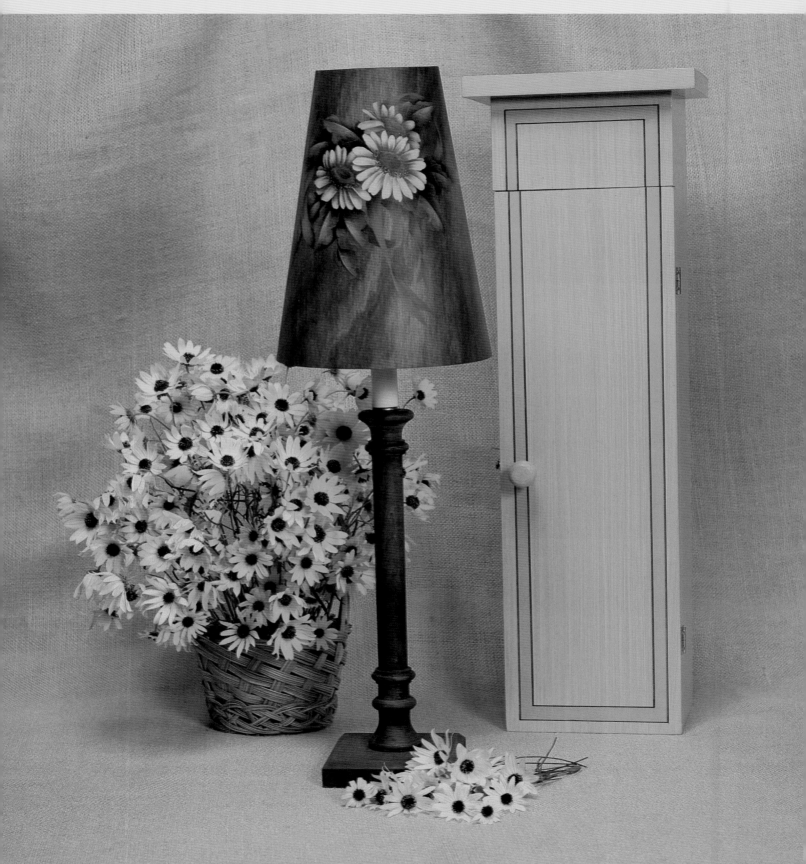

Black-eyed Susans have about as much country charm as any flower I know of. These pretty wildflowers belong to the family of composite plants, of which daisies and sunflowers are also members. The classic composite flower comprises a circular disk made up of many tiny florets that is surrounded by numerous ray flowers, which are commonly referred to as "petals." The degree of detail involved in painting composite flowers can be a little daunting at first, but the task can be made much easier by approaching it in a systematic way.

SURFACE PREPARATION

I painted these charming flowers on an unfinished wooden lampshade. Stain the exterior of the shade with a burnt umber glaze. Let dry, then paint the inside of the shade with black acrylic paint. (It is unnecessary to prime the shade first.) Use white transfer paper to transfer the pattern to the stained shade.

IF YOU'RE WORKING IN ACRYLICS

See page 96 for a complete list of materials.

Leaves. Undercoat with a green mixed from cadmium yellow light + Mars black; let dry. Shade with a no. 8 flat brush sideloaded with Mars black. Let dry, then highlight with a value scale of greens using the optical blending technique (see page 31). Create the range of greens by gradually adding small amounts of cadmium yellow light to the green of the undercoat. As you reach the lighter end of the scale, lighten the color further by adding touches of titanium white. Work with a dry brush and let each layer of highlights dry before applying the next. Add accents of yellow oxide and burnt sienna.

Ribbons. Undercoat the ribbon with cadmium red medium; let dry. Apply the shading in two sideloaded layers, first with alizarin crimson, then with alizarin crimson + Hooker's green, letting the first dry before adding the second. Once the shading has dried, highlight using the optical blending technique (see page 31), first with cadmium red medium, then finishing with cadmium red light.

Varnishing. Wait at least 24 hours before varnishing the completed painting.

IF YOU'RE WORKING IN OILS

See page 98 for a complete list of materials.

Leaves. Begin by mixing three values of green. Combine cadmium yellow medium + ivory black to make a medium-value green. For the shading, darken the medium-value green by adding more ivory black. Create a light-value green by lightening the medium-value green with cadmium yellow medium + titanium white. Block in the three values with a no. 8 flat brush, then wipe the brush on a paper towel and soften the areas where two values meet. Reinforce the peak of each highlight with a touch of titanium white, then soften its edges. If needed, intensify the shading with a little ivory black, then soften. For the accents, apply burnt sienna and yellow ochre with the no. 8 flat.

Ribbon. Block in light, medium, and dark values of red: Use cadmium red light for the light value, cadmium red medium for the medium value, and alizarin crimson + burnt sienna for the dark value. Wipe the brush on a paper towel and gently blend the lines of demarcation between values until there is a smooth gradation between them. If needed, intensify the shading with a mixture of alizarin crimson + burnt umber and enhance the highlights by reapplying the cadmium red light, then use a dry brush to soften them.

Varnishing. If you used japan drier, you should wait at least 72 hours before varnishing your completed painting; if you didn't, you may need to wait a few weeks to ensure that the paint film is completely dry.

WHAT YOU'LL NEED

ARTISTS' ACRYLICS

Titanium white

Cadmium yellow light

Yellow oxide

Burnt sienna

Burnt umber

Cadmium red light

Cadmium red medium

Alizarin crimson

Ultramarine blue

Hooker's green

Mars black

BRUSHES

Flat: No. 8 *(Golden Natural series 2002S)*

Script liner: No. 2 *(Golden Natural series 2007S)*

Filbert: No. 8 *(Ruby Satin series 2503S)*

MISCELLANEOUS

Disposable paper palette

Sta-Wet palette

Palette knife

Paper towels

Water container

PAINTING TECHNIQUES

Undercoating (page 29)

Sideloading (page 32)

Optical Blending (page 31)

See also: U Stroke (page 26)

INSTRUCTIONS

1 Use the no. 8 filbert to undercoat each petal with yellow oxide (A). To make the task of painting the black-eyed Susan easier, leave "cheat lines" between the petals (B). ("Cheat lines" are very thin spaces between petals that are left unpainted in the first step so that individual petals remain distinct.) Once you've undercoated all the petals, let them dry completely.

2 Begin shading with a no. 8 flat brush sideloaded with burnt sienna. Apply the color along the length of each petal, walking it from the base out toward the tip, covering anywhere from one-third to two-thirds of its length (A). (If the petal is underneath another one, apply shading over more of it; if it isn't, use less.) Let dry. Sideload the brush with burnt umber, then apply a second layer of shading over the first, concentrating it at the base of each petal (B). Let dry.

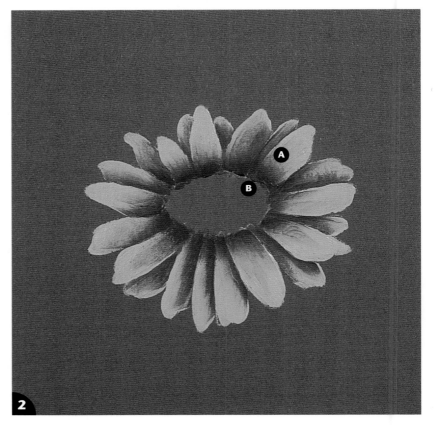

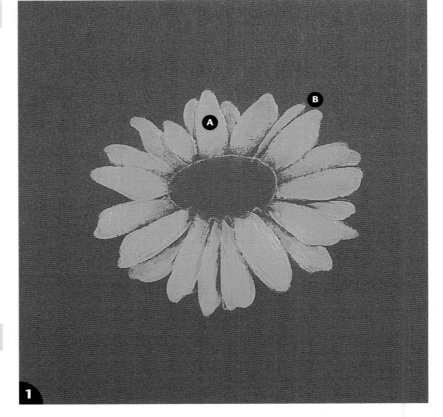

3 Add the highlights using the optical blending technique (see page 31). To begin, load the filbert with yellow oxide, wipe the brush on a paper towel to remove excess, then lightly skim the color along one side of each petal, working from the tip down toward the base. The color should be applied to the same side of each petal, and fade away as it is drawn toward the base.

Once you've highlighted all the petals with yellow oxide, let dry, then repeat the process with each of the following values. Let each layer of highlights dry before adding the next, and apply each successive layer to an increasingly smaller area.

- *Second layer.* Yellow oxide + cadmium yellow light.
- *Third layer.* Cadmium yellow light.
- *Fourth layer.* Cadmium yellow light + titanium white.

After applying the second layer of highlights, you can omit the third and fourth layers on the bottommost petals to make them recede within the composition (A). Apply the fourth layer of highlights only to the topmost petals (B).

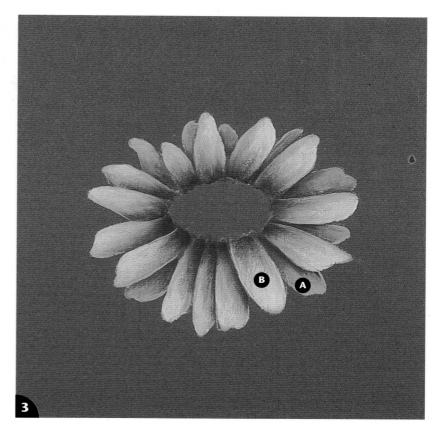

4 Using the no. 8 flat brush, paint the center with burnt umber, shade it with a sideload of Mars black, and highlight it with a sideload of burnt sienna. Let each color dry before adding the next.

To create the oval indentation (A), sideload the no. 8 flat with Mars black and paint a U stroke on its side. Let dry, then repeat with cadmium red light, painting a U stroke on its side opposite the black one. Once the red U stroke has dried, sideload the brush with a dull, dark blue mixture of titanium white + ultramarine blue + burnt umber, then use it to follow the outer contour of the black U stroke.

Add water to thin each of the following colors/mixtures to an inklike consistency: burnt umber, burnt umber + titanium white, cadmium red light, and cadmium yellow light. Use a script liner brush to paint the tiny "pollen dots" (florets) around the outside edge of the center (B).

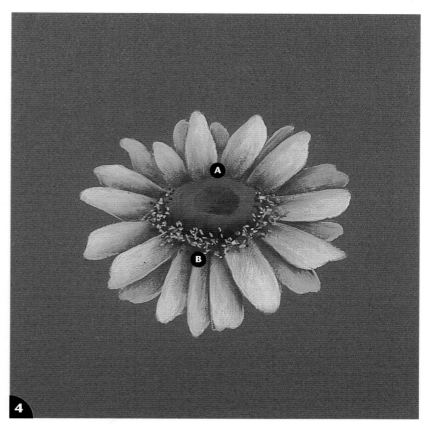

Painting in Oils/Black-Eyed Susans

PAINTING TECHNIQUES

Blocking In (page 29)

Doubleloading (page 33)

Drybrushing with Oils (page 31)

See also: U Stroke (page 26)

INSTRUCTIONS

1 Use a no. 6 flat to block in the basic values on the petals.

For the light value, apply cadmium yellow medium to the tip of each of the topmost petals (A), sometimes pulling it along one edge. (Apply the color to the same side of each petal.)

For the medium value, apply yellow ochre beneath the cadmium yellow medium, closer to the base in the middle of each petal (B). On the bottommost petals, this value should extend to the tip (C).

For the dark value, doubleload the brush with burnt umber and burnt sienna, then apply the umber side of the brush to the base of each petal (D), extending it along one edge where one petal overlaps another.

2 Wipe the brush on a paper towel, then use it to gently blend the values on each petal. When you're done, you should still be able to identify all three of the values that were applied in step 1.

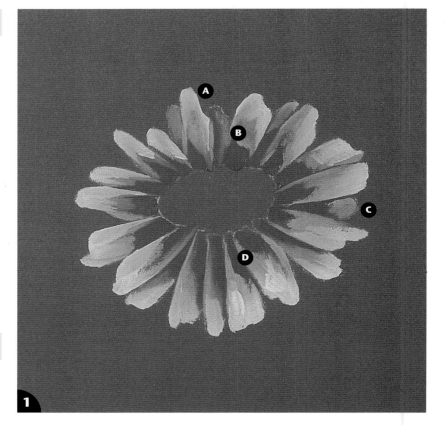

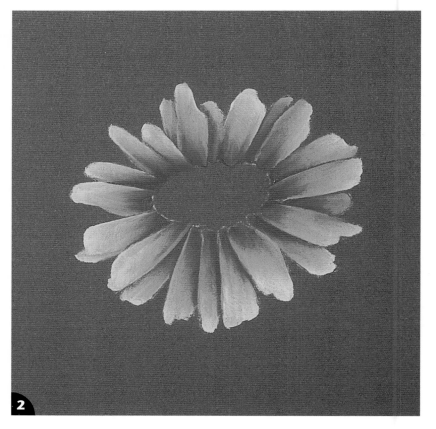

3 Intensify the highlights by placing cadmium yellow light on the tips of most of the petals (A). So that some petals are lighter than others, don't highlight every petal with the same amount of yellow, and don't apply highlights to the bottommost petals (B).

Apply the highlights by exerting pressure on the brush to ensure that they will stay in place when they are blended in the next step.

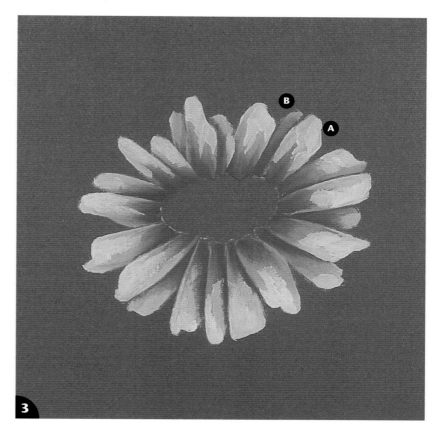

4 Wipe the brush on a paper towel to remove most of the paint, then blend the highlights with a light touch so they remain bright and clear (A).

Block in the disk with burnt sienna, then highlight its center with burnt umber. Soften the edges of the highlight.

To create the indentation in the center of the disk, doubleload a no. 8 flat with burnt umber and ivory black. Paint a U stroke on its side to form one half of the indentation. For the other half, paint a U stroke with a doubleload of cadmium red light and burnt umber opposite the first so that the two form an oval. To complete the indentation, sideload a brush with titanium white + ultramarine blue + burnt umber and paint a U stroke next to the burnt umber and black stroke, following its outer contour.

Load the blue mixture on the script liner brush, then use it to add the final highlight to the disk.

Thin black, burnt sienna, cadmium yellow light, and cadmium red light with mineral spirits to an inklike consistency. Use each of the colors and the script liner brush to create the tiny "pollen dots" (florets) that surround the disk (B).

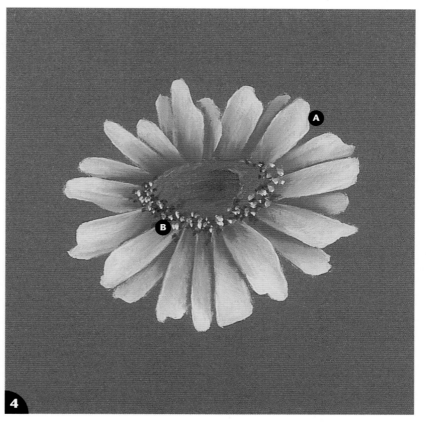

Tulips

Tulips are available in a startling number of varieties and color combinations. Many of these were developed in Holland, where tulips have been cultivated since the 17th century. The tulip fields there are absolutely breathtaking.

You don't have to plant bulbs to have beautiful tulips year-round—just paint some! If you can't find any real tulips to paint from, consult some catalogs that sell bulbs by mail; many include detailed color photographs of flowers and their foliage.

SURFACE PREPARATION

I painted the tulip design on a wooden lampshade using a *color-on-color* or *monochromatic* color scheme, which means that the subject and background were painted using the tints, shades, and tones of a single color (in this instance, a dull pink). This color scheme is great fun to paint, and a challenge as well. While making sure that your subject harmonizes with the background, you must also make it stand out by skillfully applying highlights and accents.

Prime the lampshade with white sealer/primer; let dry, then basecoat it with burgundy acrylic. Because the basecoat color is dark, you'll probably need to apply several coats in order to get good coverage. Let each coat dry before applying the next. Lightly flyspeck the dried basecoat with light pink acrylic, let dry, then paint two thin bands of light pink around the entire shade.

Transfer the pattern to the surface with white transfer paper.

IF YOU'RE WORKING IN ACRYLICS

See page 102 for a complete list of materials.

Leaves and Stems. Use a no. 12 flat to undercoat the leaves and stems with a dull green mixture of cadmium yellow light + Mars black + a dab of alizarin crimson. (The alizarin crimson mutes the green, which in turn diminishes the contrast between the leaves and the burgundy background.) Once the undercoat has dried, shade with a no. 12 flat sideloaded with Mars black. Let dry, then use the no. 8 filbert and the optical blending technique (see page 31) to add highlights in a value scale of greens mixed by adding small amounts of titanium white to the green of the undercoat.

Add accents of alizarin crimson + titanium white and a tint of purple (alizarin crimson + ultramarine blue + titanium white) with a no. 12 flat.

Varnishing. Wait at least 24 hours before varnishing the completed painting.

IF YOU'RE WORKING IN OILS

See page 104 for a complete list of materials.

Leaves. Mix three values of green: For the medium value, combine cadmium yellow medium + ivory black + alizarin crimson (the latter will dull the green slightly); for the dark value, add more black to the medium-value green; for the light value, add more cadmium yellow medium + titanium white to the medium-value green.

Block in these three values with the no. 12 flat, wipe the brush on a paper towel, then use it to soften the areas where two values abut. Reinforce the peaks of the highlights with titanium white, and add accents of pink (alizarin crimson + titanium white) and purple (dioxazine purple + titanium white), then soften their edges with a dry brush.

Varnishing. If you used japan drier, you should wait at least 72 hours before varnishing your completed painting; if you didn't, you may need to wait a few weeks to ensure that the paint film is completely dry.

Painting in Acrylics/Tulips

WHAT YOU'LL NEED

ARTISTS' ACRYLICS

Titanium white

Cadmium yellow light

Burnt umber

Alizarin crimson

Ultramarine blue

Hooker's green

Mars black

BRUSHES

Flats: Nos. 8 and 12 *(Golden Natural series 2002S)*

Script liner: No. 2 *(Golden Natural series 2007S)*

Filbert: No. 8 *(Ruby Satin series 2503S)*

MISCELLANEOUS

Disposable paper palette

Sta-Wet palette

Palette knife

Paper towels

Water container

PAINTING TECHNIQUES

Undercoating (page 29)

Sideloading (page 32)

Optical Blending (page 31)

INSTRUCTIONS

1 Use the no. 12 flat brush to undercoat the tulip with a mixture of alizarin crimson + burnt umber + a touch of titanium white. If the paint is not covering well, let dry, then apply a second coat.

Once the undercoat is dry, retransfer the pattern lines that delineate the petals if they were covered by paint.

2 Apply the shading in two layers. For the first layer, sideload a no. 8 flat brush with alizarin crimson, then apply it to approximately one-third of the visible area of each petal (A), pulling the paint up from the base toward the tip. Let dry.

For the second layer of shading, apply a sideload of a translucent mixture of alizarin crimson + Hooker's green, this time just to the nooks and crannies between and around the interior petals (B), and to the clefts in the exterior ones (C). Make sure the first layer of shading can still be detected beneath the second layer. Let dry before proceeding to the next step.

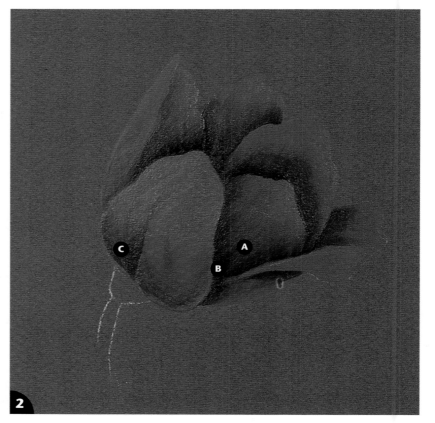

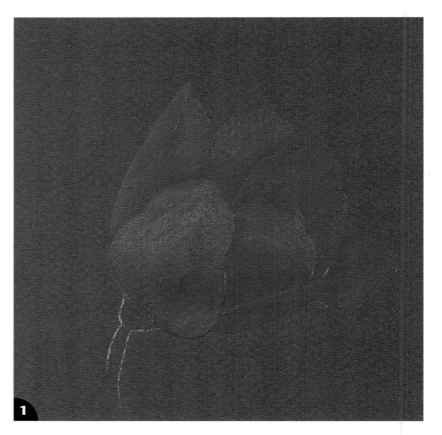

3 Use the optical blending technique to highlight the tulip with a value scale of pinks, which are mixed by incrementally lightening the pink mixed for the undercoat (see step 1) with small amounts of titanium white.

Make sure you always use a dry brush: Load the filbert with just a small amount of paint, wipe it on a paper towel to remove excess, then lightly skim the hairs over the surface. Apply each value to a progressively smaller area, and let each application dry before adding the next.

Within a grouping of tulips, some flowers should be lighter in coloration, while others should be darker. To create this variety, apply a layer of highlighting to every petal, then evaluate the entire composition to decide which tulips (and petals) you will continue to highlight.

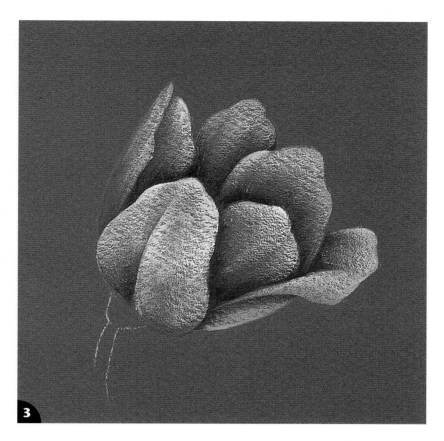

4 Again using the optical blending technique, apply some reflected lights of purple (alizarin crimson + ultramarine blue + titanium white) to the base and edges of the foremost petals with a dry filbert (A, B). If desired, lighten the purple just slightly by adding a little more titanium white, then use it to accent the first layer (C).

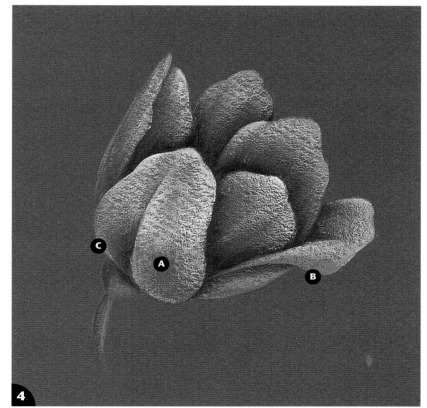

Painting in Oils/Tulips

WHAT YOU'LL NEED

ARTISTS' OILS	BRUSHES	MISCELLANEOUS
Titanium white	Flats: Nos. 8, 10, and 12 (*Golden Natural series 2002S*)	Disposable paper palette
Cadmium yellow medium		Palette knife
Burnt umber	Script liner: No. 2 (*Golden Natural series 2007S*)	Paper towels
Alizarin crimson		Japan drier
Dioxazine purple		
Ivory black		

PAINTING TECHNIQUES

Blocking In (page 29)
Drybrushing with Oils (page 31)

INSTRUCTIONS

1 Start by mixing alizarin crimson + burnt umber to make a medium-value color. Take a portion of that mixture and add titanium white to lighten it. Now take some of the second mixture and add still more titanium white to lighten that color even more.

Use a no. 10 flat to block in all three values, referring to the example above, right, as a guide to placement. Apply the lightest value along the outer edges and at the tip of each petal, covering about one-third of its visible surface. The bottom edge of the application should create a "3" shape that repeats the shape of the petal's edge (A). On the foremost petal, extend the lightest value along one side of its center cleft (B).

When applying the medium-value pink, place it beneath the light value, following its curved contour (C). Apply the dark value to the remaining areas, concentrating it in the nooks and crannies between petals and at the base (D). On the foremost petal, extend it along the opposite side of the center cleft (E).

2 Wipe the brush on a paper towel, then use it to soften the areas on each petal where two values meet. Since you're confined to working with three values of the same color, avoid overblending or you'll end up with just one value. When you've finished, there should be a smooth transition from light to dark.

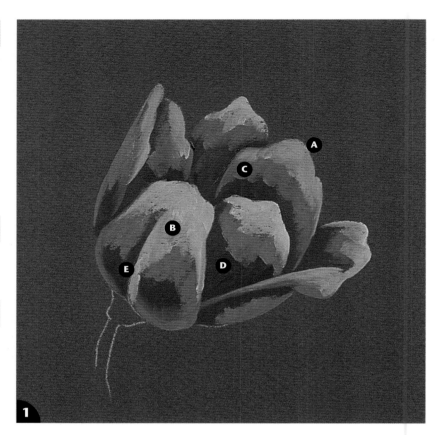

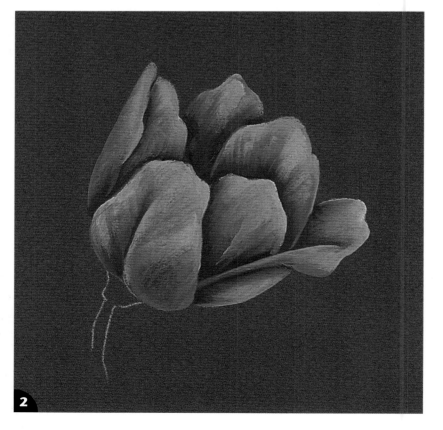

3 Exerting firm pressure on the brush, use the no. 8 flat to intensify selected portions of the lightest areas with titanium white (A). Apply the white more liberally toward the front of the flower (B).

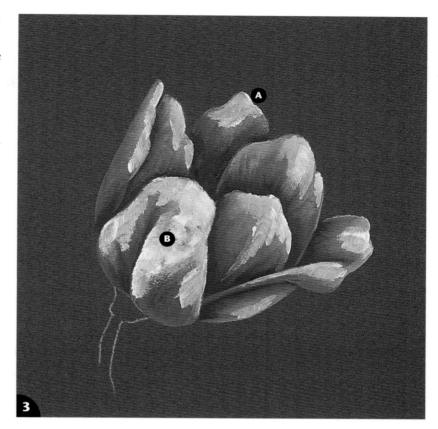

4 Wipe the brush on a paper towel, then use it to lightly blend the peaks of the highlights into each petal. To incorporate the white without making it disappear, concentrate on softening the edges of the application (A).

Use the no. 8 flat to add reflected lights of purple (dioxazine purple + titanium white) to the outer edges and along the bottom of the frontmost petals (B). If desired, you can intensify the reflected lights by lightening the purple with a little more white and applying it to the center of each one (C).

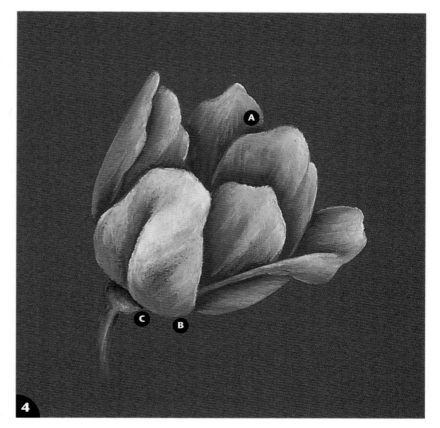

Pansies

Pansies come in a veritable rainbow of colors: white with warm and cool accents, yellow, blue, purple, orange, rust, and burgundy. The large, flamboyant blooms of the multicolored pansy are my favorite. Each of its components—the two rear petals, the three foremost petals, and the distinctive streaked pattern, which I call the "face" because it resembles a bushy beard and eyebrows—can be a different color. Check out your local nursery or leaf through some seed catalogs to find your favorite variety. The technique for painting a pansy is always the same, regardless of its coloration.

SURFACE PREPARATION

I painted the two pansy designs on an English cache box, one on the front and the other on the lid. The unique shape and styling of the box inspired me to devise an unusual "black-and-blue" surface treatment that includes antiquing, flyspecking, and metal leaf.

Prime the box with white sealer/primer, let dry, then basecoat it with light blue acrylic paint. Once dry, antique the front and lid with a very dark blue mixed from ultramarine blue + black, then flyspeck it with some of the dark blue as well.

Apply black variegated metal leaf to the concave moldings on the lid and the base and to the ball feet beneath the box. Let the leaf dry completely, then antique it with black.

Use white transfer paper to transfer the patterns to the front and lid.

IF YOU'RE WORKING IN ACRYLICS

See page 108 for a complete list of materials.

Leaves and Stems. Use a no. 8 flat brush to undercoat the leaves with a green mixed from cadmium yellow light + ultramarine blue + Mars black, then let dry. Shade with a no. 8 flat sideloaded with Mars black + ultramarine blue. Once dry, highlight with a no. 10 filbert and a value scale of greens made by adding small increments of titanium white to the green of the undercoat. Let dry, then add accents of light blue (titanium white + ultramarine blue).

Varnishing. Wait at least 24 hours before varnishing the completed painting.

IF YOU'RE WORKING IN OILS

See page 110 for a complete list of materials.

Leaves and Stems. Mix three values of green: a medium value (cadmium yellow medium + ivory black + ultramarine blue), a dark value (the medium-value green + ivory black + ultramarine blue) and a light value (the medium-value green + titanium white). Block in the three values with a no. 8 flat, then soften the areas between them with a dry no. 10 flat brush. Intensify the peaks of the highlights with pure titanium white. Accent the leaves with a mixture of titanium white + ultramarine blue applied with the no. 8 flat.

Varnishing. If you used japan drier, you should wait at least 72 hours before varnishing your completed painting; if you didn't, you may need to wait a few weeks to ensure that the paint film is completely dry.

Painting in Acrylics/Pansies

WHAT YOU'LL NEED

ARTISTS' ACRYLICS

Titanium white

Cadmium yellow light

Yellow oxide

Raw sienna

Burnt sienna

Dioxazine purple

Ultramarine blue

Mars black

BRUSHES

Flats: Nos. 8 and 10 (*Golden Natural series 2002S*)

Script liner: No. 2 (*Golden Natural series 2007S*)

Filbert: No. 10 (*Ruby Satin series 2503S*)

MISCELLANEOUS

Disposable paper palette

Sta-Wet palette

Palette knife

Paper towels

Water container

PAINTING TECHNIQUES

Undercoating (page 29)

Sideloading (page 32)

Optical Blending (page 31)

See also: Comma Stroke (page 24)

INSTRUCTIONS

1 Use the no. 10 flat brush to undercoat the yellow petals with yellow oxide + cadmium yellow light (A). Rinse the brush, then use it to undercoat the blue petals with ultramarine blue + dioxazine purple + a bit of titanium white (B). Leave "cheat lines" (thin unpainted spaces) between petals (C). Let dry.

2 To apply the shading, sideload the no. 12 flat brush with each color and apply it from the base of each petal outward, covering the "cheat lines" as you work. Let each color dry before adding the next.

The first color for the yellow petals is yellow oxide (A). Follow that with a layer of raw sienna (B). For the third layer, concentrate a little burnt sienna at the base of each petal (C).

Shade the base of each blue petal with a sideload of ultramarine blue + a touch of Mars black, drawing the color outward over half of its area until it gradually fades (D).

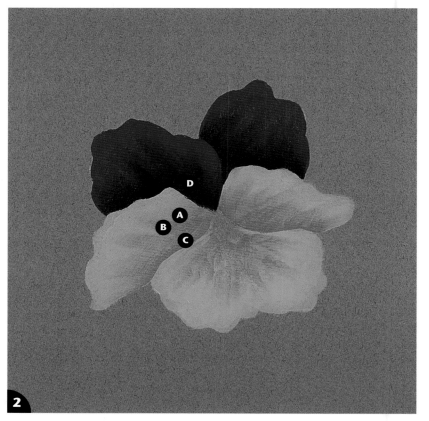

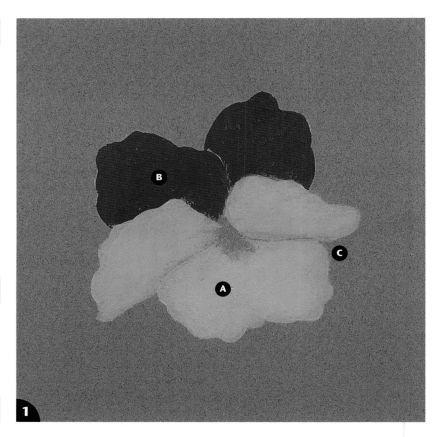

3 Use the optical blending technique (see page 31) to highlight the outer half of each petal with a value scale of either yellow or blue, depending on its foundation color. Make sure you always use a dry brush: Load the filbert with just a small amount of paint, then wipe it on a paper towel to remove excess. Lightly skim the hairs over the surface and apply each successively lighter value to a progressively smaller area. Let each application dry before adding the next.

- *Yellow petals.* Begin with the medium-value yellow that was mixed for the undercoat (see step 1). Let dry, then apply a layer of cadmium yellow light. Continue adding several layers of cadmium yellow light, making each one lighter by adding a small amount of titanium white (A).
- *Blue petals.* Begin with the blue that was mixed for the undercoat (see step 1), then lighten it gradually by adding small amounts of titanium white (B).

4 Use the lightest highlight colors to accent the tips of the petals of the other color. Accent the yellow petals with pale blue (A), and the blue petals with light yellow (B). Let dry.

Add the pansy's "face"—the streaks that radiate from the center of the three foremost petals—with the no. 12 flat sideloaded with the color that was mixed to shade the blue petals (see step 2). Position the more heavily loaded side of the brush toward the center of the flower, then "walk" the brush around an imaginary point in the center, applying varying degrees of pressure on it as you tilt it from side to side to create the streaked effect (C). Let dry.

Use the script liner brush to paint the very center of the flower on the primary petal. Apply yellow oxide, then lightly streak it down into the dark area beneath it (D). Let dry. Repeat with burnt sienna, this time applying it to a smaller area and extending it only into the yellow oxide (E). Complete the center by adding a dot of light green (cadmium yellow light + ultramarine blue) (F); let dry, then pull two comma strokes of titanium white on either side and onto the edges of the primary petal (G).

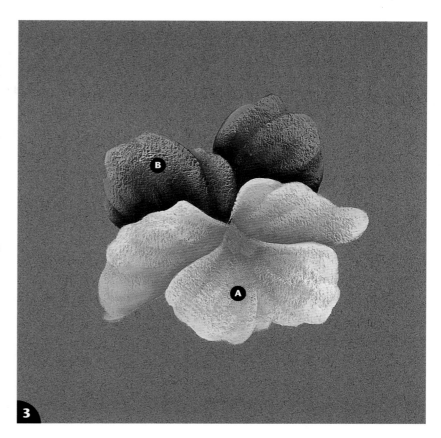

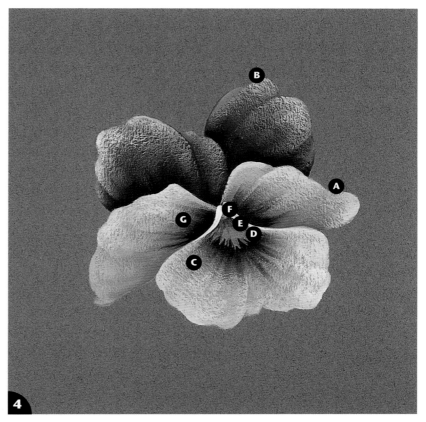

Painting in Oils/Pansies

WHAT YOU'LL NEED

ARTISTS' OILS

Titanium white

Cadmium yellow light

Cadmium yellow medium

Yellow ochre

Raw sienna

Burnt sienna

Alizarin crimson

Ultramarine blue

Ivory black

BRUSHES

Flats: Nos. 8 and 10 *(Golden Natural series 2002S)*

Script liner: No. 2 *(Golden Natural series 2007S)*

MISCELLANEOUS

Disposable paper palette

Palette knife

Paper towels

Japan drier

PAINTING TECHNIQUES

Blocking In (page 29)

Drybrushing with Oils (page 31)

INSTRUCTIONS

1 Using the largest flat brush you can comfortably maneuver in each space, block in two values on each petal. Use a separate brush for each set of values, or wipe the brush thoroughly on a paper towel before applying the second set. If any unwanted color remains, simply wipe the brush again, then reload it.

- *Blue petals.* To each petal, apply a medium-value (but still fairly dark) mixture of ultramarine blue + titanium white + a touch of alizarin crimson to the outer half (A). Apply a darker value (ultramarine blue + alizarin crimson + a touch of ivory black) to the base, extending it over about half (B).
- *Yellow petals.* Paint the inner third of each petal with raw sienna (C), and the outer two-thirds with a light mixture of yellow ochre + cadmium yellow medium (D).

2 Wipe the brush on a paper towel until no more paint is discharged, then use it to blend the areas where two colors meet. (NOTE: Be sure to wipe the brush thoroughly after working on one color and before working on the other.) Soften the two values to create a third, transitional value between them (A, B). Take care not to overblend, or you're likely to end up with just one value.

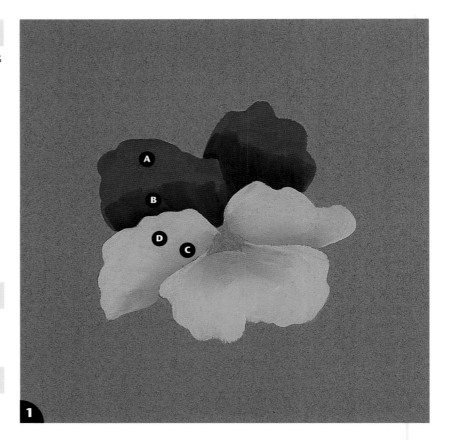

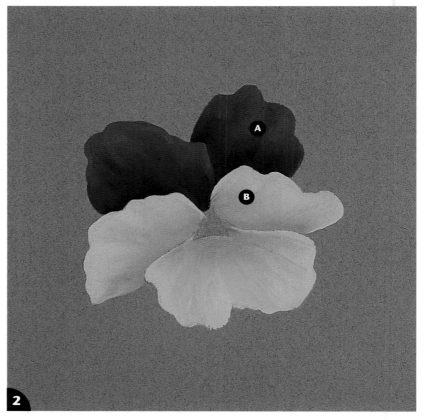

3 Use a no. 10 flat brush to apply highlights of titanium white to the blue petals, feathering out the edges of the strokes toward the base. The color will gradually become a light blue as it is brushed on (A). Add more white to the edges of the petals if the highlight doesn't seem strong enough.

Apply titanium white highlights to alternate lobes of the yellow petals, along their outer edges (B). Intensify the shading on the innermost edges with burnt sienna (C).

4 Wipe the brush on a paper towel, then blend the edges of the colors that were applied in step 3. Work first on one set of petals, then the other, wiping the brush thoroughly in between.

Add the pansy's "face"—the streaks that radiate from the center of the three foremost petals—using the no. 10 flat sideloaded with the darker blue mixed for the blocking in (see step 1). Pat the loaded side of the brush near the base, letting the color fan out in streaks onto each petal (A). If you paint the "face" with a fully loaded brush, it will look stiff and unnatural.

Use the script liner brush to paint the very center of the flower on the primary petal. Apply yellow ochre, then lightly streak it down into the dark area beneath it (B). Repeat with burnt sienna, pulling streaks of it onto the yellow ochre (C). To complete the center, add a dot of light green (cadmium yellow medium + ultramarine blue) in the cleft (D), then make a titanium white comma stroke on either side so that their tails align with the edges of the petal (E).

Accent the edges of the yellow petals with pale blue (titanium white + a touch of the dark-value blue) (F) and the edges of the blue petals with light yellow (cadmium yellow light + titanium white) (G).

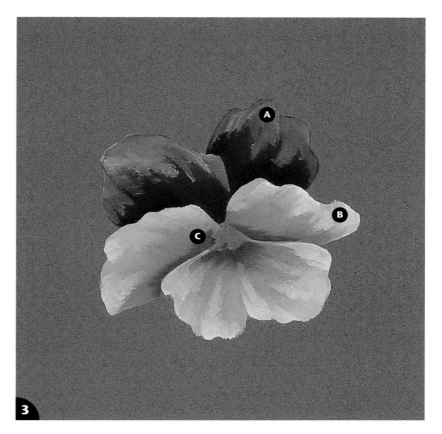

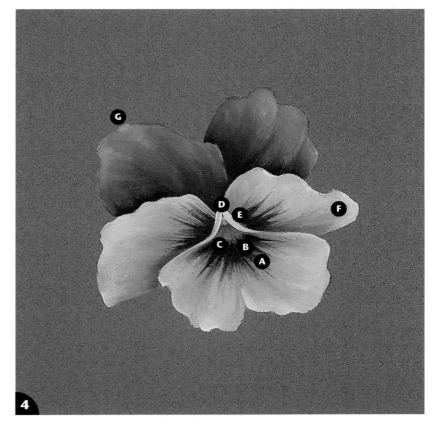

Pink Rose

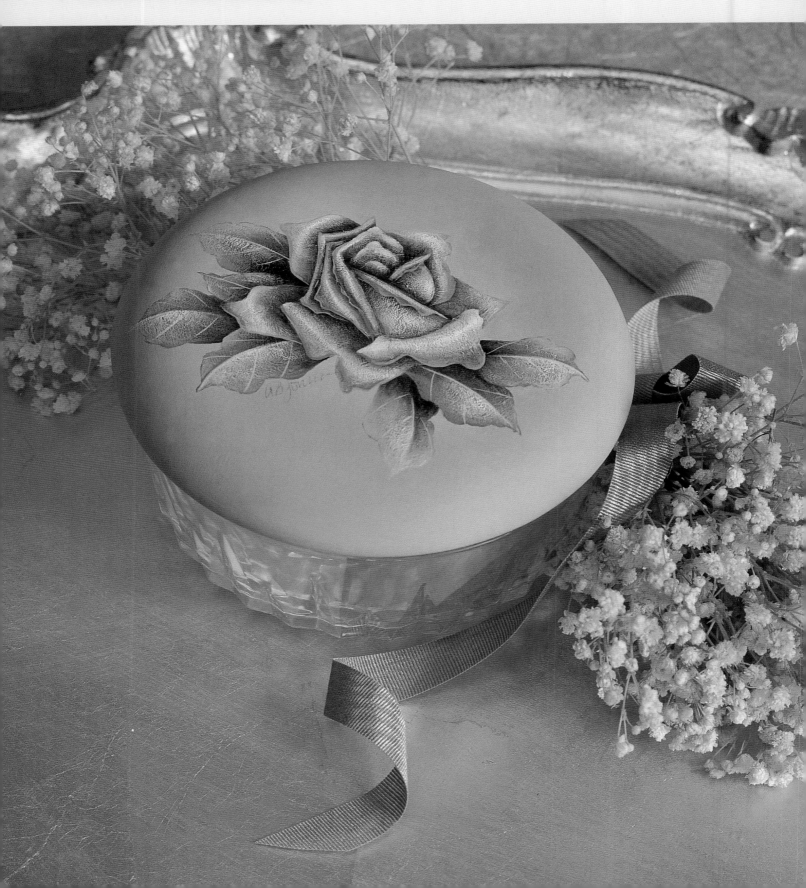

Always beautiful and elegant, roses are loved by just about everyone—which is why nearly every decorative artist wants to paint them! If you allow yourself plenty of time and give yourself permission to make mistakes, you'll be able to enjoy learning how to paint this exquisite flower.

The distinct values of the colors used to paint pink roses make them a little less difficult to work on, so beginners should start with them. If you work slowly and carefully, you shouldn't have any trouble mastering them. Carefully read through the notes on page 114 before you begin, and refer to them throughout the process. Then you can apply what you've learned to roses of other colors, like red and yellow (see page 115 for examples). Eventually, you can work your way up to the delicate white rose, which is the most difficult (see pages 118–123).

SURFACE PREPARATION

I decided to paint the small rose design on the wooden lid of a glass dish. The completed project could be used as a jewelry box or as a container for bath salts or guest soaps.

Prime the lid with white sealer/primer; let dry. Basecoat it with a dusty blue acrylic paint. Make sure that the basecoat is opaque; apply more than one coat if necessary.

Transfer the pattern to the surface with white transfer paper.

IF YOU'RE WORKING IN ACRYLICS

See page 116 for a complete list of materials.

Leaves. Undercoat the leaves with the no. 8 flat brush loaded with a cool light green mixed from cadmium yellow light + Mars black. Let dry, then shade with the no. 8 flat sideloaded with Mars black. Once the shading has dried, highlight the leaves in several layers using a no. 10 filbert and a value scale of greens made by gradually adding titanium white to the green of the undercoat. Finish the leaves by adding accents of soft pink (titanium white + cadmium red light + alizarin crimson).

Varnishing. Wait at least 24 hours before varnishing the completed painting.

IF YOU'RE WORKING IN OILS

See page 118 for a complete list of materials.

Leaves. Block in the leaves with three values of a cool light green. For the medium value, combine cadmium yellow medium + ivory black + titanium white. For the dark value, mix cadmium yellow medium + ivory black. The light value, a very light green, is a mixture of the medium-value green + titanium white. Thoroughly wipe the brush on a paper towel, then use it to soften the lines of demarcation between values to create a gradual transition between them. Reinforce the peaks of the highlights with titanium white; wipe the brush, then blend the edges of the application. Add accents of pale pink (titanium white + cadmium red light + alizarin crimson).

Varnishing. If you used japan drier, you should wait at least 72 hours before varnishing your completed painting; if you didn't, you may need to wait a few weeks to ensure that the paint film is completely dry.

NOTES ON PAINTING ROSES

Because the structure of a rose is so intricate, many artists prefer to paint traditional "tole"-style or stroke roses, in which the petals are portrayed with a series of comma strokes (see page 24), an approach that can yield charming results. My roses, which are more realistic, take a bit more time and practice to paint, but I think the effort is worth it. Study the finished roses shown on the opposite page and the step-by-step demonstrations on pages 116–119 and 122–125 to familiarize yourself with the approach.

A Rose's Structure. In order to paint a rose successfully, you must understand its underlying form. A rose is composed of many petals arranged in several layers. Each individual petal is connected to the stem, which lies at the center, and originates from a different side of the flower, wrapping around the others and in many cases rolling or curling outward away from them.

Value Follows Form. Each petal comprises light, medium, and dark values. The placement of these values is what gives a petal its shape and indicates the direction of its movement. The highlight always follows the crest of a petal's curve. When painting a rose, you'll have to look carefully at each petal and make sure that the lightest value and the peak of the highlight follow the direction in which it turns or curls.

Helpful Hints. The ability to paint beautiful roses is a skill that can be developed, but only with many hours of practice. If you're uncomfortable handling a brush, you can't make it perform the way you want it to, which in turn will make painting a rose difficult. The only way to handle brushes confidently is to use them often, and to challenge yourself by painting complex subjects like roses. Once you've tried it, you'll be able to see where improvements need to be made so that you can work to correct those problems the next time.

In addition to frequent practice sessions, I have two specific recommendations for beginning rose painters. First, be sure to use small brushes. A rose has so many small parts that a large brush simply cannot fit into them. Second, "stack" the rose's petals as you paint them: Start with the ones at the back of the rose, then paint the ones along the base, and finally the ones at the front.

Before You Get Started. To help demystify the process, read through the following summaries of how to paint a rose in each medium.

- *If you're working in acrylics,* begin by undercoating the entire flower; once the undercoat has dried, retransfer the outlines of the individual petals. Next, apply the shading in layers, one color at a time, with a sideloaded brush (see page 32), letting each dry before adding the next. Once the shading has dried, use a dry brush to add several values of highlights, each lighter than the last (see "Optical Blending," page 31). Apply the same value to every petal, let dry, then move on to the next. Once several layers have been applied, you can concentrate on finishing each individual petal. Apply accents and reflected lights to the completed flower.

- *If you're working in oils,* work on one petal at a time, which will help you control the overall look of the flower. First, block in three values, then soften the lines of demarcation between them, until every petal is painted. Next, reinforce the peaks of the highlights, then soften the edges of the application, again working on one petal at a time. Once the flower is essentially complete, you'll be ready to add the accents and reflected lights. (You can't really judge where to place them until that point.)

Regardless of the medium you use, don't hurry through the painting process. Take your time and get lost in the flower.

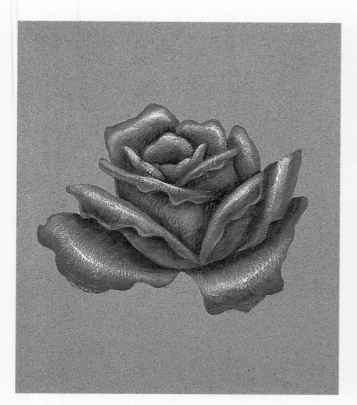

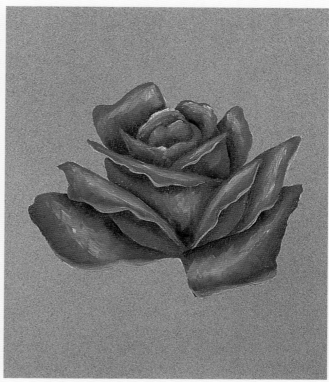

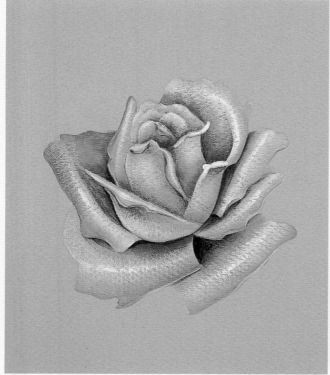

Red and yellow roses painted in acrylics (left) and oils (right).

Painting in Acrylics/Pink Rose

PAINTING TECHNIQUES

Undercoating (page 29)

Sideloading (page 32)

Optical Blending (page 31)

INSTRUCTIONS

1 Use the no. 8 flat brush to undercoat the entire rose with a mixture of titanium white + alizarin crimson + cadmium red light. Let dry, then retransfer the outlines of the interior petals. Work carefully so that the lines are transferred accurately.

2 The flat brush you use to paint the two layers of shading in this step will be determined by the size of the petal you're painting: For the small petals, use either the no. 4 or the no. 8; for the large petals, use the no. 12.

Sideload a brush with alizarin crimson, then carefully apply it to at least half the area of every petal that is overlapped by another. Make sure the shape of the shading follows the contour of the petal (A). Also, place some shading near the outside edges of the largest petals (B). Let dry.

For the second layer of shading, sideload a brush with a mixture of alizarin crimson + Hooker's green. Use this layer of shading to emphasize the first, concentrating it around the edges of the overlapping petals and in the rose's deepest folds (C). Let dry.

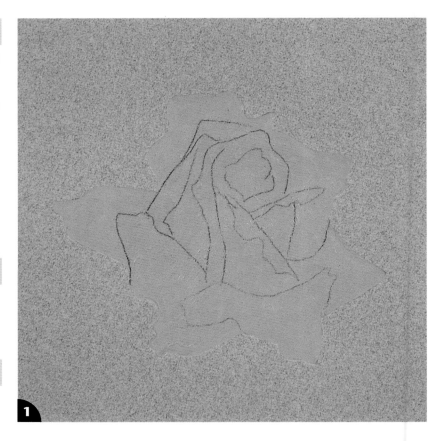

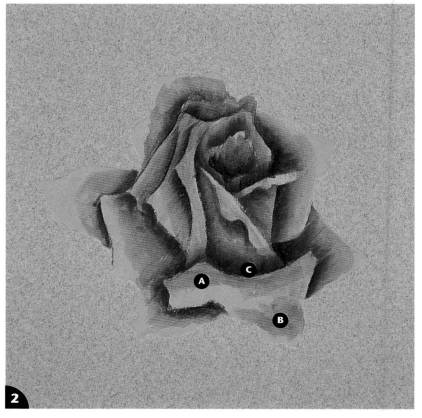

3 Use a no. 6 or 8 filbert to highlight the rose with a value scale of pinks, finishing with white. See page 31 for a description of the optical blending technique, in which a dry brush—one that's been loaded with a small amount of paint, then wiped on a paper towel—is skimmed lightly over the painting surface. Each value is applied to a progressively smaller area and allowed to dry before adding the next.

Begin highlighting with the pink of the undercoat (see step 1) (A). Gradually lighten the pink by adding incremental amounts of titanium white until you've reached the peaks of the highlights, which should be pure white (B). Take your time with the highlighting step. As with the shading, you'll apply each value to every petal, let it dry, then proceed to the next, lighter value.

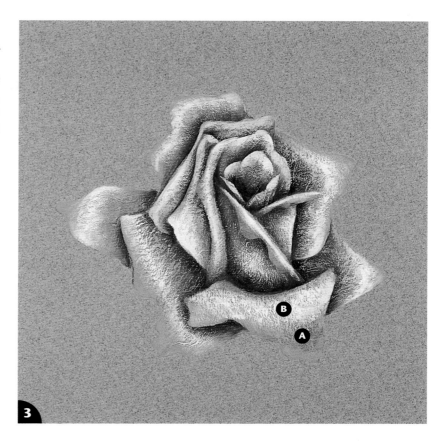

4 To paint the reflected lights on the larger petals, load a no. 8 flat brush with lavender (titanium white + dioxazine purple + a touch of alizarin crimson), wipe it on a paper towel to remove excess, then accent the curled-over edges of the petals (A). On tiny petals, use a script liner brush and paint that has been thinned with water to an inklike consistency.

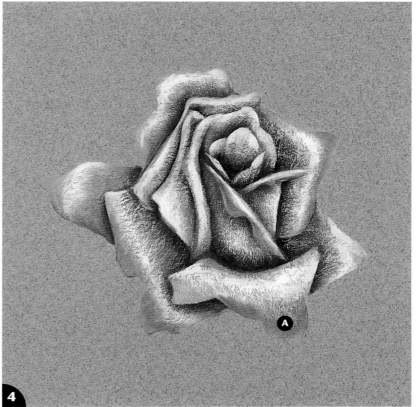

Painting in Oils/Pink Rose

WHAT YOU'LL NEED

ARTISTS' OILS	BRUSHES	MISCELLANEOUS
Titanium white	Flats: Nos. 6, 8, and 10 (*Golden Natural series 2002S*)	Disposable paper palette
Cadmium yellow medium		Palette knife
Burnt umber	Script liner: No. 2 (*Golden Natural series 2007S*)	Paper towels
Cadmium red light		Japan drier
Alizarin crimson		
Ultramarine blue		
Ivory black		

PAINTING TECHNIQUES

Blocking In (page 29)

Drybrushing with Oils (page 31)

INSTRUCTIONS

1 Mix three values of pink. Mix the dark value by combining alizarin crimson + a tad of burnt umber. Make the medium value by adding titanium white to some of the dark-value mixture. To make the light value, lighten some of the medium value with more titanium white.

Working on one petal at a time, block in the three values. Use the largest flat brush that you can comfortably fit in the petal. (It may be necessary to use the liner brush on some of the smaller petals.) Confine the darkest value to the deepest folds, which basically outline the innermost petals (A). Apply the lightest value to the crest of each petal's curve (B). Fill in the remainder of each petal with the medium value (C).

2 Thoroughly wipe the brush on a paper towel (once again, use the largest one you can handle comfortably), then soften the areas *on each petal* where two values meet. Do not blend values that are next to one another if they are on two different petals. Also, follow the contours of each petal as you work. When you're done, you should still be able to see all three values of pink on each petal.

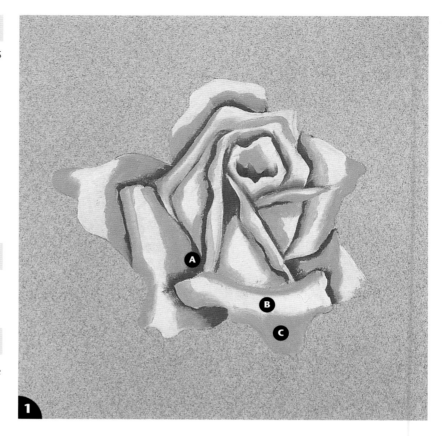

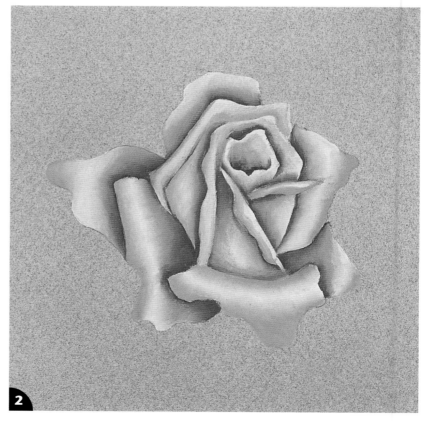

3 Use a no. 8 flat brush to apply titanium white to the peaks of the highlights, which should conform to the shape of the light-value pink on the crest of each petal's curve (A). Apply the paint with some pressure so that it will stay in place when its edges are softened in the next step.

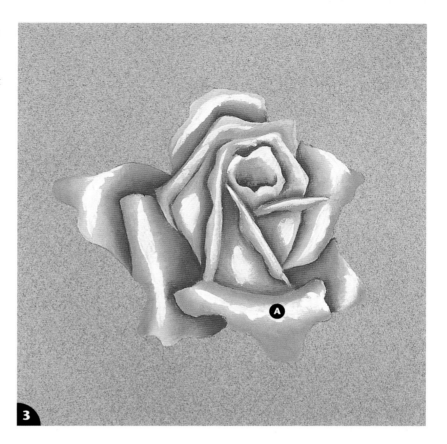

4 Soften the edges of each white highlight into the petals (A). Concentrate the highlights on the petals in the foreground.

Place reflected lights of lavender (titanium white + alizarin crimson + ultramarine blue) opposite the highlights on the outside edges of each petal (B).

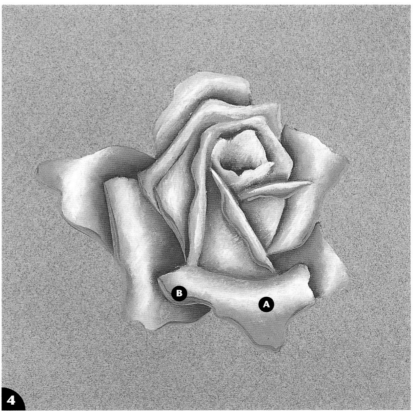

White Roses

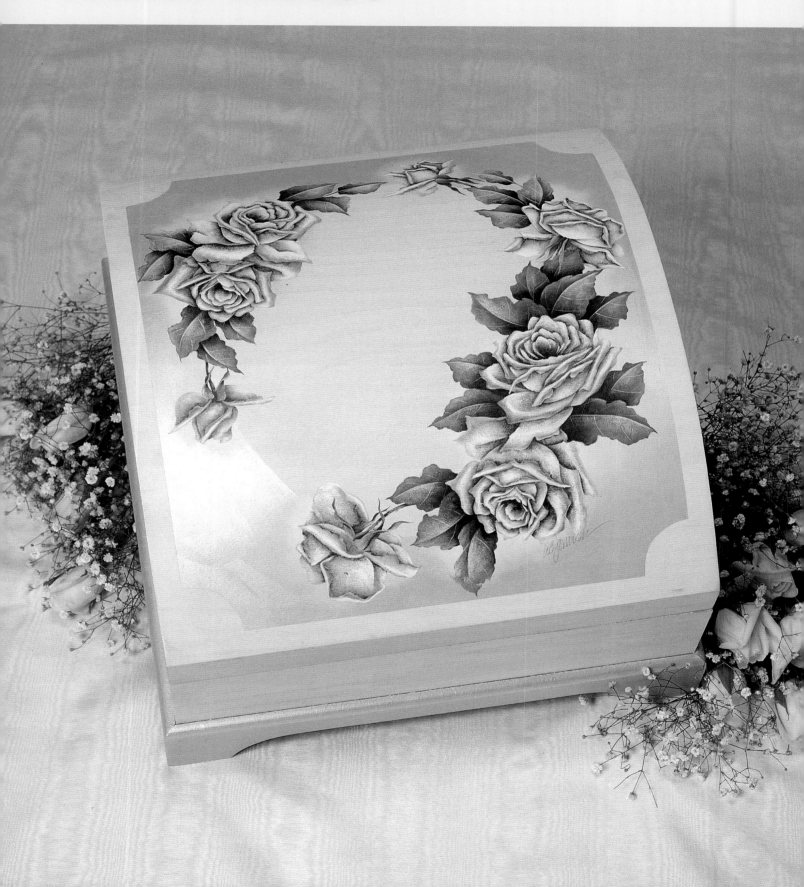

The white rose's gentle coloration makes it one of my favorite floral subjects. The fun lies in being able to choose its palette and temperature, to decide whether the colors used to express shadows and highlights will be light or dark, warm or cool. You can opt for any combination, from pale neutrals to deep greens, purples, or burgundies. When painting a large number of roses, such as those featured on the project shown on the opposite page, you'll need to vary the intensity of the values in order to create variety in the composition.

SURFACE PREPARATION

I painted the two rose garlands on a beautiful wooden trunk. So that the overall effect would be light yet formal, the palette of the roses, the color of the trunk, and the color of the oval frame over which the roses were painted are closely related, providing a subtle link among them.

Pickle (stain) the trunk with white. Let dry. Draw the shape of the oval frame in pencil, then paint it with metallic beige acrylic paint.

Once the oval frame is dry, transfer the patterns to the surface with gray transfer paper.

IF YOU'RE WORKING IN ACRYLICS

See page 122 for a complete list of materials.

Leaves. This project calls for light, cool leaves. Use a no. 12 flat to undercoat the leaves with a green mixed from yellow oxide + ultramarine blue + a tad each of Mars black and titanium white. Let dry, then shade with a sideloaded mixture of Mars black + ultramarine blue. Once the shading has dried, begin highlighting with the no. 8 flat, gradually lightening the green mixed for the undercoat by adding small

amounts of titanium white. Accent some of the leaves with a mixture of ultramarine blue + burnt umber + titanium white.

Varnishing. Wait at least 24 hours before varnishing the completed painting.

IF YOU'RE WORKING IN OILS

See page 124 for a complete list of materials.

Leaves. Block in the leaves with three values of green with a no. 12 flat brush. For the medium value, combine yellow ochre + ultramarine blue + ivory black. The dark value is a mixture of ivory black + ultramarine blue. The light value is made by mixing titanium white with a tad of the medium-value green. Using a dry brush, gently soften the areas where values abut. Reinforce the peaks of the highlights with pure titanium white. Accent the leaves with some yellow ochre or burnt sienna.

Varnishing. If you used japan drier, you should wait at least 72 hours before varnishing your completed painting; if you didn't, you may need to wait a few weeks to ensure that the paint film is completely dry.

Painting in Acrylics/White Roses

WHAT YOU'LL NEED

ARTISTS' ACRYLICS

Titanium white

Yellow oxide

Raw sienna

Burnt sienna

Burnt umber

Alizarin crimson

Dioxazine purple

Ultramarine blue

Hooker's green

Mars black

BRUSHES

Flats: Nos. 8 and 12 (Golden Natural series 2002S)

Script liner: No. 2 (Golden Natural series 2007S)

Filbert: No. 8 (Ruby Satin series 2503S)

MISCELLANEOUS

Disposable paper palette

Sta-Wet palette

Palette knife

Paper towels

Water container

PAINTING TECHNIQUES

Undercoating (page 29)

Sideloading (page 32)

Applying a Wash (page 30)

Optical Blending (page 31)

See also: Notes on Painting Roses (page 114)

INSTRUCTIONS

1 Combine titanium white + alizarin crimson + Hooker's green to create a medium gray. (You may need to add a little Mars black to make it dark enough.) Use a no. 12 flat to undercoat the rose (A). To impart variety to the undercoat, add white to your brush as you work (B).

Once the undercoat has dried, retransfer the outlines of the petals to the rose.

2 Make a dark, neutral gray by mixing Hooker's green + alizarin crimson. (Make sure it isn't either too red or too green.)

Apply the shading to one petal at a time. Sideload no. 8 flat with the dark gray, stroke the heavily loaded side of the brush around its outline (A), then pull the color out toward the edge (B). Leave the crest of the petal's fold (and any other areas that will be highlighted) unpainted. Let dry.

When all the petals have been shaded, diversify the shaded areas by randomly applying washes of pure Hooker's green, dioxazine purple, or alizarin crimson with the no. 8 flat (C).

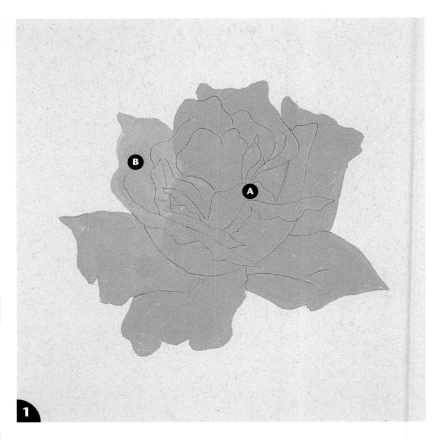

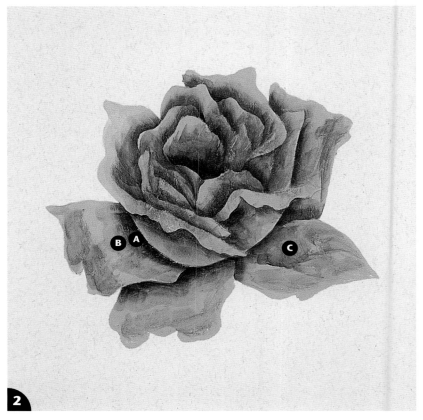

3 Use the optical blending technique to paint the highlights along the crest of each petal's curve with a value scale of grays, ending with almost pure white.

Load the filbert with a small amount of the medium gray of the undercoat (see step 1) to which a little bit of yellow oxide has been added, then wipe it on a paper towel to remove excess paint. (The yellow adds warmth to the rose and keeps it from looking artificial.) Working one petal at a time, skim the color over the very edges of the areas that were left unpainted in step 2 (A).

Let dry, then repeat, incrementally lightening the gray with small amounts of yellow oxide and titanium white and applying the color to smaller areas within the highlight. Finish the highlights with a light gray that is nearly white (B).

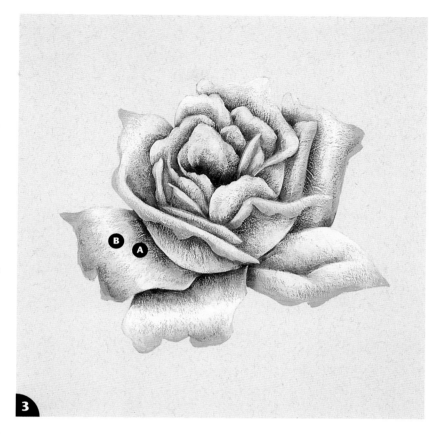

4 Accent the edges of the foremost and side petals with yellow oxide. (Use these accents very sparingly, or you may end up painting your white roses yellow!) Apply the color to the larger petals with a dry filbert (A); use a sideloaded no. 8 flat on the smaller ones (B). Let dry.

To heighten the drama of the accents, apply washes of raw sienna and burnt sienna to the very tips of the petals with a script liner brush (C).

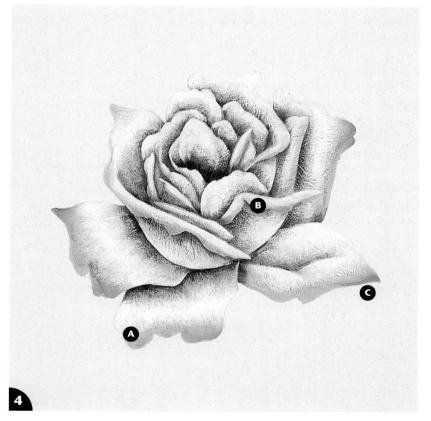

Painting in Oils/White Roses

WHAT YOU'LL NEED

ARTISTS' OILS	BRUSHES	MISCELLANEOUS
Titanium white	Flats: Nos. 6, 8, and 12 *(Golden Natural series 2002S)*	Disposable paper palette
Naples yellow hue		Palette knife
Yellow ochre	Script liner: No. 2 *(Golden Natural series 2007S)*	Paper towels
Burnt sienna		Japan drier
Burnt umber		
Ultramarine blue		
Ivory black		

PAINTING TECHNIQUES

Blocking In (page 29)

Drybrushing with Oils (page 31)

See also: Notes on Painting Roses (page 114)

INSTRUCTIONS

1 Mix three values of gray: dark (ultramarine blue + burnt umber + a touch of white), medium (some of the dark-value gray + titanium white), and light (titanium white + some of the medium-value gray).

Working on a petal at a time, block in the three values with a no. 6 flat brush. Restrict the darkest value to the petals' outlines (A). Apply the lightest value to the crest of each petal's curve (B). Fill in the remainder of each petal with the medium value (C).

2 Thoroughly wipe the brush on a paper towel, then use it to soften lines of demarcation between values *on each petal.* Do not blend adjacent values if they are on two different petals, and follow the contours of each petal as you work. Strive to create smooth gradations, but don't overblend—you'll end up with just one value.

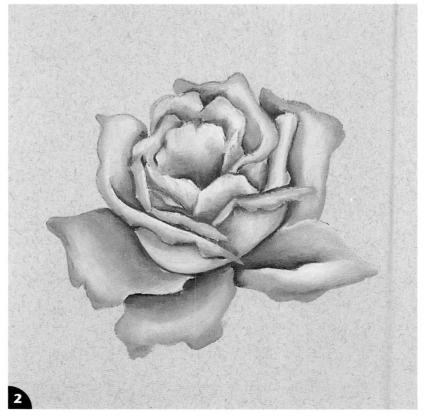

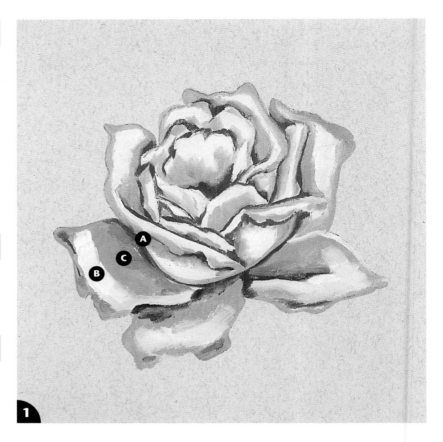

3 Use a no. 6 flat brush to apply titanium white to the peaks of the highlights (A). Exert pressure on the brush to help the highlight remain in place when its edges are blended in the next step.

Add some accents of Naples yellow hue to the very edges of the side and foremost petals with a no. 8 flat brush (B).

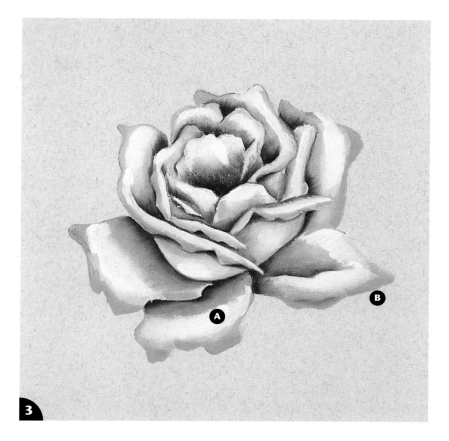

4 Wipe the no. 6 flat on a paper towel, then use it to blend the edges of the white highlights, taking care to confine them to the lightest areas of each petal (A).

Wipe the brush again, then soften the accents at the tips of the petals. If desired, you can create a "bruised" or blemished edge by intensifying the accents with yellow ochre or even a little burnt sienna (B).

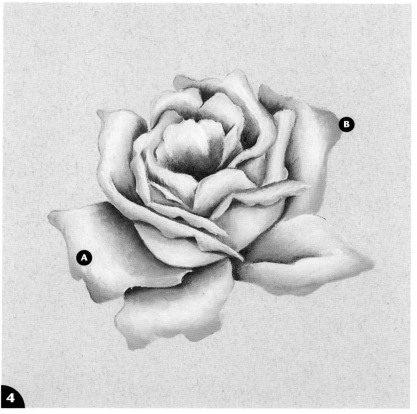

Irises

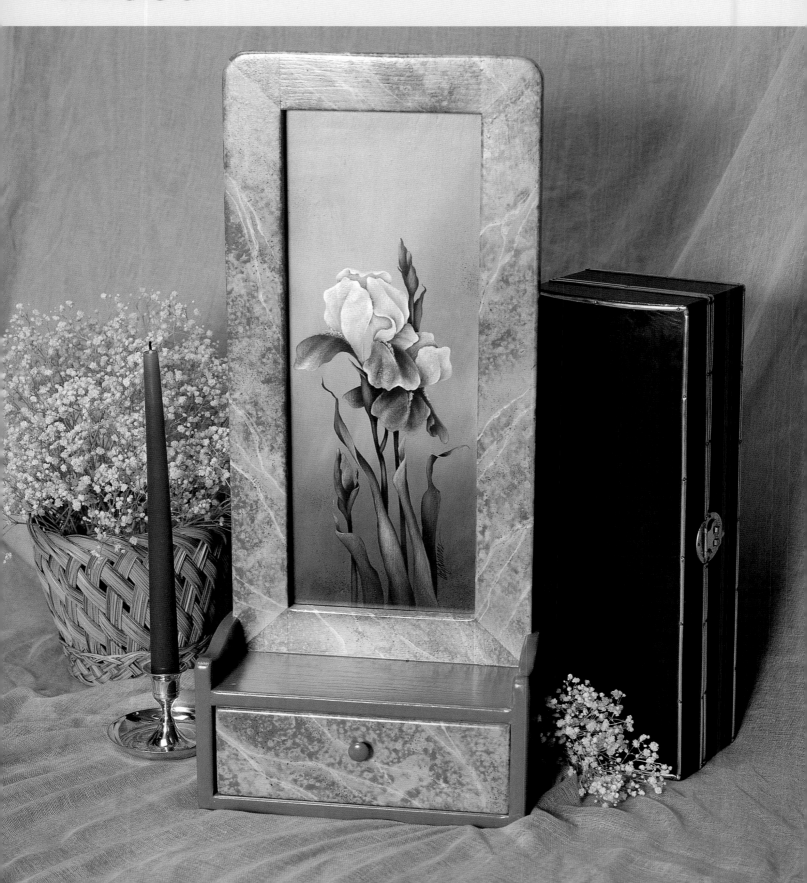

I painted the duo of irises shown opposite in a complementary color scheme of yellow and violet. When working toward a color harmony, especially between two highly contrasting colors, one should take precedence over the others, whose values must then be adjusted in order to link them all visually. Subtle accents can also be used to further balance and unity.

SURFACE PREPARATION

I painted the bicolor irises on a drawer frame that I had finished with a quick-and-easy faux marble. If you don't want to marbleize your project's surface, you could simply basecoat it with a light neutral green so that it won't conflict with the flowers.

To begin, prime the entire item with white sealer/primer; let dry, then basecoat it with a dull celadon green.

Combine cadmium yellow light + Mars black + burnt umber to make a dark, dull green, add a bit of the basecoat color, then thin the entire mixture with water. Use a clean wash brush to lightly moisten the frame and drawer front with water. (Do not drench the surface.) Crumple some plastic wrap into a small wad, lightly load it with the thinned paint, then dab it on the dampened surface. To vary the values, pat the wad over the surface, turning it as you work. Immediately flyspeck the surface with rubbing alcohol to create an interesting fossilized pattern. Let dry.

Sideload a wash brush with the basecoat color + a little bit of burnt umber. Lightly skim this color on wherever you want to create veins, then let dry. Combine titanium white + a bit of the basecoat color, then use a script liner brush to paint some delicate veins. Let dry.

To create a blended basecoat on the center panel, lightly dampen the surface with water, then use a wash brush to quickly apply the basecoat color and a mixture of Hooker's green + burnt umber opposite one another. Blend the area where the two colors meet by working the brush in a crisscross motion, then soften it with a mop brush. Let dry.

Transfer the pattern to the surface with white transfer paper.

IF YOU'RE WORKING IN ACRYLICS

See page 128 for a complete list of materials.

Leaves. Use a no. 12 flat brush to undercoat the leaves with a mixture of cadmium yellow light + Mars black + ultramarine blue. Let dry, then shade with a no. 12 flat sideloaded with Mars black + ultramarine blue. Once the shading has dried, use the optical blending technique (see page 31) and the filbert to highlight the leaves with a value scale of soft greens. Create the greens by incrementally adding a small amount of titanium white to the green of the undercoat before applying each layer. Let each layer of highlights dry before adding the next. Use the filbert to add accents of dioxazine purple.

Varnishing. Wait at least 24 hours before varnishing the completed painting.

IF YOU'RE WORKING IN OILS

See page 130 for a complete list of materials.

Leaves. Mix three values of green: medium (cadmium yellow light + ivory black + a bit of ultramarine blue), dark (ivory black + ultramarine blue), and light (the medium-value green + cadmium yellow medium + titanium white). Block in the three values with a no. 10 flat, then wipe the brush on a paper towel and soften the adjoining edges of the values. Reinforce the peaks of the highlights with titanium white, then soften the edges of each application. Add some tints of alizarin crimson + ultramarine blue + titanium white.

Varnishing. If you used japan drier, you should wait at least 72 hours before varnishing your completed painting; if you didn't, you may need to wait a few weeks to ensure that the paint film is completely dry.

Painting in Acrylics/Irises

WHAT YOU'LL NEED

ARTISTS' ACRYLICS

Titanium white

Cadmium yellow light

Yellow oxide

Burnt sienna

Burnt umber

Cadmium red light

Dioxazine purple

Ultramarine blue

Mars black

BRUSHES

Flats: Nos. 8 and 12 *(Golden Natural series 2002S)*

Script liner: No. 2 *(Golden Natural series 2007S)*

Filbert: No. 8 *(Ruby Satin series 2503S)*

MISCELLANEOUS

Disposable paper palette

Sta-Wet palette

Palette knife

Paper towels

Water container

PAINTING TECHNIQUES

Undercoating (page 29)

Sideloading (page 32)

Optical Blending (page 31)

INSTRUCTIONS

1 Undercoat the petals with a no. 8 flat brush. Paint the yellow petals with a mixture of cadmium yellow light + burnt umber + titanium white (A). For the purple petals, use a mixture of dioxazine purple + titanium white (B). Let dry.

Retransfer any pattern lines that were covered by the undercoat.

2 Shade the yellow petals with two layers of color. Using a sideloaded no. 8 flat, stroke yellow oxide along one side of each petal's cleft, beneath curls and rolls, and on the base (A). Let dry, then intensify the shaded areas with a sideloaded mixture of the yellow of the undercoat (see step 1) + burnt umber (B). Let dry.

Shade the purple petals with a no. 8 flat sideloaded with Mars black (C). Let dry.

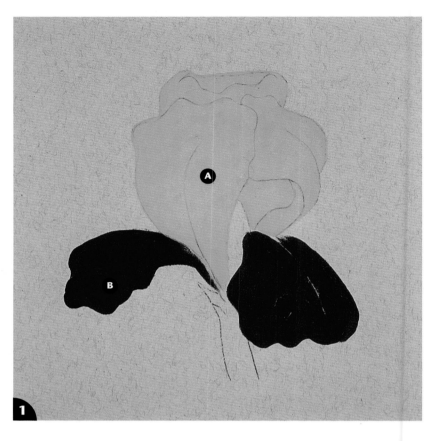

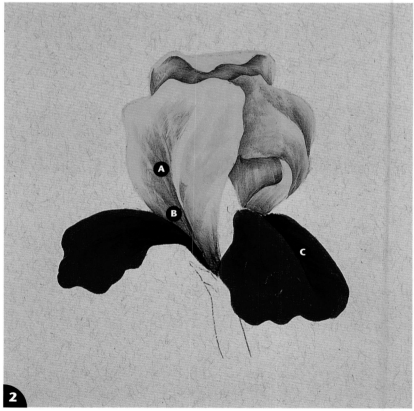

3 Highlight the petals with a range of values using the optical blending technique (see page 31). Note that the petals on the iris in the foreground should be lighter than those on the one in the background.

For the yellow petals, start with the yellow that was mixed for the undercoat (see step 1). Load the filbert with a scant amount of paint, wipe it on a paper towel, then lightly graze the hairs over the surface. Repeat to apply a range of yellows that have been incrementally lightened. by adjusting the undercoat mixture first with small amounts of titanium white, then cadmium yellow light, then ending with titanium white. Let each layer dry before applying the next, and apply each one to a progressively smaller area (A).

Repeat to highlight the purple petals, gradually lightening the purple of the undercoat with titanium white (B).

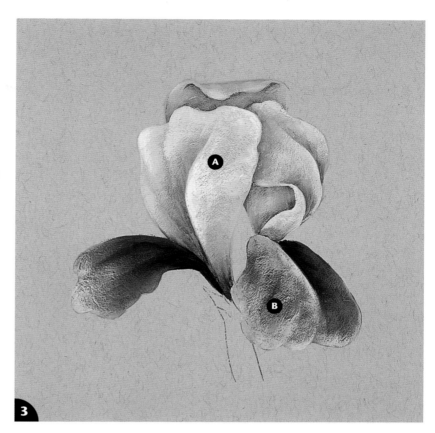

4 Using the colors that were mixed for the highlights, visually link the two sets of petals by accenting the yellow ones with purple and the purple ones with yellow. Very lightly apply the color only to the very tips of the petals with the filbert (A).

To paint the beards, thin a small amount of each of the following colors or mixtures to an inklike consistency: burnt sienna, burnt umber, yellow oxide, cadmium yellow light, cadmium yellow light + titanium white, and cadmium red light. Use the script liner brush to paint clusters of small dots along the inner third of each of the purple petals (B).

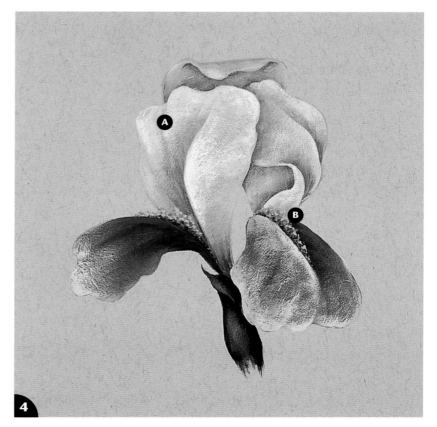

Painting in Oils/Irises

WHAT YOU'LL NEED

ARTISTS' OILS
Titanium white

Cadmium yellow light

Cadmium yellow medium

Naples yellow hue

Yellow ochre

Burnt sienna

Burnt umber

Cadmium red light

Alizarin crimson

Cobalt violet hue

Ultramarine blue

Ivory black

BRUSHES
Flats: Nos. 6, 8, and 10 (*Golden Natural series 2002S*)

Script liner: No. 2 (*Golden Natural series 2007S*)

MISCELLANEOUS
Disposable paper palette

Palette knife

Paper towels

Japan drier

PAINTING TECHNIQUES

Blocking In (page 29)

Drybrushing with Oils (page 31)

INSTRUCTIONS

1 Working on one petal at a time, use the no. 8 flat brush to block in two values.

For the yellow petals, combine Naples yellow hue + cadmium yellow medium for the light value, and cadmium yellow medium + burnt umber for the dark value. Apply the dark value to the base of each petal, the areas along their central clefts, and where one petal overlaps another (A). Apply the light value to the remainder of each petal (B).

The light value on the purple petals is cobalt violet hue (C), and the dark value is a mixture of ultramarine blue + alizarin crimson. Concentrate the dark value along the base, extending it over approximately one-third of the petal (D).

2 Thoroughly wipe the brush on a paper towel, then use it to soften the areas where two colors meet, but only enough to eliminate the harsh line between them. Your strokes should follow the contours of each petal.

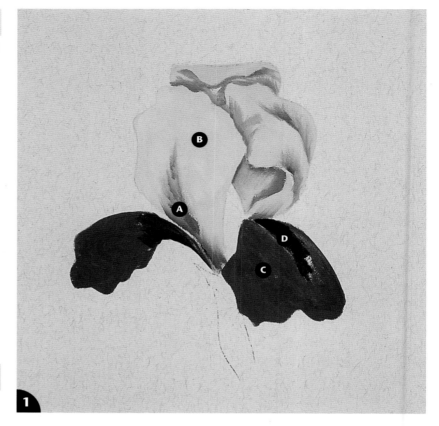

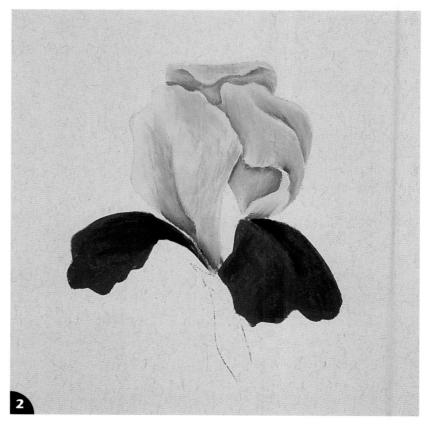

3 Pressing firmly, use a no. 8 flat brush to apply titanium white to the peaks of the highlights on all the petals (A). The white will pick up some of the wet color beneath them when they are applied.

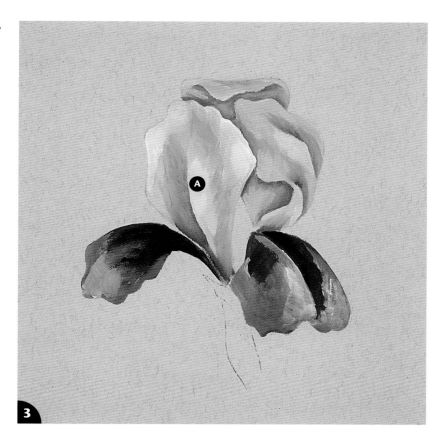

4 Use a light touch to blend the white highlights into the petals (A). Reapply any that are overblended or otherwise need strengthening.

Concentrating on the tips of the lobes, use the no. 6 flat to accent the yellow petals with purple (B) and the purple petals with yellow (C).

Use mineral spirits to thin each of the following colors and mixtures to an inklike consistency: burnt umber, burnt sienna, yellow ochre, cadmium yellow medium, cadmium red light, and cadmium yellow medium + titanium white. Following the same sequence of colors, use the script liner brush to paint the beard of the iris with clusters of dots (D).

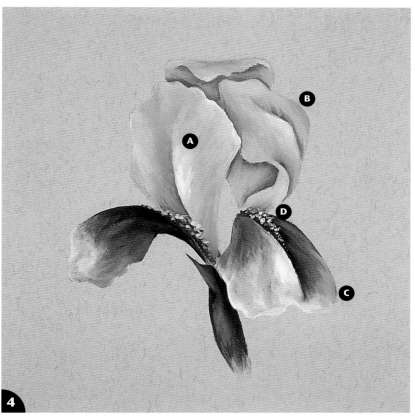

Decorative Painting Patterns

Pears
Enlarge 164%. See pages 52–57 for project and
painting instructions.

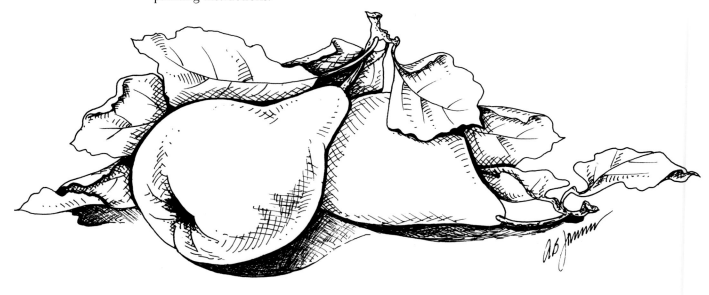

Yellow Apples
Enlarge 164%. See pages 58–63 for project and
painting instructions.

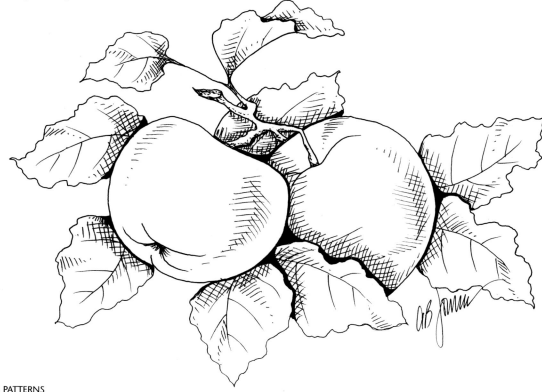

Red Apples

Enlarge 125%. See pages 64–69 for project and painting instructions.

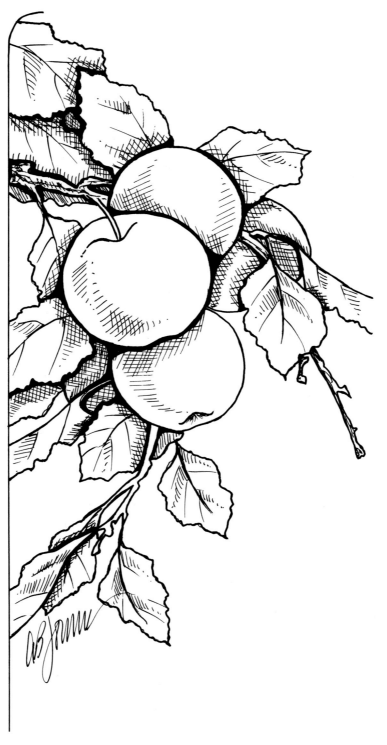

Plums

Enlarge 118%. See pages 70–75 for project and painting instructions.

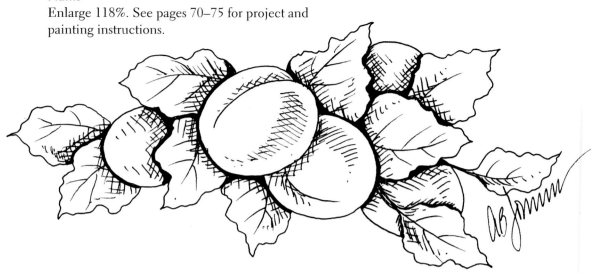

Strawberries

Enlarge 143%. See pages 76–81 for project and painting instructions.

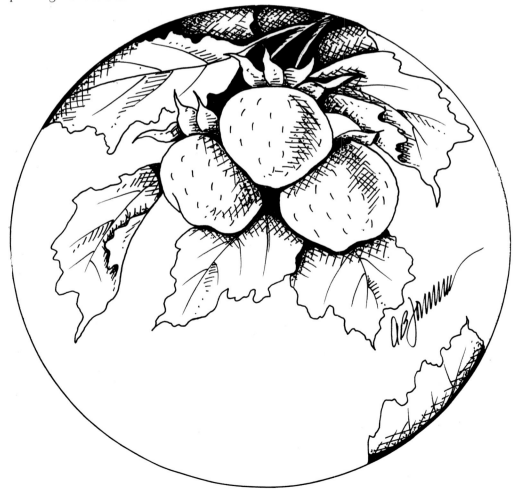

Green Grapes

Use same size. See pages 82–87 for project and painting instructions.

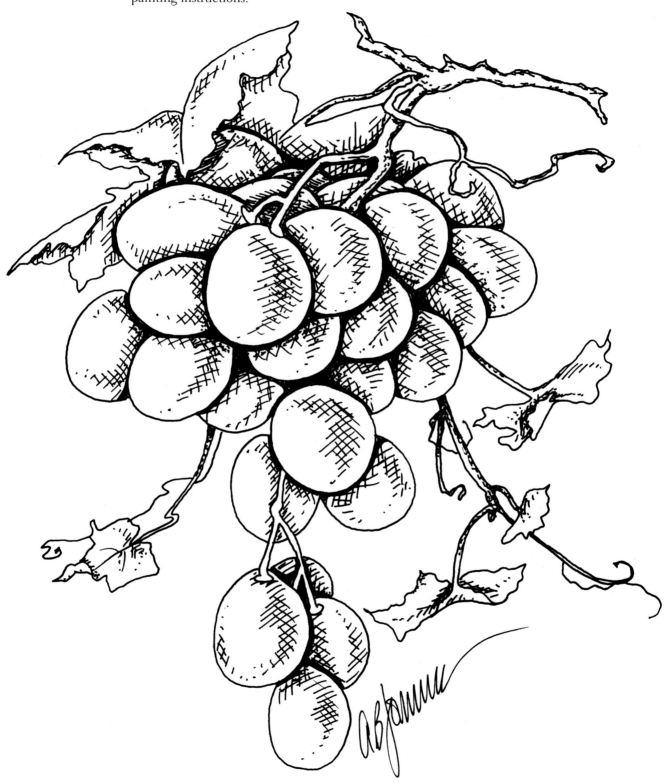

Poppies
Enlarge 125%. See pages 88–93 for project and painting instructions.

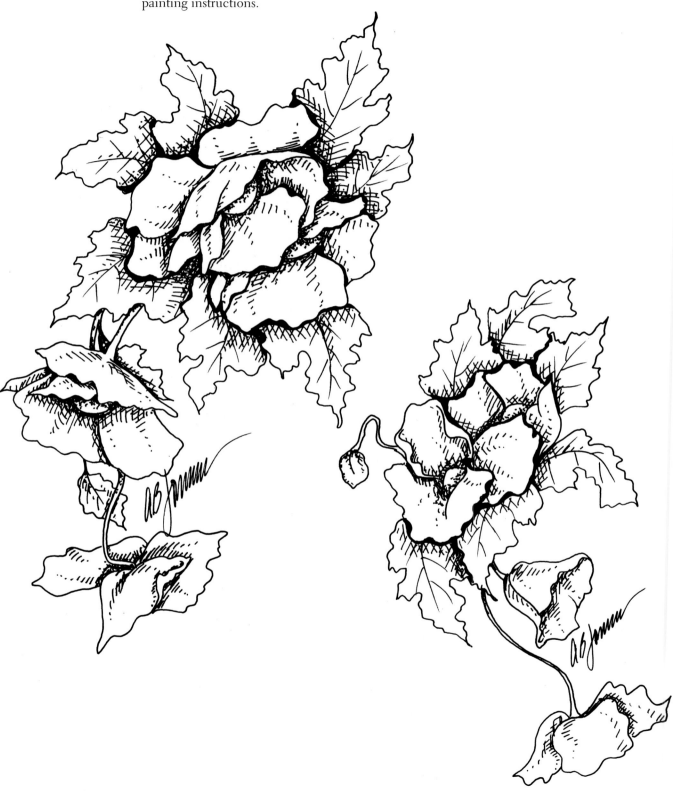

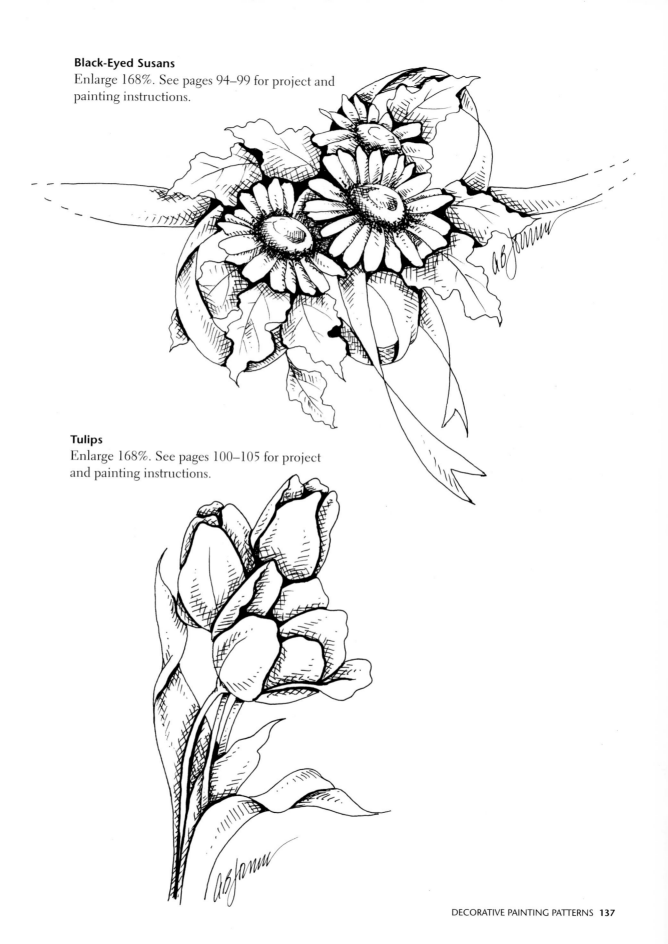

Black-Eyed Susans
Enlarge 168%. See pages 94–99 for project and painting instructions.

Tulips
Enlarge 168%. See pages 100–105 for project and painting instructions.

Pansies
Enlarge 118%. See pages 106–111 for project
and painting instructions.

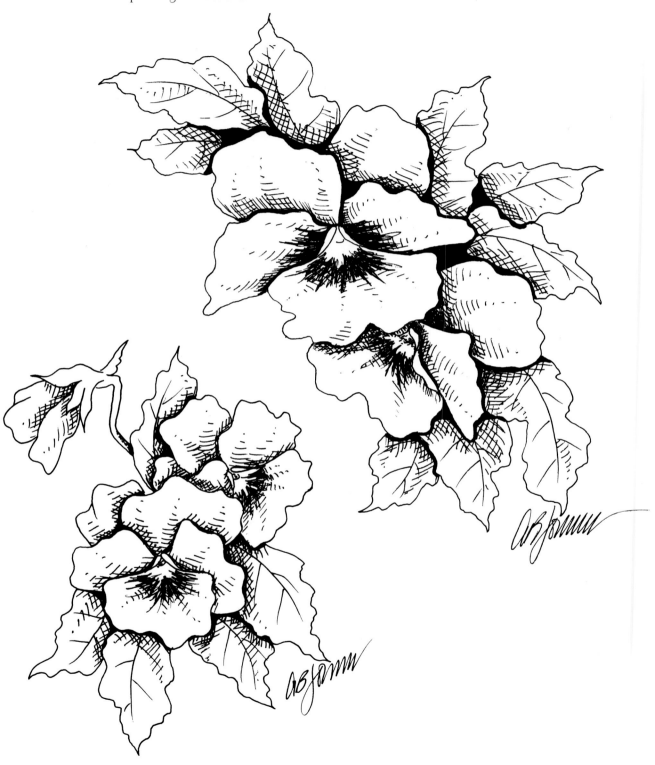

Pink Rose

Use same size. See pages 112–119 for project and painting instructions.

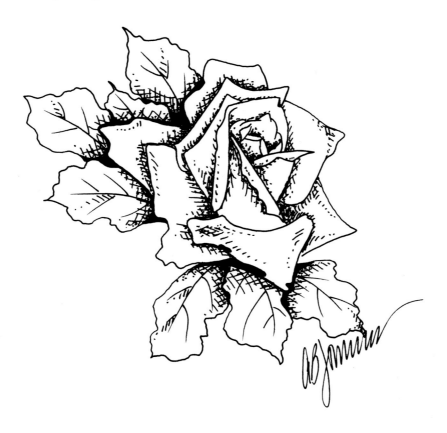

White Roses
Enlarge 196%. See pages 120–125 for project
and painting instructions.

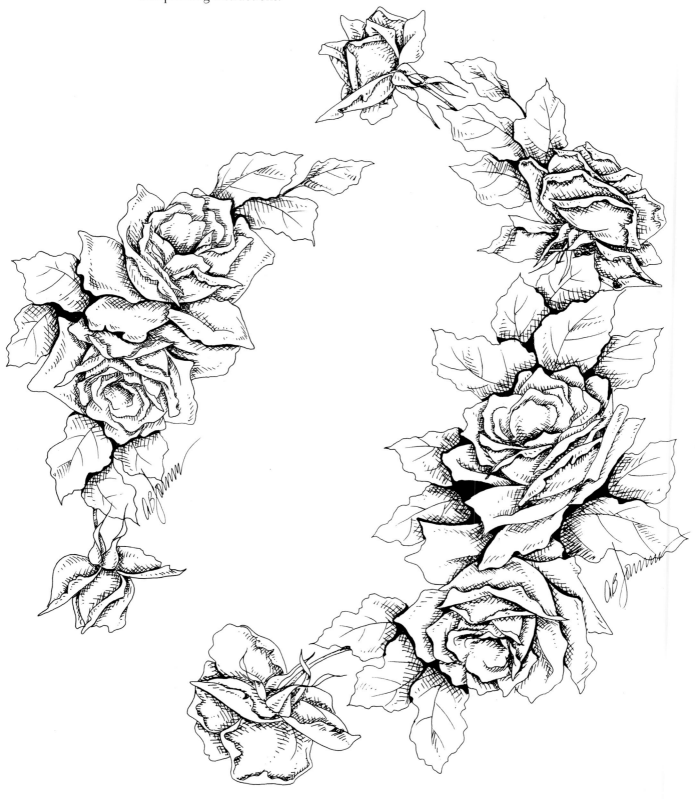

Irises
Enlarge 164%. See pages 126–131 for project
and painting instructions.

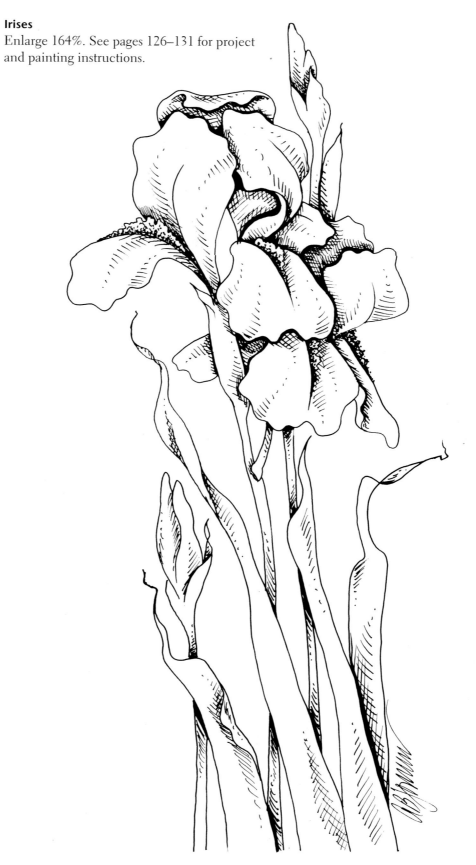

Source Directory

Listed below are the suppliers for some of the materials used in this book. The companies that make wooden surfaces sell their products via mail order to individual decorative painters and crafters. In contrast, the first two listings are nationally distributed manufacturers that sell their products in large quantities only to art supply and craft retailers. If you would like to try the paints and brushes that are used in this book (see pages 10 and 13 for descriptions), check with your local art supply or craft store. If you can't find a store in your area that carries products by Silver Brush Limited, you can order them from PCM Studios. If you need information on where to find Prima paints, Martin/F. Weber Co. can direct you to the retailer nearest you that carries their products.

Paints
Prima Acrylics and Oils
Martin/F. Weber Co.
2727 Southampton Road
Philadelphia, Pennsylvania 19154
(215) 677-5600

Brushes
Silver Brush Limited
P.O. Box 414
Windsor, New Jersey 08561
This company sells its products exclusively to retailers. For individual mail orders, refer to the listing for PCM Studios.

Wooden Painting Surfaces
Allen's Wood Crafts
3020 Dogwood Lane
Sapulpa, Oklahoma 74066
(918) 224-8796
Drawer frame (Irises, pages 126–131)

Covered Bridge Crafts
449 Amherst Street
Nashua, New Hampshire 03063
(603) 889-2179
Glass dish with wooden lid (Pink Rose, pages 112–119)
Tin box with wooden lid (Dogwood, page 46)

The Elbridge Company
6110 Merriam Lane
Merriam, Kansas 66203
(913) 384-1080
Lamps and lampshades (Black-Eyed Susans, pages 94–99; Tulips, pages 100–105)

Gretchen Cagle Publications
P.O. Box 2104
Claremore, Oklahoma 74018
(918) 342-6188
Heart box (Red Roses, pages 2–3)

PCM Studios
731 Highland Avenue N.E. - Suite D
Atlanta, Georgia 30312
(404) 222-0348
Mail-order and information source for brushes by Silver Brush Limited
English cache box (Pansies, pages 106–111)
Gold leaf tray (Yellow Roses, page 34)

Pesky Bear
5059 Roszyk Road
Machias, New York 14101
(716) 942-3250
Basket (Plums, pages 70–75)

Valhalla Designs
343 Twin Pines Drive
Glendale, Oregon 97442
Herring plate (Strawberries, pages 76–81)
Hindeloopen tray (Green Grapes, pages 82–87)
Valet trunk (White Roses, pages 120–125)

Woodcrafts
P.O. Box 78
Bicknell, Indiana 48512
(800) 733-8420
Bentwood box (Pears, pages 52–57)

Index